Mustangs
WILD HORSES OF THE WEST

Marie-Luce Hubert • Jean-Louis Klein

FIREFLY BOOKS

A FIREFLY BOOK

Published by Firefly Books Ltd. 2007
English translation © 2007 Firefly Books

Originally published as *Chevaux en Liberté: Mustangs*
ISBN: 2-03-582253-X
Copyright © Larousse 2006
English Translation copyright © 2007 Firefly Books

Publisher Cataloging-in-Publication Data (U.S.)
Hubert, Marie-Luce.
 Mustangs : wild horses of the west / Marie-Luce Hubert and Jean-Louis Klein
[224] p. : col. photos., maps ; cm.
Includes bibliographical references and index.
Summary: Photographs of wild mustangs in their natural habitat
with detailed text outlining their history, daily lives, the dangers they face and their relationship
with humans
ISBN-13: 978-1-55407-318-4
ISBN-10: 1-55407-318-9
1. Wild horses — West (U.S.). 2. Wild horses — West (U.S.) — Pictorial works. 3. Mustang.
4. Mustang — Pictorial works. I. Klein, Jean-Louis. II. Title.
599.665/5/0978 dc22 SF360.3.U6H83 2007

Library and Archives Canada Cataloguing in Publication
Hubert, Marie-Luce
 Mustangs : wild horses of the West / Marie-Luce Hubert and
Jean-Louis Klein.

Translation of : Chevaux en liberté.
Includes bibliographical references and index.
ISBN-13: 978-1-55407-318-4
ISBN-10: 1-55407-318-9
 1. Mustang—Pictorial works. 2. Mustang.
I. Klein, Jean-Louis II. Title.
SF293.M9H8213 2007 599.665'5 C2007-901250-7

Published in the United States by
Firefly Books (U.S.) Inc.
P.O. Box 1338, Ellicott Station
Buffalo, New York 14205

Published in Canada by
Firefly Books Ltd.
66 Leek Crescent
Richmond Hill, Ontario L4B 1H1

Senior Editor: Catherine Delprat
Editors: Sylvie Cattaneo and Cécile Beaucourt, Assisted by Anne Codin
Art Director: Emmanuel Chaspoul
Graphics: Maud Allenet
Layout: Sophie Compagne
Cover: Maud Allenet under the direction of Véronique Laporte
Illustrations/Iconography: Laure Bachetta under the direction of Valérie Perrin
Design: Laurent Blondel
Reading-Correction: Larousse
Production: Annie Botrel
Photoengraving: AGC, Saint-Avertin
English Translation: Klaus and Margaret Brasch

Printed in China

Acknowledgments

Our thanks go out to all, near and far, who helped us locate and understand the mustangs: Susan Hahn, Jane Nibler and Kayla Grams, those keen and enthusiastic observers with whom we had many passionate discussions.

Our friend, Don Galvin, who never ceased to believe in our project. His curiosity and fresh spirit were a great source of motivation. All our gratitude extends to Gary Starbuck who did not hesitate to open the doors to Riverton Honor Farm, as well as to Mike Buchanan for his assistance and explanations.

Thanks to the mustang specialists of the Bureau of Land Management, Roy Packer, Linda Coates-Markle and Tricia Hatle, for their friendly collaboration, as well as to Kevin Lloyd who helped us discover the most far-fetched mustang habitats in the Wyoming Red Desert. We also wish to express our gratitude to the team of wranglers: in particular Jason Hein and Kyle Sammons for allowing us to participate in the day-to-day activities of the roundup process.

All our gratitude extends to Steve Mantle, outstanding horse whisperer, who unveiled to us the secrets of mustang taming, as well as to Mike Leffingwell, a very sensitive cowboy and fine horse connoisseur.

Finally, our most sincere thanks go out to Catherine Delprat and Sylvie Cattaneo. Without their inspiration and creativity, our long voyage side by side with the mustangs would not have led to this piece of work.

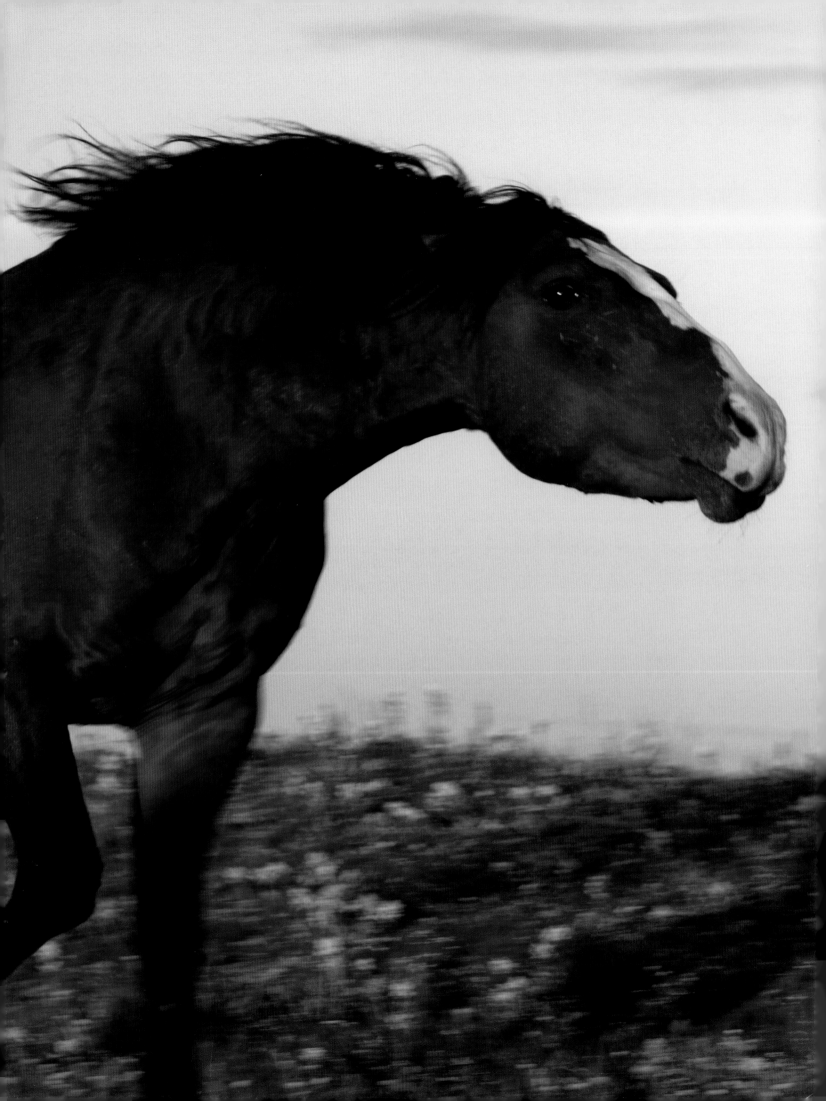

Armed with binoculars we tirelessly scrutinize every shrub and boulder across the seemingly endless terrain of the American West. For several days now we have been looking for wild horses, which roam freely across the desolated Wyoming expanses. The loud caw of a huge crow momentarily distracts us; we marvel at its flight high in the sky. Is it an omen? We know the mustangs are there, invisible amid the endless hills.

Suddenly we are startled by a distant whinnying. Mustangs! Surging as if carried by the wind, they gallop at full speed, the ground shaking under their hammering hooves. Mares are accompanied by their foals and an ocher-colored stallion follows the herd. A blond mane outlines the contours of his powerful neck when he turns his head. As the herd is enveloped by a cloud of dust, a chill runs down our backs. Our dream has been realized.

We followed them patiently from then on — day after day and week after week — until they grew accustomed to our presence. Curious single males were the first to check us out, opening a window for us. Gradually we learned to recognize the subtleties of equine communication. Over the course of many months, some of the mares accepted us into their intimate family circles, even allowing their foals to play near us. This tremendous adventure lasted five years.

Apart from learning a great deal about the behavior of these wild horses, we shared moments of intense harmony and serenity with these mustangs that greatly enriched our lives. This book is an invitation to every rider to look deeply into the eyes of a horse and gradually discover its true nature.

Marie-Luce Hubert
& Jean-Louis Klein

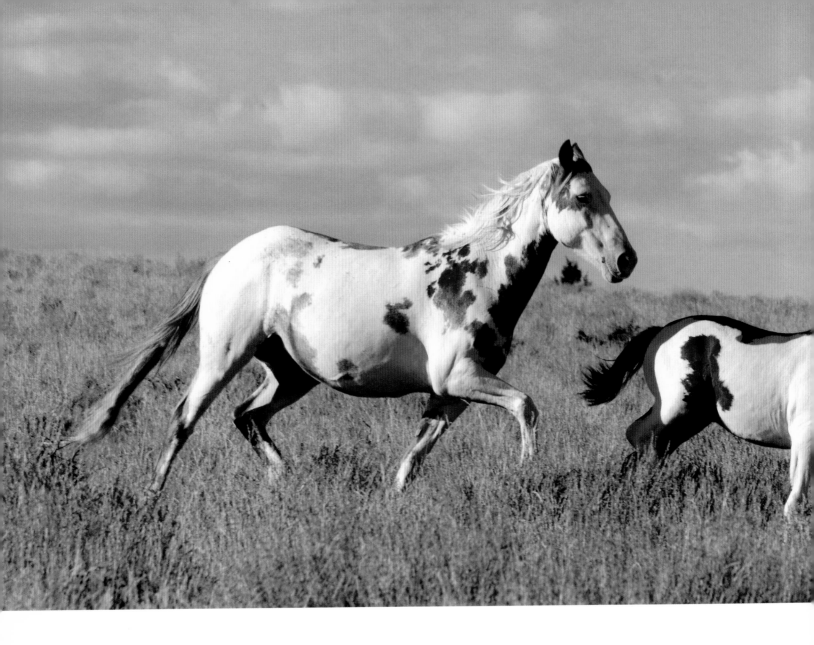

The Origin of Horses 9

Living Free 39

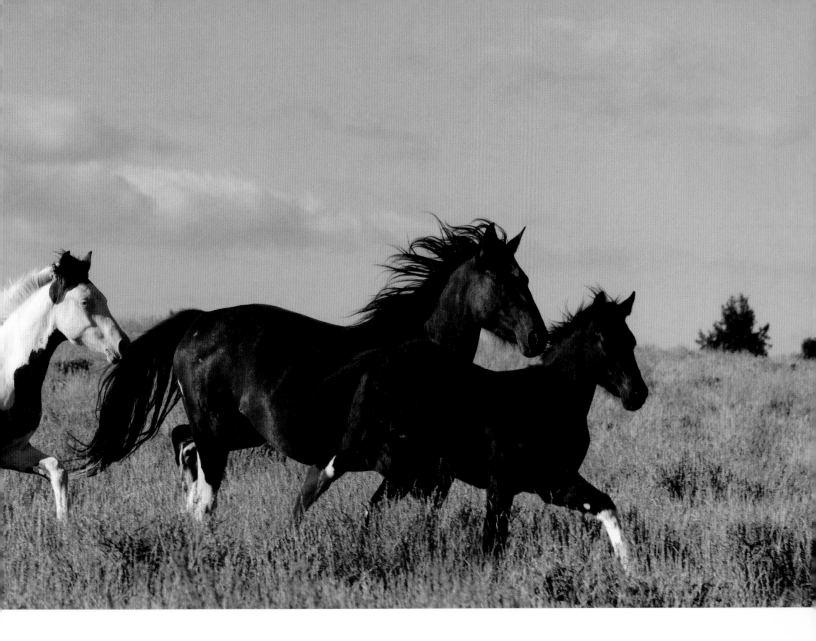

The Origin of Horses

The First Horses

Well before the first hominids, the horse's ancestors appeared during the Eocene epoch on the supercontinent of Laurasia, which consisted of what are now North America, Greenland and Eurasia. The North American continent subsequently became the principal region of equine evolution, though several branches spread into the Old World in successive waves.

THE HORSE FAMILY

Eohippus, "the dawn horse" (also known as *Hyracotherium*), was a small, forest-dwelling animal measuring between 10 and 20 inches (25 and 50 cm) in height. Toward the end of the Eocene, about 38 million years ago (mya), it had gradually evolved into *Mesohippus*. As the forests gradually receded due to climate changes, the horse's ancestors adapted to a more open environment. At the start of the Miocene, 23 mya, *Parahippus* roamed across savannas and grassy prairies but continued to feed primarily on leafy vegetation. These animals were succeeded by an even more horselike herbivorous form, *Merychippus*, about 17 mya. The distinctly hoofed intermediary *Dinohippus* became widespread between 13 and 5 mya, toward the end of the Miocene. The first modern equine representatives finally appeared at the end of the Pleistocene some 4 mya. Represented by more than a dozen species, *Equus* diversified during the Pleistocene and spread throughout all of North America before spreading into Asia, Europe and Africa.

Adapted for Survival

During its 57-million-year evolution, the equine lineage grew both in size and strength. At the same time the number of digits on their feet was reduced, generating a unique single-toed hoof highly suitable for locomotion over diverse terrain and making it easier for these ungulates (hoofed animals) to evade predators. Concurrently, their jaws and teeth strengthened to feed on tough grasses and grains.

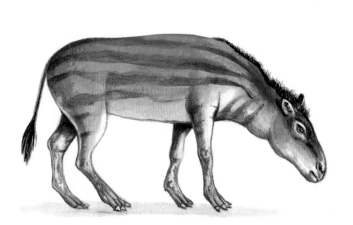
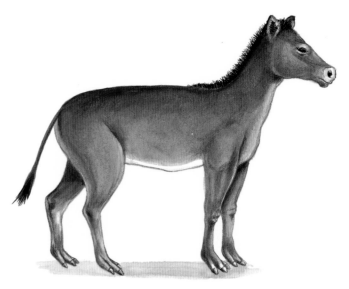

Eohippus and Mesohippus, *the earliest ancestors of the horse, fed solely on foliage and had feet with separate digits. The latter gradually evolved into a distinctive hoof.*

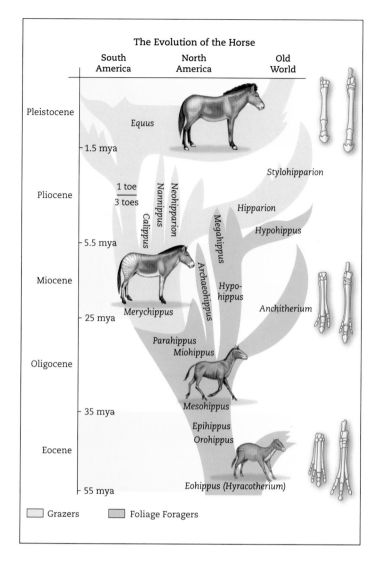

The Evolution of the Horse

South America | North America | Old World

Pleistocene

Equus

1.5 mya

Stylohipparion

Pliocene

1 toe
3 toes

Namippus
Neohippippus
Calippus

Hipparion

Megahippus

Hypohippus

5.5 mya

Miocene

Archaeohippus

Hypo-hippus

Anchitherium

Merychippus

25 mya

Parahippus
Miohippus

Oligocene

Mesohippus

35 mya

Epihippus
Orohippus

Eocene

Eohippus (Hyracotherium)

55 mya

☐ Grazers ■ Foliage Foragers

A Complex Evolution

Many biology textbooks use the phylogeny of the horse as an excellent example for students to understand the theory of evolution. In reality, however, the equine evolutionary tree is rather complex and does not follow a simple or linear progression of successive species. Natural selection is a process of trial and error, branching off in various directions; as new species emerge, some adapt to new conditions, some lead to evolutionary dead ends and others coexist for millions of years.

Like *Homo sapiens*, the evolutionary tree of equines has numerous branches, where many advanced forms coexisted with ancestral forms. For example, 10 mya, there was an extraordinary diversity of both genera and species, where *Pliohippus*, the "grandfather" of the modern horse, with vestigial lateral toes, was contemporary with the three-toed *Hipparion*, as well as the small *Protohippus*. As many as a dozen different species of equines often shared the same

biome, much like zebras, gnus and impalas do in the immense Serengeti plains today.

Today, only representatives of the genus *Equus* remain, comprising seven species: the horse, the African ass, the Asiatic wild asses (onager, khur and kulan), the kiang, Grevy's zebra, as well as mountain zebras and plains zebras.

GEOGRAPHIC DISTRIBUTION OF THE HORSE

Ironically, the demise of the North American horse occurred when it was at its greatest distribution, roaming all regions of North America. This geographical dominance came to an abrupt end about 11,000 years ago — in the blink of an eye, geologically speaking. At this time, North American equines disappeared from the scene along with the other megafauna of the period: woolly rhinoceroses, mammoths, camels, giant sloths and mastodons. Scientists have proposed two hypotheses to account for the rapid extinction of North American equines: rapid and sudden climate change, which may have occured in conjunction with extensive hunting by prehistoric humans who had crossed over from Asia about 40,000 years ago.

Eastward Migration

Before disappearing completely from North America, several *Equus* species migrated to Eurasia just prior to the first great period of glaciation at the end of the Pleistocene (2.6 mya). During the period of glaciation, the Bering Strait separating Alaska and Siberia became an effective land bridge and a migratory route for numerous species. Equine forms migrated first to Asia and subsequently to the Middle East and Europe, with some reaching as far as the African continent. The ancestral three-toed lines gradually disappeared as members of the genus *Equus* proliferated and adapted to a wide range of climatic and geographic conditions.

The Obscure Origins of the Domestic Horse

The closest ancestors to the modern horse arrived in Eurasia about 900,000 years ago and gradually gave rise to the other representatives of the genus *Equus*. Recent genetic analysis of Przewalski's horse (*Equus ferus przewalskii*), the only authentic wild horse to have survived to this day, indicates it is not the ancestor of the domestic horse, but that the two lines diverged from each other some 500,000 years ago. In fact, it is likely that several species and subspecies of wild horses overlapped in the past and became domesticated in Neolithic times.

The Return to Ancestral Lands

The settlers in North America — European explorers, trappers and woodsmen — were no doubt unaware that the horses ridden by the Native peoples of the Great Plains, as well as the huge herds of wild horses grazing alongside bison and antelope, were the descendants of horses originally brought over during Spanish colonization.

CONQUEST AND BREEDING GO HAND IN HAND

In the wake of his second voyage to the New World in 1493, Christopher Columbus left behind about 30 horses on Hispaniola (on the portion of the island that is now Haiti). In subsequent years, the largest islands in the Antilles became centers of horse breeding in order to provide mounts for anticipated future explorers. Hispaniola had the first royal stables in 1497, followed by Puerto Rico (1509) and Cuba (1511).

Despite heavy losses incurred during the crossings, Spain did not hesitate to ship its best reproductive horses overseas until 1507, after which an export ban to the West Indies was enforced until 1510.

Freedom after War

With much terror and cruelty, the conquistadors subjugated two great empires during the 16th century: the Aztecs in Mexico and the Incas in Peru. Horses were the secret weapon during these invasions. The Native peoples flew in terror at the sight of the centaur-like figures of men on horseback, fearing they would devour them.

The first horses to set foot on the North American continent after an absence of 11,000 years were 16 brought by the expedition of Hernando Cortés, who landed in Mexico in 1519 with 500 soldiers. These 11 stallions and five mares all came from the noted breeding stables of Cordoba. Except for one young male, all horses were shipped back to Spain, so Cortés' horses left no descendants in America. As well, not one of the 20 horses abandoned by a subsequent expedition in 1542 by Hernando De Soto survived, as they were hunted by Native peoples on the shores of the Mississippi. Around the same time, the troops of Francisco Vásquez de Coronado were exploring Arizona in search of the legendary cities of gold. This exploration began with more than 1,000 horses and it is highly likely that at least some escaped over the course of time. It is unlikely that these animals survived long enough to reproduce in sufficient numbers, however, considering the hostile terrain and likely predation.

Between 1597 and 1610, a colony was established close to what is now Santa Fe, New Mexico, by Juan de Oñate. This settlement included missionairies and about a hundred men and women, as well as several horses and heads of cattle. Although this colony became an important center of horse distribution, raising them in open pasture led to considerable loss and theft. Horses that did escape from farms and missions were called *mesteño*, derived from the Spanish *mesta* ("cattle raisers" or "collectives"), as well as *mestengs* ("without owner"). One or both of these terms gave rise to the anglicized term mustang.

A Good Blend

At this point in time the various races and breeds of horses in North America were not yet established, and it is not easy to retrace which lineages were exported to the New World. During their near eight-century (from 711 to 1492) occupation of the Iberian Peninsula, the Moors left a profound impact on the architecture, culture and science of the region, as well as in the equestrian domain. Mixtures of indigenous horses and those of various invaders, principally eastern Vandals and Goths, whose horses were mainly wild, gave rise to various Iberian breeds. In the 16th century the Spanish

bred horses of exceptional quality, clearly superior to the animals bred in neighboring kingdoms. To this day, Spanish horses are considered to be imbued with extraordinary nobility and endurance.

NATIVE AMERICANS DISCOVER THE HORSE

The Apache, Ute and Navajo peoples soon launched raids against colonists and stole their horses. At first they treated these captured animals poorly, even cruelly. Gradually, though, they learned how to mount and ride horses, coached by escaped Native American captives who had learned the skill from Spanish missionaries. By 1664, the Apaches and their allies had managed to acquire some 100,000 horses from colonies in Sonora and Sinaola in Mexico.

Raids and Forays

In August 1680, Christianized Pueblo peoples, who had been harassed and brutalized as slaves, revolted against the colonists and drove them out. The fugitives left virtually all their livestock behind. They retreated to the area of El Paso on the Rio Grande, where they established new agricultural centers and missions. Several thousand stallions and mares belonging to the Spanish government in Mexico were subsequently sent there to help quell endless raids by Native peoples. By then, however, the Comanche and Apache had become accomplished horse riders and the skirmishes with colonists became ever more frequent.

Poorly tended and freshly stolen, many of these horses escaped and soon adapted to their natural surroundings. Over time, their numbers multiplied and they started spreading freely across the vast southwestern plains. As the Native peoples were inexperienced in handling or breeding horses and unable to maintain them properly, they actually preferred raiding settlements for new animals. They favored trained and branded Iberian horses over wild horses, since these were easier to mount and ride. Concurrently a profitable trade of swapping slaves for horses started in the Pueblo villages, which then became lucrative centers of equestrian commerce. The colonists, for their part, began annual roundups of mustangs to replenish their own stocks.

Dispersion through Barter

It was primarily due to bartering by the Apache, Comanche, Pawnee and Osage, that northern and eastern tribes also acquired horses. This occurred via two primary intertribal trading routes: in the west, along mountain trails as far as Idaho, Montana and up into Canada, and then eastward toward the Dakotas; while in the east, toward Kansas and Iowa, as well as to Ohio through Arkansas. Thus, despite geographic barriers like mountains, rivers, canyons and deserts, stealing and trading for slaves, furs and firearms led to the distribution of horses across most of North America in less than a century. As a result many tribes actually acquired horses well before encountering the first European settlers. Ironically, the acquisition of horses by Native tribes helped stop the advance of the Spanish Empire beyond New Mexico and slowed the overall colonization of North America. The advent of the horse was a major advance in the history of Native American tribes from the Great Plains to the Great Basin and the Colorado Plateau. This key period in United States history represents the Native American horse culture stage, which spanned from 1640 to 1880.

Mustangs by the Millions

While in Texas in 1846, Lieutenant Ulysses S. Grant reported that "wild horses were visible from horizon to horizon." It is estimated that in Texas alone their population reached about a million head in 1850. Some scholars place the peak population of mustangs across the United States at that time at about seven million. Settlers crossing the Great Plains in covered wagons feared mustangs almost as much as attacks by Native tribes, as the wild horses could trigger panicked stampedes among the convoys of horses and mules.

Horses brought to Mexico by Hernando Cortés in 1519 were brought back to Spain without leaving any descendants. The origin of mustangs can be traced back to the 17th-century colonies established near what is now Santa Fe, New Mexico.

The Horse in Native American Culture

Before the arrival of horses, Native Americans used dogs for many domestic tasks, including moving camping materials and collecting firewood. Dogs could carry loads up to 45 pounds (20 kg) — or even heavier when hitched to a travois. They were also used for hunting, as guard dogs, for garbage disposal and, if needed, as food.

When horses appeared on the scene, many Native tribes naturally saw them as a strange new kind of large dog. The Sioux name for the horse was *sunke wakan* ("mysterious dog"), the Blackfoot called it *ponokamita* ("wapiti dog") and the Tsu T'ina (Sarcees) termed it *chisti* ("seven dogs," since a horse was considered seven times as strong as a dog).

THE HORSE AS A FACTOR IN PROGRESS

The advent of the horse engendered a major cultural, warring and economic revolution among Native Americans, particularly for the nomadic tribes, which now acquired much greater mobility. Horses were capable of pulling heavy loads, particularly when outfitted with a travois suitable for their size. They could haul larger, heavier and more comfortable tents over longer distances to seasonal hunting grounds and better trading routes. A typical trek would cover 3 to 4 miles (5 to 7 km) a day, or even double that if needed.

Tribes with horses had a clear advantage over tribes without them in warfare and the horses also allowed them to cover a wider hunting territory. Some tribes, like the Pueblo, were sedentary, not nomadic, and relied on corn and agriculture for a living. Tribes such as the Mandan and Hidatsa were more versatile, in that while practicing agriculture they also retained horses to hunt bison. The more eastern tribes abandoned sedentary lifestyles completely and became nomadic both to follow migratory game and to avoid increasing pressure from the ever-larger numbers of settlers.

Partner in the Hunt

The introduction of the horse into the daily lives of Native Americans had an especially big impact on those tribes that were hunters and gatherers. Fast, enduring and courageous, horses were capable of chasing bison, evading their horns and riding amid a panic-stricken herd; a true godsend for Native peoples previously limited to hunting on foot. The access to ample quantities of game greatly enriched those tribes and reduced their mortality rates. Their quality of life improved by not having to travel long distances on foot while carrying heavy loads.

A Source of Pride

Raids against rival tribes to steal prized horses soon became an exalted and very lucrative practice among many tribes — a way of life really. A warrior gained much glory by procuring horses for the poorer members of his band. His exploits were then retold to others many times around the campfire, making him a hero in their eyes. Bands that had been victimized in this way would quickly avenge such deeds, resulting in ongoing cycles of reprisal. As late as 1888, the Crow and Blackfoot continued a longstanding rivalry of horse rustling, thereby violating their enforced confinement to reservations. European settlers responded by confiscating the horses — whether stolen or not — to quell these rivalries for good. Although huge herds of mustangs were available as potential sources, not all tribes had the access, courage or knowledge necessary to capture and tame these horses. The Comanche, Apache and Cheyenne, as well as the Dakota and Blackfoot, specialized in capturing and breaking mustangs — a very lucrative undertaking at the time.

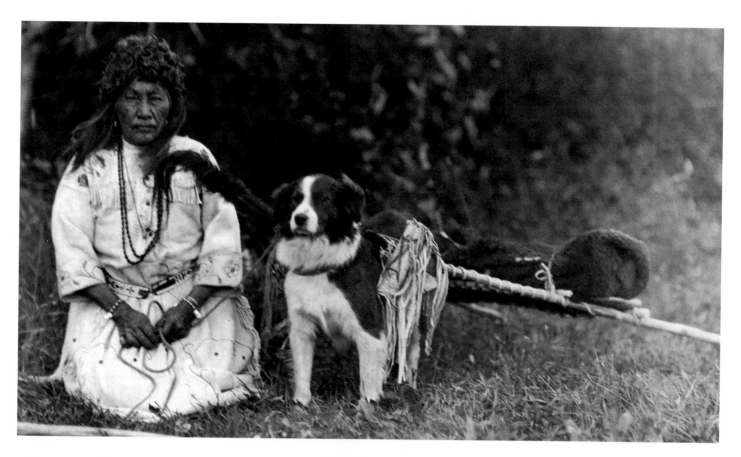

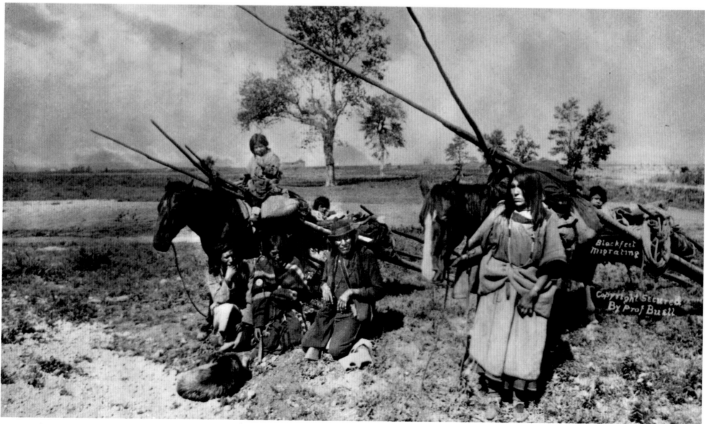

Mustangs were domesticated at the beginning of the 17th century. They became indispensable for hunting and transportation and soon replaced dogs for such tasks. Nevertheless, as seen in these images of Blackfoot migration, taken in 1930 by Mary Jane Heavy Face, the use of dogs as draft animals persisted.

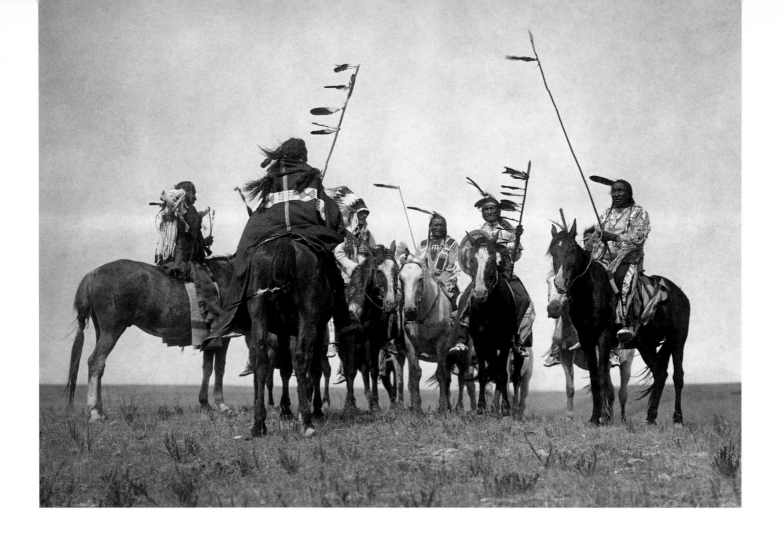

MORE THAN A MOUNT: A SYMBOL

Once they became an important socioeconomic factor in Native American culture, horses soon acquired a mystical status and entered the spiritual realm, becoming a part of their taboos, symbols, songs, legends, religious celebrations and rites.

Small but Sturdy!

At the start of the 18th century, the Plains peoples rode horses that were very sturdy and stood about 14 hands (4.5 feet/1.4 m) high at the withers. Though fast and agile, these small horses were also very sure-footed. Shaggy and hardy looking, they were quite different in appearance from those strains imported by European settlers, who gave them the pejorative name "Cayuse pony" after one of the Oregon tribes. These animals were noted, however, for their speed, and they readily outdistanced the larger and heavier grain-nourished cavalry horses. Some witness accounts told of these ponies covering distances up to 80 miles (130 km) without food or water. The horsemanship of Native American riders, particularly the Comanche, was also renowned. Riding bareback and holding only a crude leather strap serving as a single rein, a warrior could hide on one side of his horse in full gallop and then, braced on his mount's back, shoot arrows under its neck.

A Sign of Wealth

The number of horses belonging to various tribes and bands varied depending on their relative wealth, the quality of their grazing sites and their mastery of animal husbandry. It is estimated that in 1878, the Plains peoples collectively held about 160,000 horses. A typical family owned about 15 horses, with at least five used to move tents and provisions. Saddle horses were used for daily travel while the best animals were retained for hunting and warfare. These were kept close to tepees, and even inside winter huts among the Mandan tribe. The poorest families had to make do with just a couple of horses, while the richest often owned 50 animals or even several hundred.

Now living in Montana, the Assiniboine, shown above in a 1908 photograph by Edward S. Curtis, were a Plains tribe that lived by hunting bison and trading with other tribes.

A Divisive Tragedy

It was the first known example of bacteriological warfare in history — colonists and settlers brought many contagious diseases, often on purpose, to the Native American populations. And by nearly exterminating the 60 million bison on the continent (by 1890 only a few hundred remained), the Native populations were effectively subdued through starvation. Military forces concluded that the only way to subjugate these nomadic people was to destroy their way of life; so in order to break Native resistance it was necessary to deprive them of their mobility. Without horses, Native American tribes would no longer launch attacks, move their villages in search of food or obtain weapons and ammunition. Consequently, their horses were confiscated and either resold or butchered — including entire herds of mustangs. Thus starved and subdued, the Native peoples had no choice but to surrender. As a result, despite the abrupt victory of the Sioux, Arapaho and Cheyenne at Little Bighorn on June 25, 1876, the 1890 massacre at Wounded Knee marked the end of the Indian Wars.

THE DECLINE OF THE MUSTANGS

Even though their numbers were already greatly reduced, the end of the 19th century saw a heavy toll taken on mustang populations.

Persecuted Everywhere

When barbed wire was first introduced in 1873, allowing farmers and ranchers to fence off their properties, major conflicts arose between proponents and opponents of the open range for seasonal drives of long-horned cattle to slaughterhouses and railway depots in towns and cities. This also affected wild mustangs, whose access to rich prairie grazing lands and water sources was increasingly limited. Consequently, mustangs were forced farther and farther west, first just beyond the Mississippi River and then farther into the foothills of the Rocky Mountains.

Since mustangs were seen as interfering with cattle and sheep ranching, they were systematically persecuted and either killed on sight or captured and sold. Thousands were also shipped to South Africa to serve in the Boer War (1899–1902) and to Europe during World War I. As mechanization started to impact agriculture and transportation, the de-

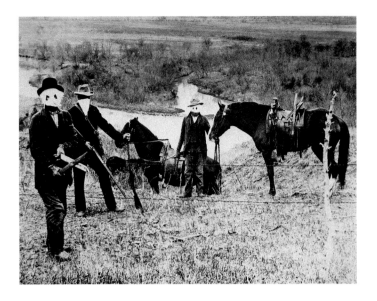

mand for horses declined. This led to an organized eradication of wild horses in the the United States, and various states offered bounties for every pair of ears handed in. By the 1920s, the capture or killing of wild horses became quite lucrative. Craftier ranchers would catch a mare and then release her again along with other horses to make them easier to capture once the herd had grown in size. The devices developed to restrict mustang movement were incredibly cruel, including placing large tires around their necks, barbed wire over their nostrils to prevent breathing and nailing horseshoes to their ankles.

Livestock as Priority

The numbers of mustangs increased again temporarily during the Dust Bowl and the Great Depression, which began in 1929. Farmers and ranchers who had fallen on hard times had no choice but to abandon their horses and let them run free. This reprieve was short-lived however. In 1934, the organization later known as the Bureau of Land Management (BLM) allocated specific tracts of public land to raise livestock. Mustangers (professional mustang hunters) were recruited to eradicate wild horses and "free" the land of them. Later, their task was made much easier through the use of jeeps and helicopters — surplus from World War II. Unfortunately these vast expanses of land were so eroded that they could not support more than 10 million head of cattle, in sharp contrast to the estimated 60 million bison that lived on the land before the arrival of European settlers. Like sacrificial lambs, the mustang suffered a fate similar to that of Native Americans.

The widespread use of barbed wire greatly changed agriculture and ended open-range practices. Some, like the Nebraska ranchers shown above, opposed the use of barbed wire and tried to sabotage such operations.

What Is a Mustang?

The mustang remains as elusive as the wind, as difficult to get close to as to define. In the large western expanses of the United States, it does not have a definitive morphology. Defined by its ancestral genes, its configuration is governed by its ability to survive in the most hostile of environments. Able to endure the changes from rigorous winters to scorching summers while subsisting on a spartan food supply and limited access to water, mustangs are the most enduring descendants as well as the most tenacious of the different breeds of horses to have accompanied European settlers of the 16th century.

A COLORFUL MELTING POT

At the onset of the 17th century, there were essentially two categories of wild horses. The most abundant category were saddle breeds with original French, English, German, Irish and Dutch traits imported from farmers and northeastern settlers from 1620 onwards. The second category originated from descendants of Iberian horses (Andalusian, Barbary) which, in turn, gave rise to the famous small Indian horse known for its stamina and speed. The Cayuse pony, Spanish barb, Spanish mustang or Chickasaw pony and Seminole pony spread over the entire North American continent from Mexico to Florida. While colonization swallowed up vast amounts of territory, the two categories of horses eventually commingled in the mid-18th century before being held back by the Rocky Mountains.

Mustangs, whose size varies greatly, range from an average height of 13–15 hands (4.3–4.9 feet/1.32–1.5 m) high at the muzzle and weigh between 700 and 1,000 pounds (320 and 460 kg). Certain mustangs display the heavy bone structure of draft horses, like the Percheron, Belgian or Frisian, while others reveal the more elongated lines of ranch, riding and cavalry horses, like the Thoroughbred, Tennessee Walker and Morgan. Finally, rare herds of Spanish mustangs give credence to their Iberian origins.

As late as the 1980s, the practice among ranchers and breeders was to replace mustang stallions with stallions of heavier or lighter breeds, including mixed breeds (Arabians, quarter horses, and so on). This process aimed at ameliorating the morphology of wild horses for riding, pulling loads or butchering.

FOOLPROOF PHYSIQUE

Whether escaped, abandoned, stolen or introduced, mustang ancestors offer a present-day melting pot rich in color and genetic diversity. Despite its short stature, the Iberian mustang became the cowhand par excellence. According to a Mexican proverb you should "admire the large one while riding the small one," and the mustang was nicknamed the "Texas cow pony" (it was the ancestor of the celebrated quarter horse). Its unbelievable endurance made it the top choice of the cavalry and the famous Pony Express.

Far from being affected by the numerous illnesses and hereditary traits of our overly bred and groomed domestic horses, "maroon" horses (from the term cimarron, a Spanish word signifying escaped herds) display incredible longevity. Their genetic variability enables them to adapt to environmental and climatic variations. Their amazingly efficient immune system, exceptionally hardy hooves and dense bone structure will contribute to the improved health of modern-bred animals in the future.

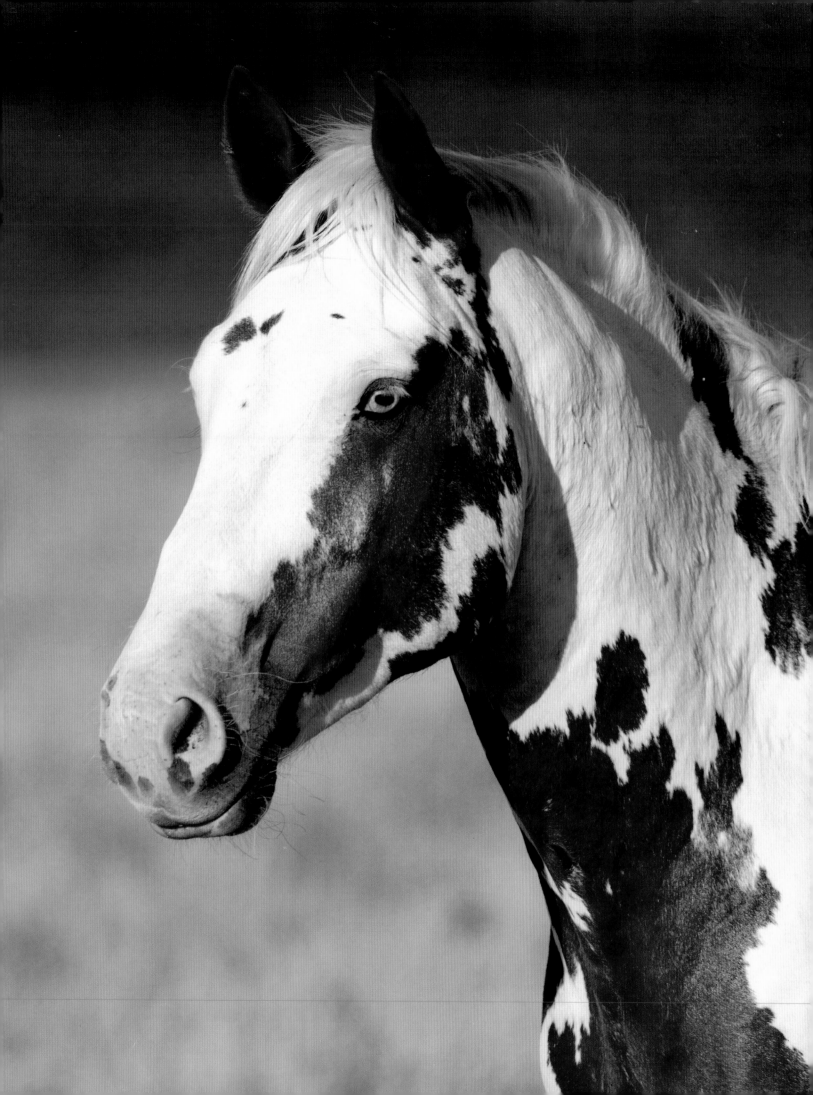

The Spanish Mustang

In certain remote regions of Oregon, Arizona, Utah, Montana and Wyoming you can still encounter equine gems. Certain herds of wild horses have endured all but a small amount of "contamination" from eastern domesticated horses. Their Iberian origin is confirmed by their overall appearance along with genetic analyses. For this reason, these mustangs have been classified in a subgroup known as Spanish mustangs.

Neither heavy nor thin, Spanish mustangs are all-terrain athletes, measuring an average of 14 hands (4.5 feet/1.4 m) at the withers. Their head is supported by a broad, short neck, a large and rectangular forehead and a slightly convex poll, with a rounded profile that echoes their Iberian origins. Their eyes, widely spread apart and almond-shaped, are very expressive. Starting with well-developed cheeks, their head then narrows quickly toward a well-defined mouth and cross-shaped nostrils. Their manes are often two-toned and doubled, and are long and thick in some stallions. Their chest is narrow and bisected by a deep furrow, once again reflecting the animal's famous endurance qualities. The front limbs join the torso to form a robust and muscular A-shape, and their shoulders, at once oblique and powerful, permit their fore limbs to lift easily. Their backs are short and straight, with a moderate croup, while their legs are solid with short and robust cannon bones. Gifted with a thickened edge, their hooves are renowned for their hardness. Their strides are wide, though certain mustangs may spontaneously display a different, peculiar gait such as the tölt or paso. The tail is attached low on the body to a well-muscled and bent rump. Overall, their coats have a dun bay or mouse-gray color, and some have a dorsal stripe as well as zebra stripes along their legs, reminiscent of the Portuguese sorraïa. Other typical coat patterns are roan (a blend of white hair with a base coat of another color) and overo (white patches on a dark coat).

Numerous associations are currently involved in the preservation of the Kiger, Sulphur and Pryor varieties of the Spanish mustang, as well as the Nokota and Choctaw breeds. The Blackfoot tribe of northern Montana, for example, is dedicated to maintaining the equine culture by raising a small herd of Spanish Barb in semicaptivity. Unfortunately, however much we may laud these preservation efforts, we must also question whether the introduction of these domestic and genetically selected mustangs may in time contribute indirectly to the disappearance of wild mustangs. As is often the case, once breeds are preserved in captivity, the preservation of the wild strains is less of a priority.

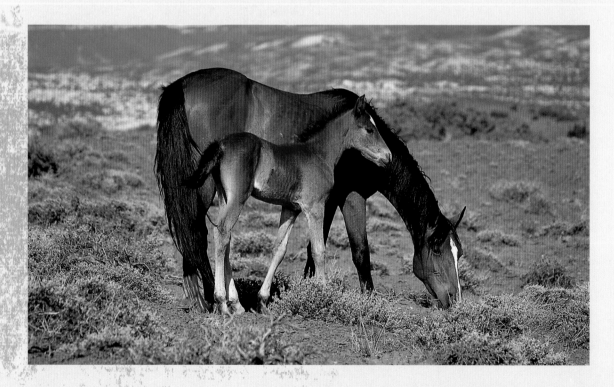

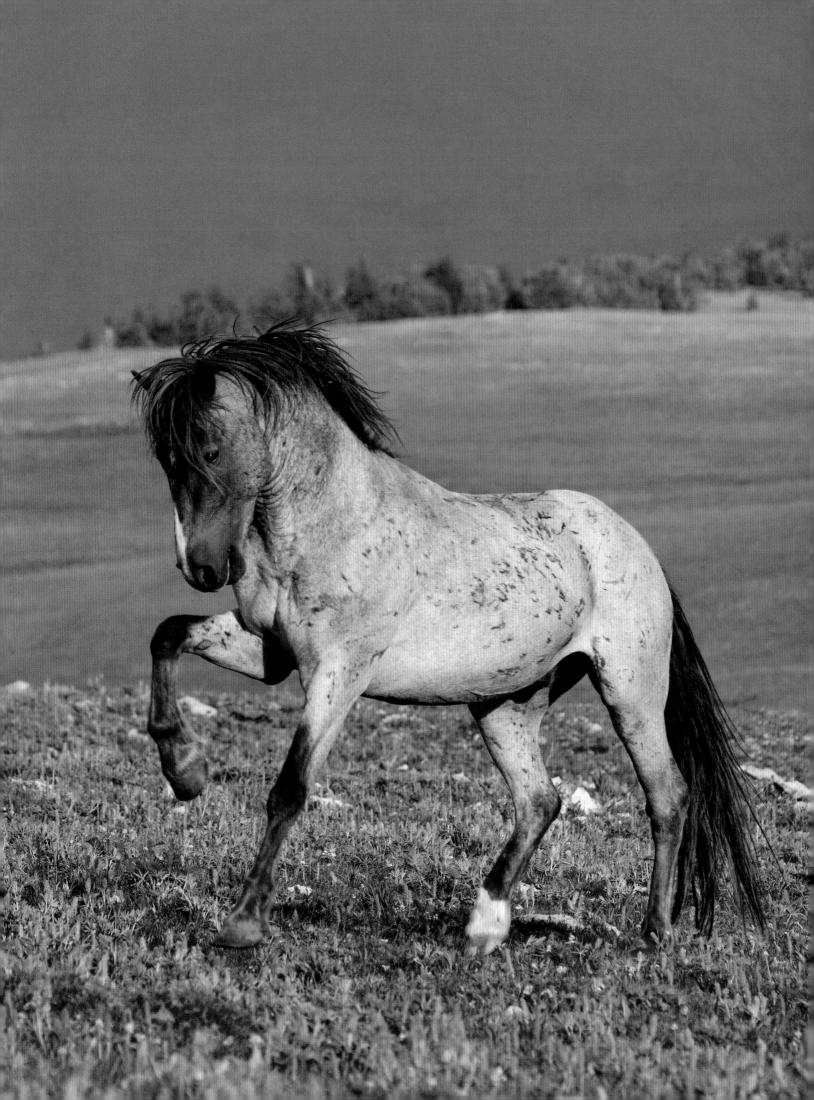

All members of the horse family do not share the same type of social organization. Przewalski's horse (6), the plains zebra (3) and the mountain zebra live in small familial groups without permanent territory. In contrast, the Grevy's zebra (1) and the wild African ass (2) are typically territorial species: the males assume the defense of the territory with the enclosed females. The Asiatic wild asses, on the other hand, to which the khurs (5) belong, are characterized by having intermediary complex and flexible organizations. Whether they are mixed or composed exclusively of males or females, well-synchronized groups of kiangs (4) are particularly impressive.

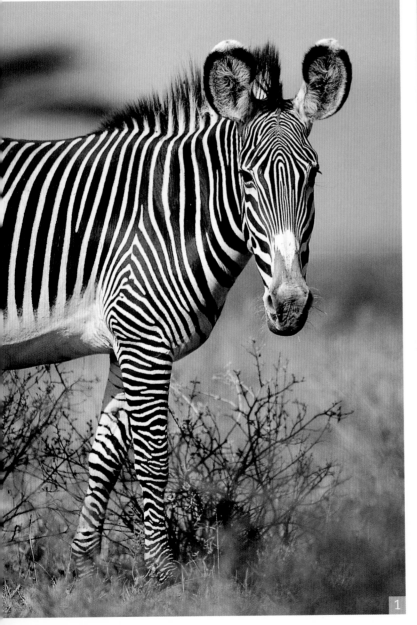

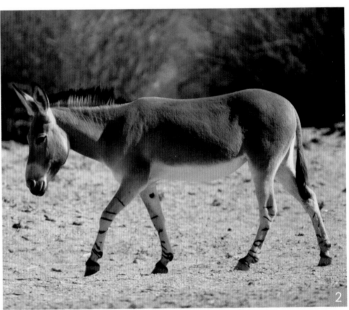

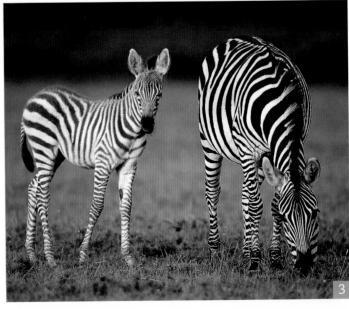

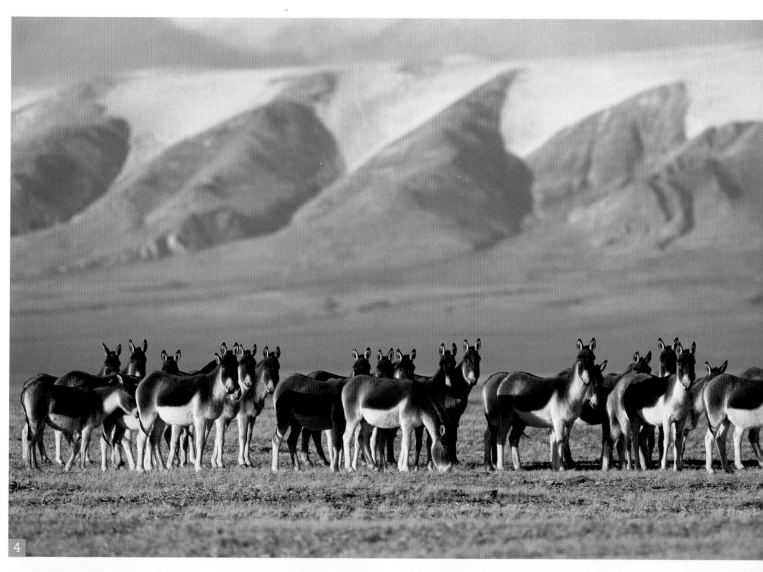

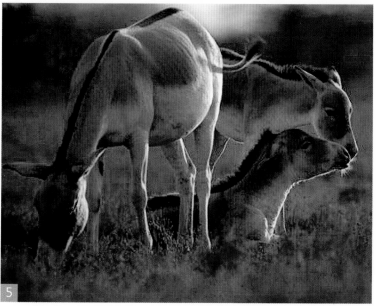

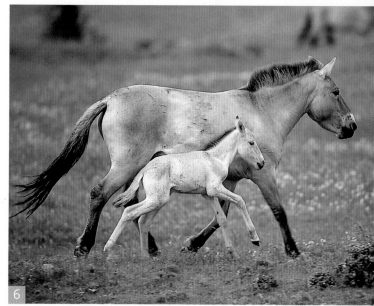

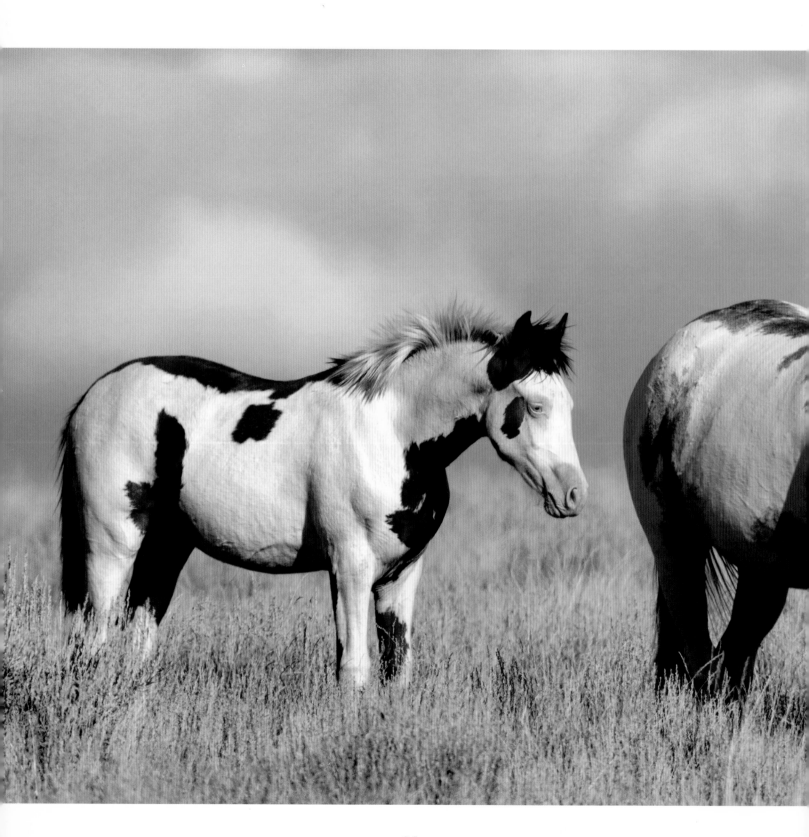

A mystical aura surrounds the piebald horses known as "Medicine Hats" by the Plains peoples. The colored forelock covering the ears and the top of the head, known as its "war bonnet," as well as the dark "shield" on its chest and lower neck were thought to protect the horse from the enemy's arrows and cannonballs. The rider-warrior felt invincible. These sacred horses were therefore particularly in demand, though only braves and medicine men were authorized to ride them.

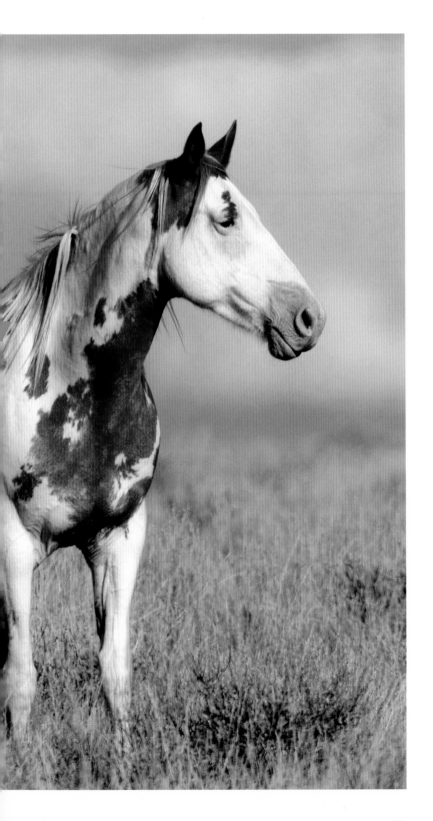

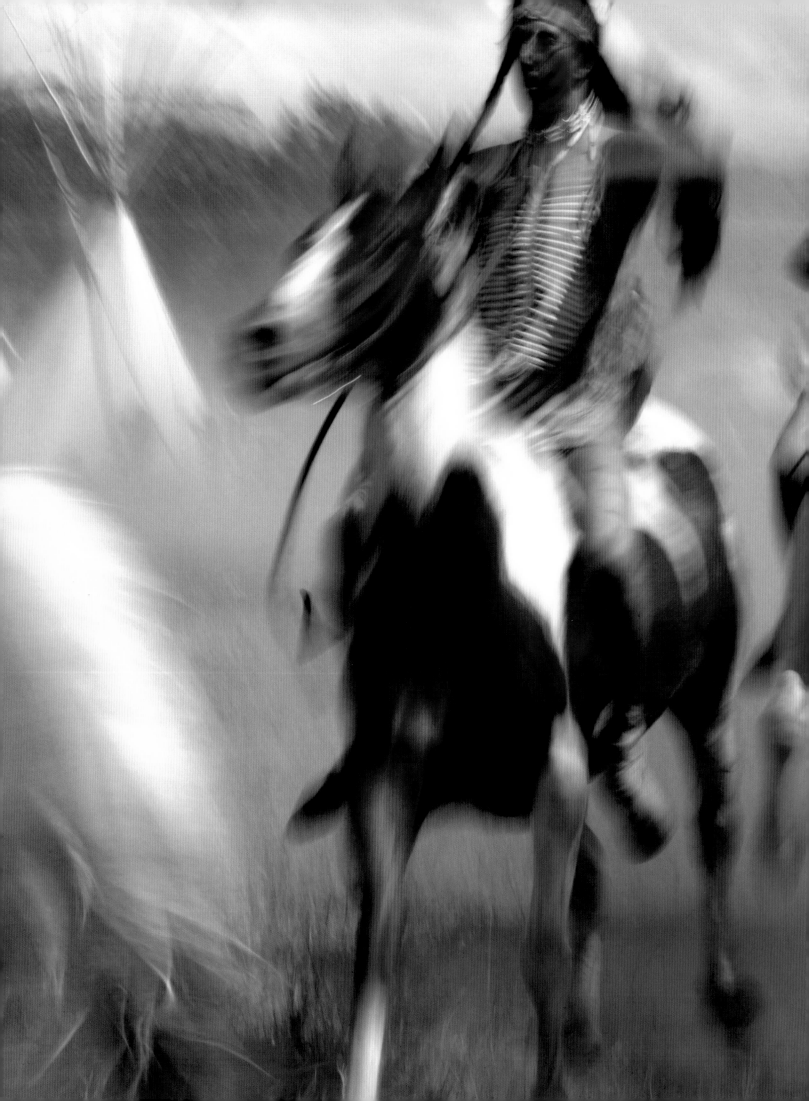

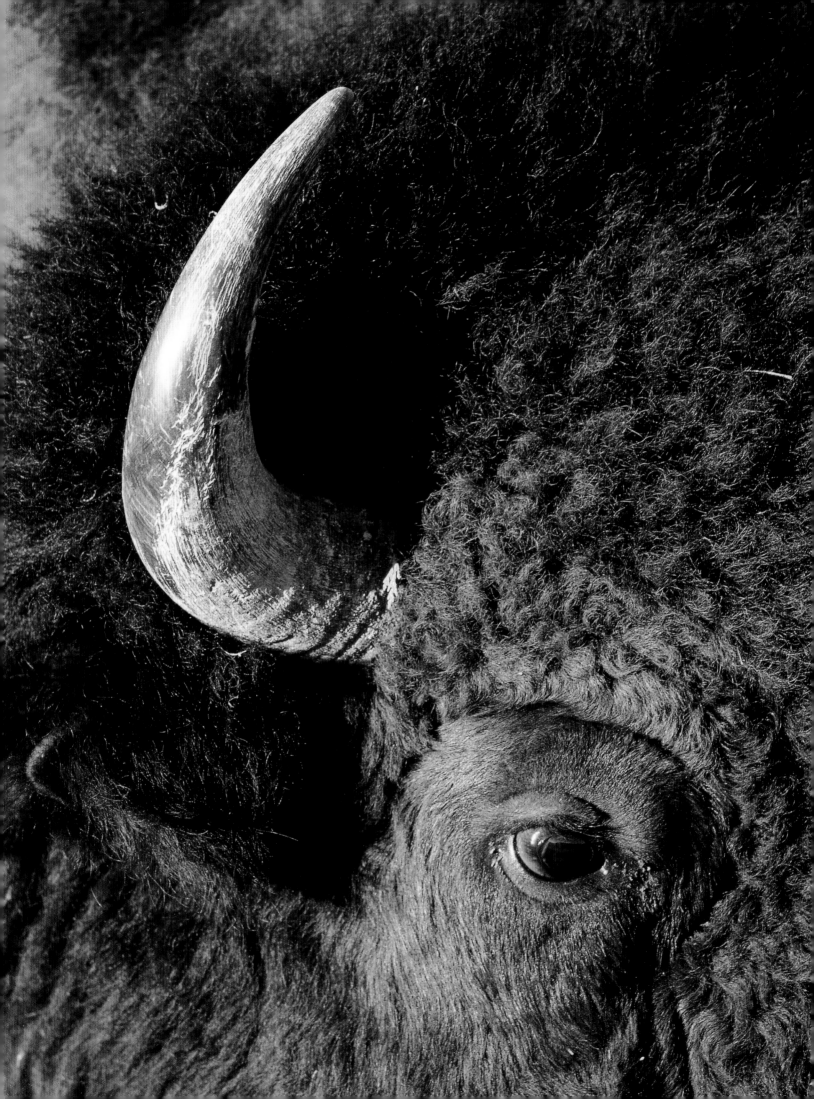

"The white man would call them 'the old Cayuse pony,' a derogatory name given to horses of inferior stock. However, we have developed this type of horse because it had the ability to catch bison while inserting itself into the herd. Only a real horse can do that! This horse was a prince, renamed by Native Americans 'one which captures bison' ... No need for oats! No need for hay! This horse survived on what it could find along the way. No need for shoes! This was a superior horse despite the lack of pedigree. His lineage was simply that of being Indian Cayuse."

— *Chief Bobby Yellowtail of the Crows tribe*

This Texas longhorn peacefully ruminating in the Grand Teton foothills is a remnant from many Western legends. Led by cowboys from 1886 to 1890, these cattle numbered in the tens of millions and migrated from Texas to the Great Plains. Since 1964, associations have worked to preserve and reintroduce this breed. Following the installation of enclosures and the Great Depression of 1929, this breed is no longer an important part of American culture.

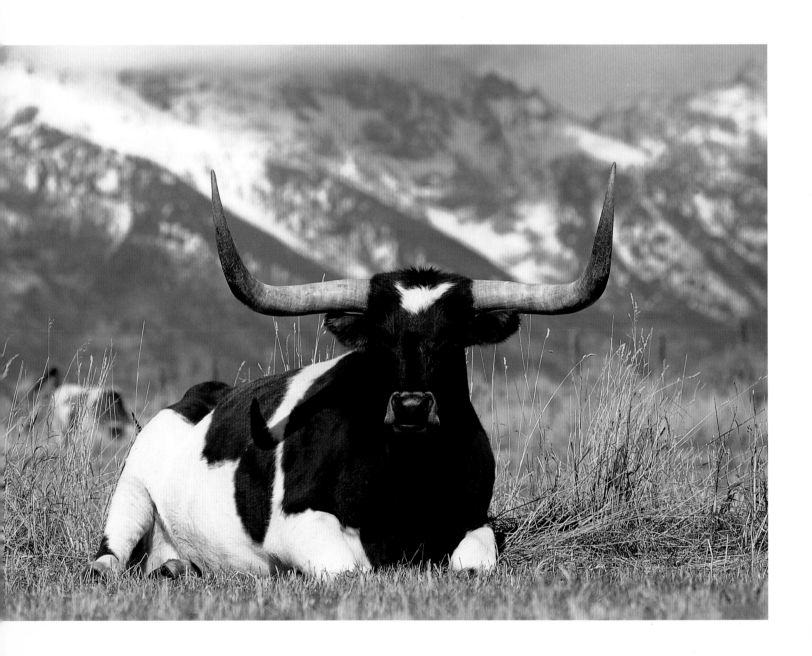

It is due to the more than 400 robust mustangs and Morgans that the intrepid riders of the Pony Express were capable of meeting the challenge of traveling for nearly 2,000 miles (3,100 km) in 10 days. Buffalo Bill Cody and Bronco Charlie were among the riders who embraced the adventure and succeeded in delivering their precious sacks of mail. Starting from St. Joseph, Missouri, and ending in Sacramento, California, they galloped through the states of Kansas, Nebraska, Colorado, Wyoming, Utah, Nevada and California.

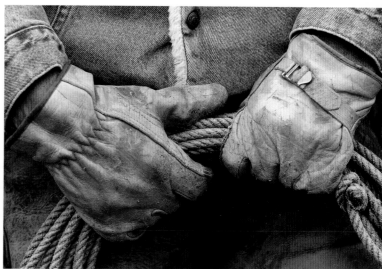

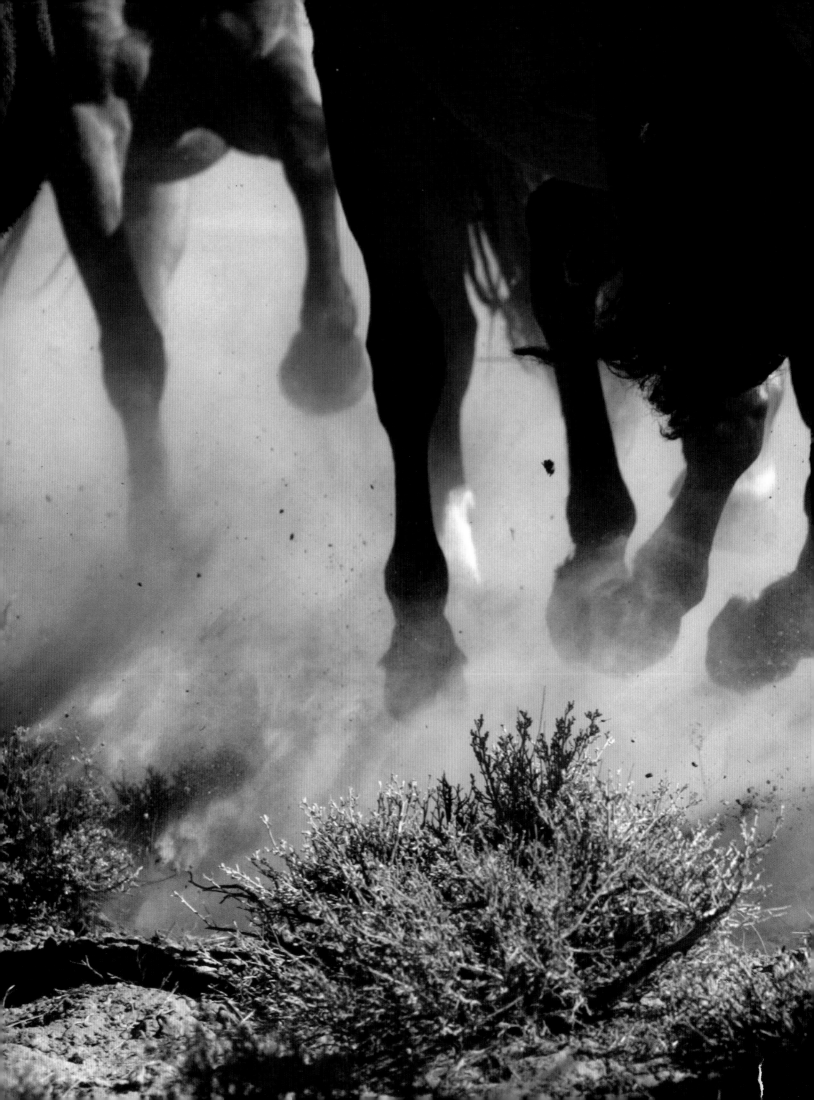

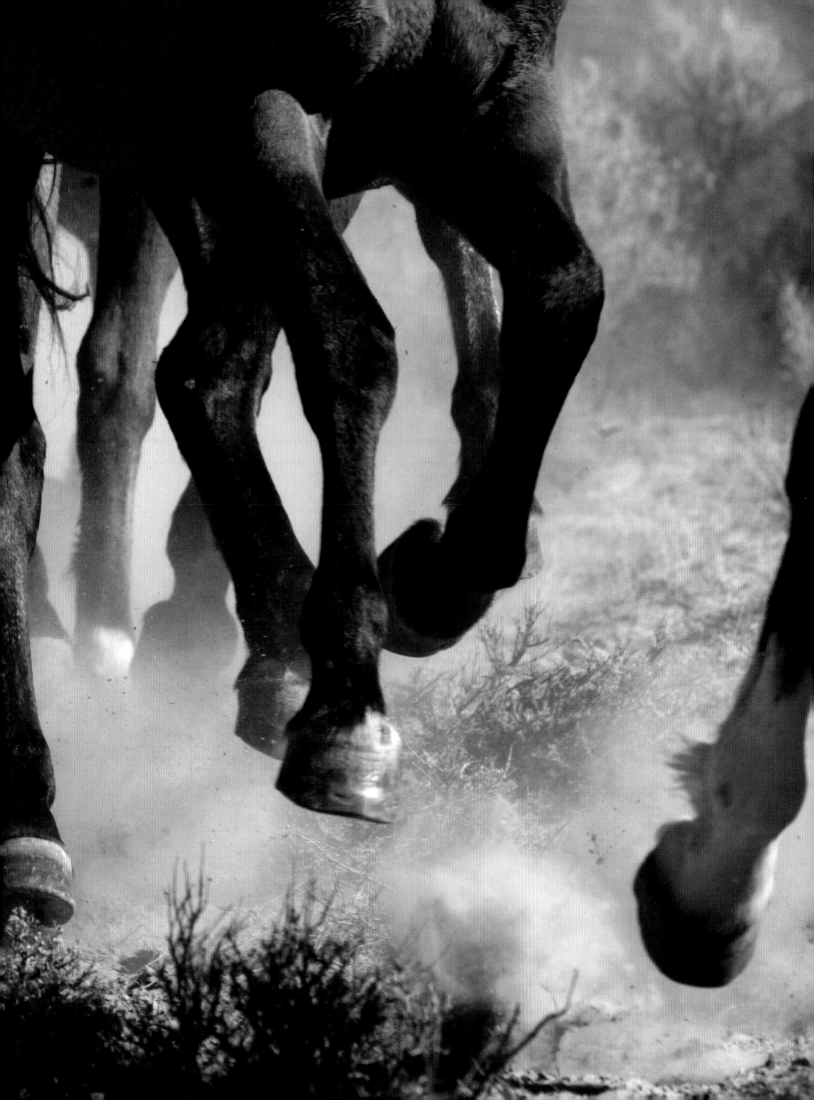

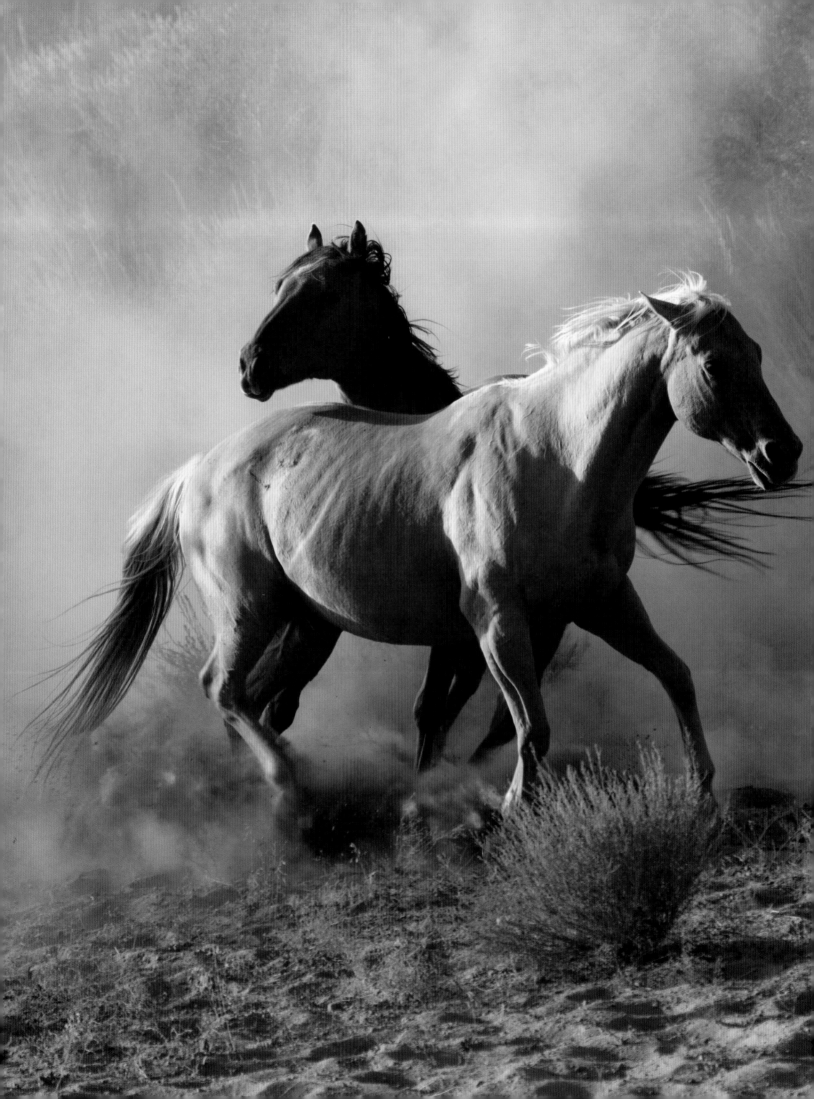

Living Free

Habitat

From North Dakota to Nevada, through Oregon and Wyoming, wild horses can roam and survive across habitats as varied as arid deserts, coniferous forests and grassy plains. Depending on the environment and pressures they might face (land management, predation, and so on), herds of wild horses behave and act quite differently from domesticated horses. For five years, we followed and observed the life and behavior of several different mustang herds across the United States.

Contrary to popular belief, the mustang is neither a nomad in search of adventure and open spaces nor a territorial species. Instead, mustangs are rather gregarious and do not stake out any particular territory nor deny others access to it. Not being territorial has the advantage of providing them with the best grazing resources during all seasons. As a result they also learn to share resources without constant competition.

SOCIAL STRUCTURE

Because they are social animals, horses spend their lives in the company of their kin. Social structure of this sort provides many advantages, foremost among them protection from predators. Horses have clearly evolved a cohesive social structure based on group stability and absence of territoriality. This type of social structure is quite distinctive in that paired stallions and mares form long-term relationships even outside mating season.

Horses in the wild form small groups known as harems (polygamous families), as well as bands of unattached stallions known as bachelors. A few individuals are solitary, including old, ousted stallions, sick or wounded animals and, rarely, old mares. Fillies, migrating foals and bachelors may also be solitary for some time while they seek new companions.

Collectively, a herd consists of several harems, bands of bachelors and solitary individuals. Most herds number between 50 and 300 horses; they are managed in the western states and confined geographically to specific herd management areas.

ADAPTING TO THEIR NATURAL ENVIRONMENT

Each herd of wild horses, including harems and groups of bachelors, is fully adapted to its particular territory or home range, which provides all of the basic needs: grazing pastures, water sources, shelter, salt licks and refuge from biting insects. These vital areas often overlap, sometimes to a considerable extent, so that optimal use must be made of their natural resources. Inevitably this means that several herds might encounter each other at key locations, resulting in dynamic changes within groups. Habitats vary considerably in size, of course, as well as in the quality and quantity of available food sources they offer, how these are distributed, as well as the availability of watering holes. In addition, habitat topography and the number of animals it can support are also very important. Vital food resources vary with the seasons — scarce in winter and highly abundant in spring.

Although about 130 wild horses range over some 33,600 acres (13,600 ha) in the Arrowhead Mountains of Wyoming, habitats providing vital resources for them vary in size from 1,000 to 8,000 acres (400 to 3,200 ha). In the spring, 23 of the herd's 32 harems reunite on a high pasture at an altitude of 7,850 feet (2,400 m). This seasonal grouping continues until the fall. During the three summer months, the plentiful habitats occupied by harems and bands of bachelors overlap extensively. In contrast, the handful of harems that do not migrate to higher elevations, but remain in the more arid and desert foothill regions, must move across large expanses, often hundreds of square miles in area, to meet their basic needs.

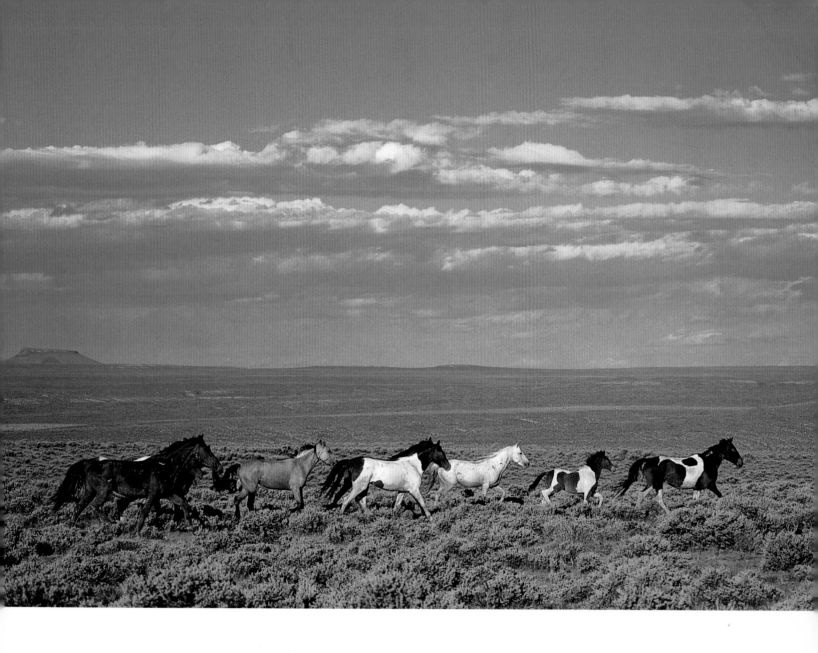

Movement and Marking

When moving from one locale to another, mustangs generally follow the same paths. They establish a system of trails linking pastures and converging on watering holes and areas for dusting and salt licking. Such trails make it easy for the horses to move in single file, generally with the head mare leading and the stallion bringing up the rear, ready to head off any threat. This sort of migratory pattern is very efficient, particularly since water sources can be far apart and shelter must be sought quickly in case of sudden inclement weather. The herd's pathways are marked by piles of horse droppings, which become larger and more evident closer to "strategically" important sites (watering holes and dusting places), often extending up to several feet in diameter and over a foot high — a sure indicator of nearby wild horses when you are looking for them!

Although they are exclusively produced by stallions, these large manure droppings do not delineate territoriality, but are more like "mailboxes," where adult males can leave visual and olfactory evidence that they've stopped by. Since they are clearly powerful cues, it is likely that these piles serve as important information for other horses regarding the identity and physiological state (including age, hierarchical and reproductive status) of the stallion that deposited them. Droppings thus serve as an effective medium of communication, and inform other stallions about dominance, associations and when the "signatory" last passed that way.

Dominant harems always occupy the best locations, thereby enhancing their reproductive capacity. If there are more grazing sources, it is more likely that mares will produce full-term young and that their foals will grow rapidly.

The Harem

As the most common unit in the herd, harems are the basic social structure among mustangs. Each harem generally includes a stallion, one to three mares and their foals (until they are juveniles between two and three years of age). A typical harem has five to seven individuals, although harems with as many as 15 horses are not uncommon. The reason why stallions do not acquire more mares is quite simple: in face of strong competition, he would not be able to control or retain all of them.

The harem is a very stable structure held together by the loyalty of the mares. Foals likewise have solid bonds and are equally attached to the stallion.

Since sex ratios among mustangs are approximately 1 to 1 and since harems generally consist of one male and several females, the "excess" males, known as bachelors, are not part of reproductive groups and form bands of celibate males or remain solitary.

Contrary to childhood impressions we may have of a single stallion leading a group of 20 mares, reality is quite different. In some areas, you will see large herds of roaming horses, particularly when water sources are far apart or during times of intense predation, but an experienced eye can easily pick out separate harems within the group.

SOCIAL COHESION

Although the harem itself is a stable structure, its composition does vary. Two opposing forces are at play in the social organization of the harem. Factors that contribute to group stability are the exclusion of outsiders by the stallion, the loyalty of harem members and the effort expended by the stallion to keep the harem intact. On the other hand, factors contributing to change include addition of new mares, lapses in vigilance by the stallion, raids by outside stallions to steal mares and the emerging independence of young adults.

These two opposing forces produce harems constant enough for stable, peaceful relationships — an important factor in raising young — but also variable enough to bring in new members and, hence, genetic diversity.

Friendly Relations

Successful group life is predicated on the recognition of individual members within the group as well as on the understanding and acceptance of certain codes and social rules in order to avoid unnecessary, destructive conflicts. There is far more amicable behavior at the core of stable harems than aggressive or dominance behavior. In fact, amicable relationships contribute more to the social cohesion and harmony of the harem than hierarchies or dominance.

As we shall see later, horses communicate primarily through body language. Intentional motion and ritual

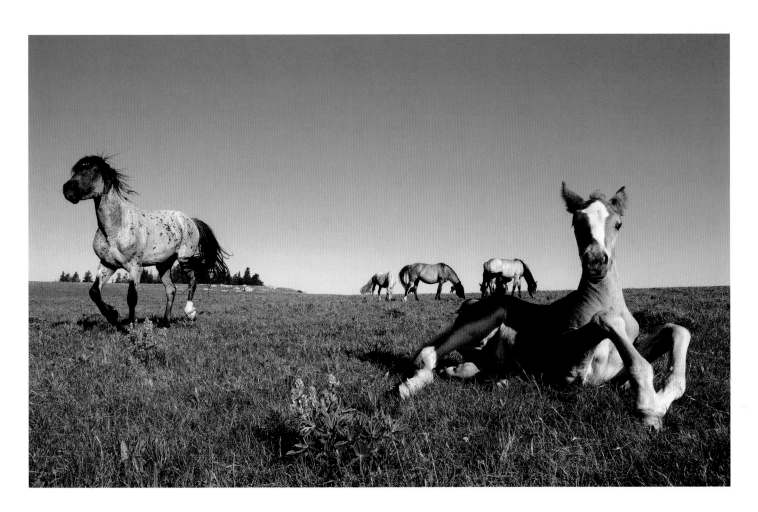

aggression signal individual intentions and disposition. For instance, a subordinate member of the group will not enter the personal space of a dominant horse unless permission is granted. If his space is invaded, the dominant individual will lower his ears, extend his neck and point his head toward the intruder. The message is quickly understood without the need for a physical attack (like a well-placed bite). Such displays of dominance and subordination clearly delineate the existence of a social hierarchy within the group. As long as individuals recognize their respective status within the group, potential tensions are channeled into adaptive behavior.

A Complementary Hierarchy

The hierarchical communication at the core of a harem is much more complex than initially apparent. Occasional reversals and three-tiered relations can sometimes mask the classic linear hierarchy model. For example, if individual A dominates individual B, and B dominates C, sometimes C may dominate A! (Linear dominances are more apparent among the bands of celibate males and illustrate their more fluid social organization.) It should also not be believed, as is often case, that the lead stallion of a harem rules with absolute power and that mares only play a minor role in traveling or daily activities. Instead, it seems that stallions and mares complement each other in the various tasks inherent to the harem.

SCRATCHING WITH TEETH

While observing horse behavior in the harem one thing becomes obvious: except for mothers and their foals, all individuals keep a minimum distance of several feet between them. Every horse lives within its own space, which it is best not to infringe on. Only parents or intimate friends will occasionally enter each other's space, either to rest side by side or to initiate friendly physical contact. A show of friendship is generally met with a similar response and personal space is momentarily breached. When, however, an unauthorized in-

The role of the stallion is not limited to reproduction; he also assures social cohesion within his group by repelling rivals, regrouping mares and awakening sleeping foals.

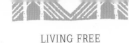

dividual or an intruder violates another mustang's personal space, that is perceived as open aggression.

Mutual Grooming

Mutual grooming is one of the essential elements in maintaining close links and social cohesion within the harem. This activity generally involves two individuals, but sometimes three, who want to express their mutual affinity and consolidate their attachment. The duration of mutual grooming sessions varies between just a few seconds to several minutes, but averages about three minutes.

Standing head to head, horses groom one another by nibbling body areas they cannot easily reach by themselves. This usually starts with the neck, proceeds to the shoulders and then along the back to the flanks and the tail. This type of communication clearly shows the animals' tactile sensitivity. In the process, the partners use their incisors and upper lip, and through short, rhythmic movements energetically scrape skin and hair. The frequency of mutual grooming rises sharply during molting season, when winter coats are shed, and during mating season when tensions are high.

A Moment of Relaxation

During grooming sessions, horses are fully relaxed with ears lowered and eyes half closed. Experiments mimicking social grooming of this sort, particularly at the top of the neck, have shown that the animal's heart rate is markedly lowered, a solid indication of deep relaxation.

Individuals engaged in mutual grooming always belong to the same harem. Every combination of partners is possible in these activities: mothers and their foals, mothers and her juvenile (up to three years of age), stallion and mare (even when she is not in heat), mares with one another, foals with other foals, foals with older siblings, young stallions with each other, adult stallions and juvenile stallions, and stallions and foals.

Social grooming is also a strong method of appeasement. An immature male might initiate grooming after being rebuffed by a mare or the harem stallion. Likewise, a mare accompanied by her foal takes time to respond to its need for affection. Although grooming is reserved for members of the family, there is one exception: two foals from different harems may groom one another before or after playing together. This only happens between harems that know each other very well. Young bachelor stallions engage in frequent grooming, both between friends and between members of different hierarchical status. Though grooming is usually initiated by a subordinate individual, the more dominant horse will usually end it.

INTERACTIONS BETWEEN HAREMS

Head stallions are not in the least bit interested in getting involved in repeated fights, as they are both exhausting and risky. Therefore, harems typically go to great lengths to avoid each other or to at least keep a comfortable distance so as not to raise tensions too high.

Sharing Pastures

The elevated prairies of Wyoming's Arrowhead Mountains consist of six regions where the pastures differ both in maturity and quality. Between 18 and 24 harems, comprising some 90 mustangs, must therefore share this sparse surface for three summer months without constant conflict. In order to do this, they distribute themselves evenly over the area and rotate along the best quality meadows. A meadow that has just been heavily grazed will be avoided for several days before being revisited. Dominant harems will usually occupy the best places, but since horses move while grazing, each site is only occupied for a few hours and then visited by other horses a day later.

Water Resources

Since they are few and far between, watering holes and their neighboring grounds are sites of tension. During the summer,

moreover, harems tend to congregate near these locations around the same time each day. Here too, visits are timed in almost perfect synchrony so that different harems follow one another a few minutes apart. If the watering site is not freed up in time, the harem that follows grows impatient. Only a dominant harem will exert its superiority by delaying its departure or by staying near the water as long as needed. In the Red Desert of southern Wyoming, water is such a scarce resource that a subordinate group of horses will often have to wait several hours before drinking.

We see from this that a type of large-scale organization exists, which is regulated through a nearly direct hierarchy among bands. In other words, the horses don't just recognize each other individually, as within harems and celibate groups, but also as whole groups.

Despite this, there is frequent conflict at watering sites. It only requires a single breach of hierarchical rules — an impatient mare, for example, escaping control of her stallion, a breakaway subordinate harem or a chaotic intrusion by bachelors — to provoke a chain reaction of clashes. Most of the changes in harem composition that have been observed (loss or gain of mares) take place near sources of water.

Accompanied by her youngest, this experienced mother does not necessarily neglect her older foal and responds spontaneously to her request for grooming.

Mares

The mares are at the heart of the harem. Bonds of friendship are so strong that, if the harem is separated by the presence of an outside stallion, the mares will echo one another's whinnies in the desperate urge to reunite. While the hierarchical relationships among females are not always easy to distinguish, the moment of arrival within the harem will determine a mare's ranking. Therefore, a newly immigrated mare will assume a subordinate status and may even become the target of aggression from other resident mares. Only after a certain time will the newest female become integrated within the harem.

LEADERSHIP

The harem is often guided by a leader mare. This is usually a mare that is experienced at finding the food sources and appears to have a well-defined relationship with the harem's stallion. This mare will decide all directions of harem movement, either toward a water source, toward pastures or toward a safe refuge.

For example, we observed that Yakima, the leader mare of Geronimo's harem, displayed unusual confidence. Possessing a remarkable ability to analyze diverse situations, she was ever attentive to potential danger and quick to react to climatic variations. From an outsider's standpoint, it appears easier to become accepted by the harem's stallion than by the leader mare, particularly if she is mindful of the well-being of those in her keep. When this particular mare authorized our presence, the foals following her displayed the same tolerance toward us, a fact that greatly facilitated our observations over the subsequent years.

Maternal Engagement

The reproductive success of a mare is dependent on many factors. If she is raised in a stable and dominant harem, she then has access to the best pasture lands — an essential asset for her pregnancy and for the raising of her foal. However, not all mares equally care for their young and, on occasion, certain mares will lose their foals after a month or two. It could be that they choose impractical terrain for their foal that risks injury, or they relax their vigilance to the point of leaving their young sleeping several feet behind them. An isolated foal or one frolicking in the bushes unsupervised can quickly become prey to a cougar. The young mother may also display too much nervousness, which over a prolonged period can lead to the exhaustion or even death of the foal, due to constant interruptions of sleep or nursing.

Not only are mares from the same harem bound to one another in order to better cooperate but they are also deeply bound to their stallion. In our own experience, one summer night the sudden intrusion of bachelors resulted in the breakup of the dominant harem. The element of surprise was so strong that, within a few seconds, the stallion found himself alone. Visibly taken aback, he remained fixed in place. His three new mothers managed to loop around to rejoin their stallion at galloping speed, thereby escaping their captors. The stallion therefore managed to recover his entire harem without going into battle.

The Dispersal of Mares

Whereas the young male rarely leaves his mother's side before the age of two or three, the filly, more precocious, takes it upon herself to leave the harem at about one and a half or two years old, at the onset of her first heat. This rapid emancipation of fillies represents an instinctive mechanism to avoid inbreeding. (Indeed, father/daughter couplings are very rare.)

However much she may follow her mother, the filly often grazes a bit apart from the harem. If a bachelor or harem stallion comes close to her, she does not hesitate to approach this stranger. The male will sniff her with interest and will attempt to lure her away by making a "swanlike motion" with its neck.

Initially, the filly's departure does not represent a definitive rupture from her birth group. She alternates these selected moments of flirtation with returns to the harem, until finally the occasional forays are replaced by a complete departure from the group, this time in the company of her first mate.

INTEGRATION INTO THE HAREM

The young mare may become immediately associated with a stallion and establish strong links with him or may show interest in several different males in succession before choosing her final partner. The acceptance within a specific harem is not always a smooth process. The adult mares can sometimes exhibit overt hostility toward the new arrival and force her to remain at the edge of the group. Also, should she have a choice, the newcomer appears more attracted to a harem where she is already familiar with or perhaps even related to one or more of the mares (such as a half-sister). However, this harem's stallion is rarely affiliated to the new mare, as demonstrated by the documented lineage of certain herds.

Privileged Relationships

The filly may also choose to follow a bachelor stallion — whether a lone bachelor or a dispossessed one from a harem. Certain young couples appear to follow the path of true love. They spend long hours grooming one another, traveling together and often sleep side by side. A privileged relationship like this between a stallion and a mare is the first step toward formation of a new harem. A stallion that garners the loyalty of his mares stands a better chance of keeping them during altercations with a rival. For her part, a maturing mare seeks the best environment to raise her young, and this is provided by the social cohesion found in the harem.

Mares in Transition

Some mares have a difficult time adapting to a given harem. They may simply not be compatible with mares already in that harem. Others can not find a stable harem, which is an indispensable necessity for raising their young. These females are then forever condemned to lives of stress and harassment.

It often happens that as a result of shifting from one harem to another, these transient females lose their foals. Notably, this is the case for any young, inexperienced filly that is assiduously pursued. Despite their efforts to protect their progeny, a swift unexpected kick can quickly handicap a foal, who then must stay close to its mother. Other mares experience difficulties in establishing themselves, and their foals become exhausted after so many relocations. (During our observations we noted one such filly, torn between two stallions over several months, who lost her foal when it succumbed to a lack of sleep and multiple wounds inflicted by rival stallions.) After one too many encounters, some females may spontaneously abort. The constant disruption of the social order, as well as brutal assaults, are particularly painful and stressful.

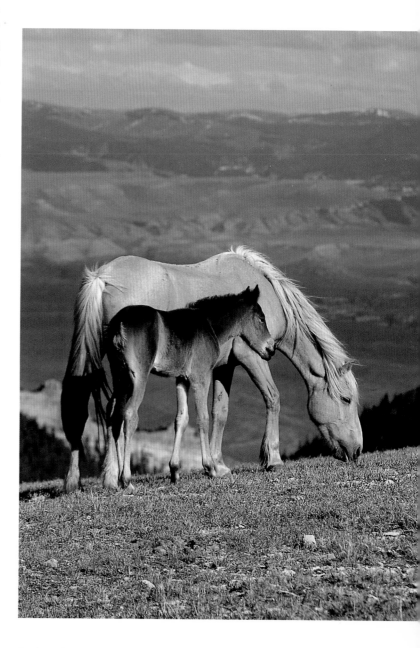

For a mare, stability is a key factor for the survival and education of her offspring. The foal of a mare on the move is much more vulnerable.

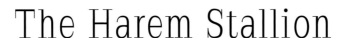

The Harem Stallion

While a stallion is dominant with respect to the mares in his harem, his scope of power is actually more limited than it first appears and he is certainly not the absolute ruler, as is so often depicted. His will does not always prevail and mares can disobey him. Their relationship is really more one of cooperation than dominance.

MAINTAINING GROUP COHESION

While mature mares are mainly involved with "internal" issues, like raising young and looking for grazing pastures, the harem stallion is in charge of "external" affairs that ensure his reproductive success. His principal preoccupation is to maintain the cohesion of his group and to ensure a secure distance of a few hundred feet between his family and other harems. Preserving this space, however, is the major cause of altercations between males.

Guiding from the Rear

While distancing his family from a nearby group, the resident stallion assumes a swan-like stance: his ears are lowered back and his head is projected forward with the neck fully extended as he pushes his family in front of him. This posture of guiding from the rear, or herding, is a powerful signal that his mares and foals understand right away. The lower his head, the more they take the threat seriously — it's a signal that might even elicit a speedy gallop.

The stallion will always interpose himself between his harem and potential danger. Even when fleeing from a predator, the stallion brings up the rear while the head mare takes the lead.

Not All Stallions are Born Equal

The dominant qualities of a harem stallion are more a measure of his age, individual disposition, temperament and experience rather than simply physical factors. Although it is hard to show, the stallion's birth order and that of his mother certainly play an important role here. We found that in herds where parental linkages were known, bachelors from dominant harems and mares of higher social status would readily form new harems, while other horses had to wait patiently for several years.

Repeatedly herding from the rear, this stallion tries to corral a three-year-old filly who does not want to stay at his side.

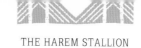
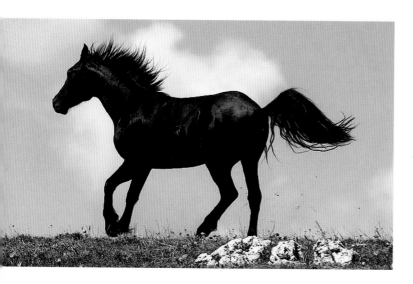

A Question of Character

Just like mares, stallions also exhibit distinct individuality or character traits, and because they are generally more demonstrative, differences in personality among stallions are more pronounced. For instance, some stallions demonstrate considerable tenderness toward their mares; others display a surprising interest in foals, even those who are not their own offspring. Such friendly relations are probably the key to a stallion's success. Moreover, links established between stallions and their mares at the beginning of a harem's formation are often long-lasting. Even toward the end of his rule, as the stallion loses one mare after another, these initial relationships persist.

BATTLE BETWEEN LEADERS

Most altercations between stallions are the result of close proximity between harems. Usually these conflicts are resolved amicably through the ritual of manure droppings. The protagonists will usually gage each other from a distance, bend their necks, exaggerate their bearing, and change their gait to an extremely powerful trot known as a passage.

Each stallion will move toward the first pile of droppings in sight, defecate there and, having left his own "signature," rejoin his harem and trot or gallop in the opposite direction. Thus there is no physical contact and the altercation is limited to an attempt at intimidation and dominance by each opponent. Defecating at a distance also signals mutual acceptance of each stallion's harem of mares.

The Lead-up to High Tension

When more serious manifestations of aggression take place, the stallions will assume a more alert posture and directly stare at each other; one may even nervously pound the ground in front of him. Their neck muscles will quiver repeatedly, their heads shake and a terribly loud whinnying will follow. With arched necks, raised tails and courageous bearing, the protagonists then face off not far from their respective harems and, head to head, with palpable tension, sniff each other nose to nose. This exchange is punctuated by strident noisemaking and is often accompanied by foot stomping, a sign of great irritation but also clear apprehension. The stallions then progress forward in concert, and sniff each others necks, flanks and finally the genital areas. During this inspection, the agitated horses flatten their ears backward as they sniff each other's hind quarters. This exchange may then be followed by a defecation ritual, whereby trotting side by side toward the nearest pile of droppings, the two rivals will examine it jointly. One of them may then scatter the most recent "signature" through energetic hoof stomping. Then, after both stallions deposit some dung droppings, either together or sequentially, they turn toward the pile and sniff their deposits. After this exchange, the protagonists either resume active hostilities or move away.

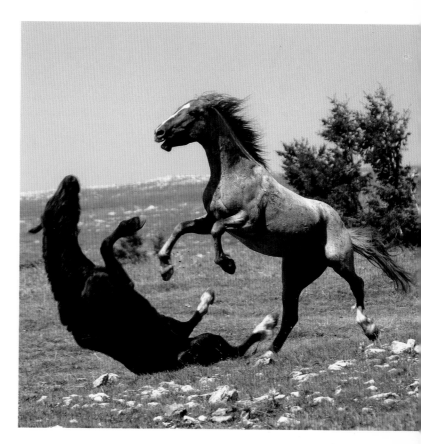

Having missed an opportunity to court a mare, two bachelors clash aggressively. The black stallion falls on his back, an unusual and dangerous position that will leave him with a nasty wound on his spine.

Simulated Combat

If two competitors decide that they "have come to hoof blows," this usually takes the form of a battle of ritualized fighting. It begins with one stallion pushing the other's hind quarters or front end. One horse will start rear-kicking as the other tries to bite his opponent's shins, and both will fall to their knees to protect their very vulnerable legs. This may be followed by upper body blows, bare-toothed bites on the withers and head blows to the opponent's neck. Like a Greek wrestler, one stallion may force the other to kneel on the ground, by first holding his opponent's neck and then placing his forelegs on his back. Being held from the rear places an animal at great disadvantage in the struggle, since they cannot stand on their hind legs and face their opponent. The bites and blows delivered in this type of fighting are not as severe as those of real combat. However, should tensions rise further, this "simulated" conflict can lead to an all-out battle.

The Urge to Conquer

Though it happens less often, true combat differs from ritualized fighting by the absence of preliminary "niceties" and the intensity of the blows exchanged. With intermittent screams of rage, the stallions snap into action, lower their ears and expose their teeth ready to bite, then gallop toward each other at high speed. A ferocious battle ensues, with no holds barred and all types of attack permittable. The fury unleashed in this type of fight is extraordinary, and the intent is clear: put your opponent out of contention, permanently if possible.

There is no more mere pushing, nipping or blows to the neck. This is a savage struggle in which the opponent's bodies are fully intertwined and rise to their full height. Kicks and bites are delivered with astonishing precision. Driven with rage, each combatant will try to sever the ligaments of his opponent's legs or feet, break his jaw or cannon bone, cut a muscle or shred the jugular. This is a veritable explosion of physical tension, built up over many years. Standing face to face on their hind legs like boxers, they try to strike each other with their fore hooves while also biting their adversary's face and neck.

At the most critical point, their eyes turned to avoid injury, one of the stallions can lose equilibrium and fall on his back. He is the target of really serious blows in this position, and if he manages to get up quickly enough, must choose flight as his only recourse. Kicks with the hind legs are the most powerful, and can inflict serious muscle damage and broken bones, leading to permanent maiming or even death. Naturally both fighters try to dodge such dangerous blows as much as possible. Effective hind-quarter kicking, whether with one leg or both, requires experience and precision, and a stallion must turn very quickly to do so. Unless his kick strikes its target right away, the opponent can take advantage of the situation and nimbly bite him on the rump or back of the leg.

During face–to-face encounters, an experienced stallion is well aware of his challenger's strengths and weaknesses and will adapt his combat strategy accordingly. He will also take full advantage of the terrain. He will use a slope, for example, to force his rival backward; at the right moment a cliff can become a death trap. A natural obstacle can be used for surprise attacks. The struggle ends simply by consensus or when the winner starts to chase the loser. The winner will pursue his defeated rival with great vigor, sometimes for a mile or two, determined to inflict one last bite on the rump of a serious opponent.

THE END OF AN ERA

An aging, lone stallion that has lost his harem is a sad sight indeed. However, the unfortunate horse is not totally banned from equine society. He might occasionally run across a band of bachelors looking for social interaction, but soon he will lose interest in their adolescent bickering or simply tire of their youthful exuberance, and move along, a distant follower of another harem.

We have seen Caporal, a large, 26-year-old stallion, sometimes travel for a couple of days with Crow, a jet-black mustang with an impressive reproductive record. Though frequent rivals in their younger years, these two dethroned kings now travel together, keeping a respectable 60-foot (18 m) distance between them, only to eventually separate again sometime later. The solitude weighs heavily on Caporal, however, and being alone for the first time in his life must be rather stressful. Even from a distance of several hundred yards, he responds to the distressed whinnying of foals that have lost sight of their mothers.

Then one fine day, the familiar figure of the old stallion no longer appears in the distance, as weakness or sickness has finally gotten the better of him. Though faced with harsh living conditions, the majority of older mustangs live to an age of about 20, a considerably long lifespan in this harsh terrain.

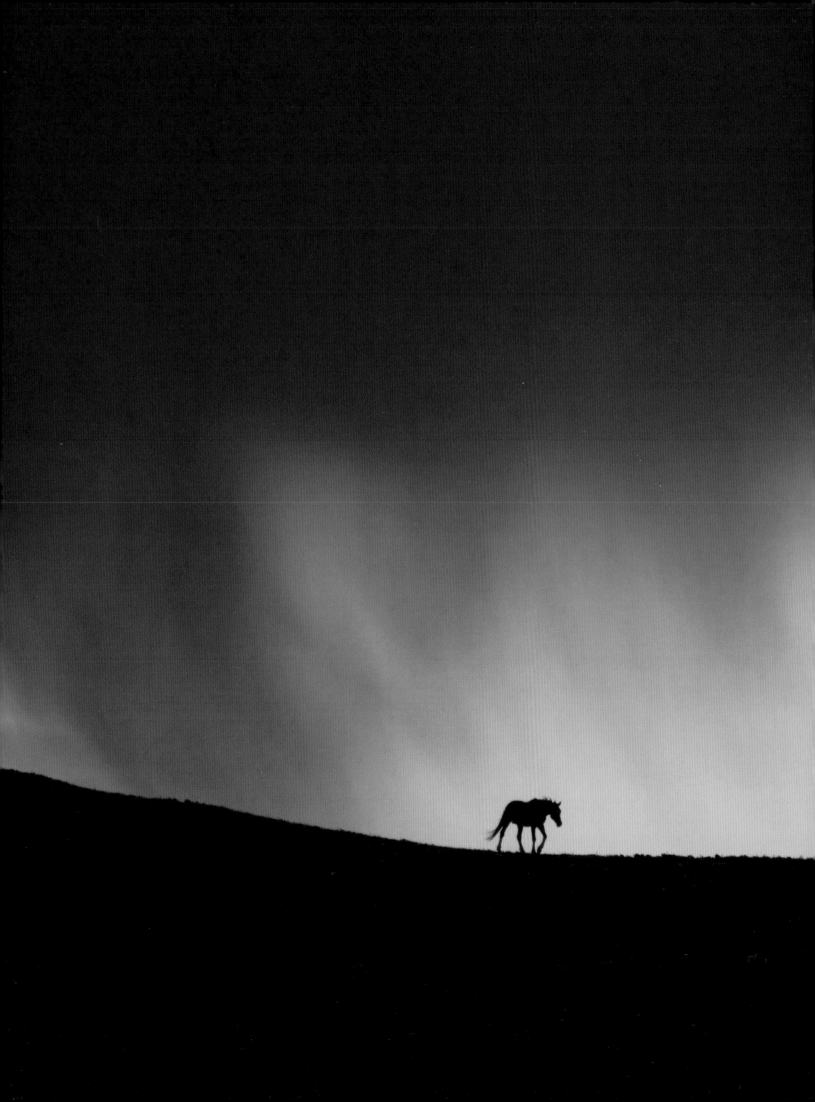

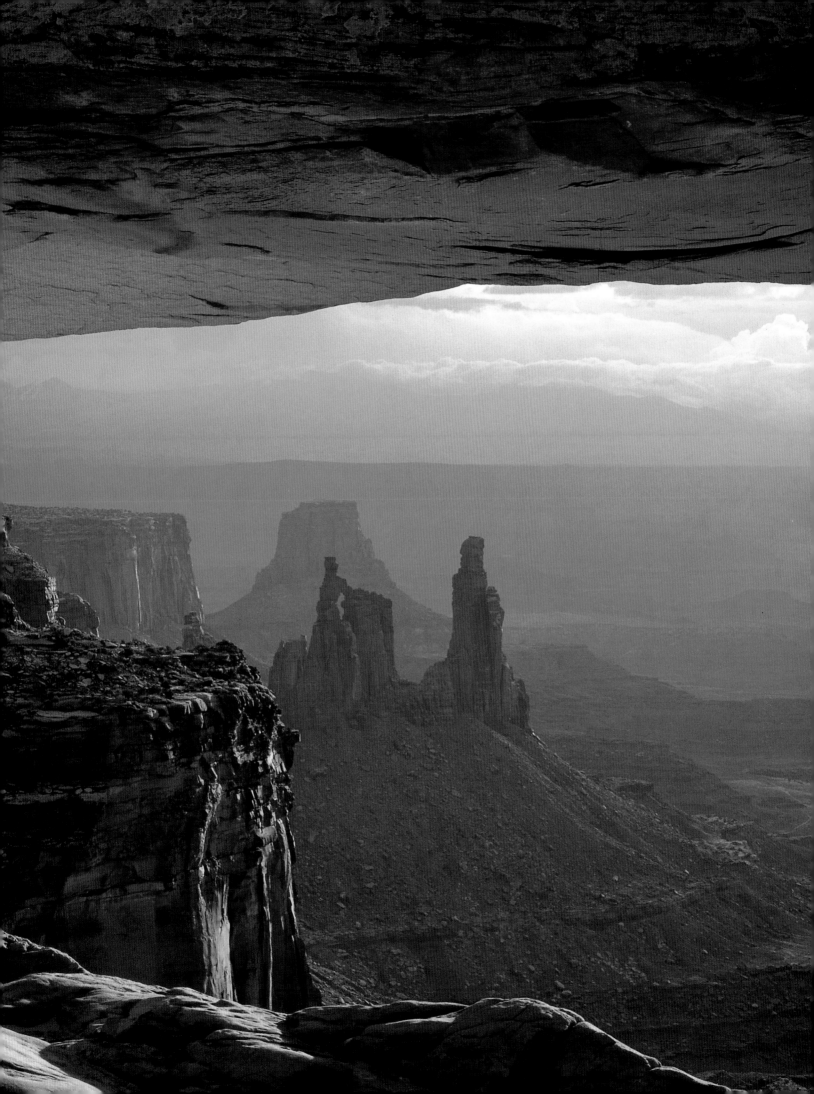

Mustangs are almost constantly moving. In order to observe and photograph them, we quickly realized that we needed to move along with them and follow their rhythm: march along when they moved, and rest when they slept, anticipating their deeds and actions. In these often haphazard locations, we were regularly left behind when they decided to pursue faraway drinking sources.

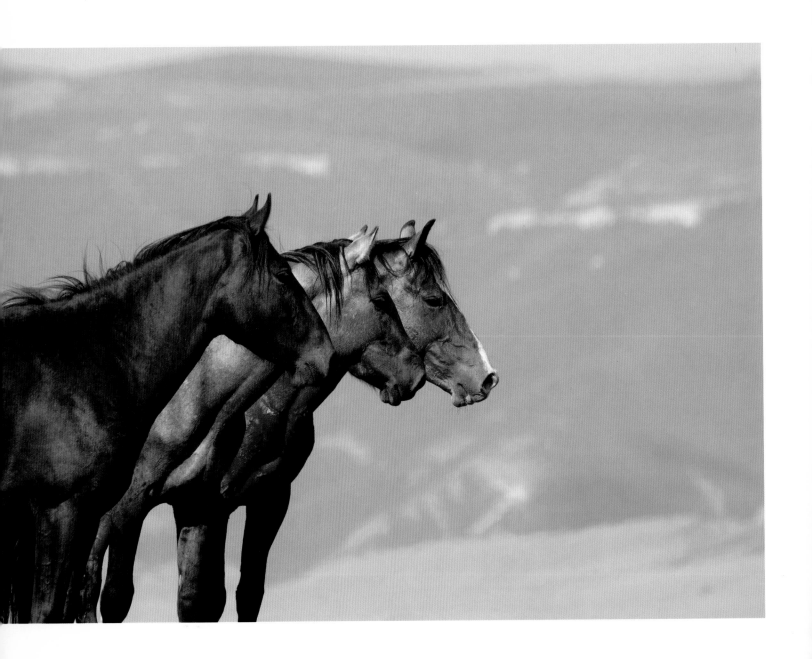

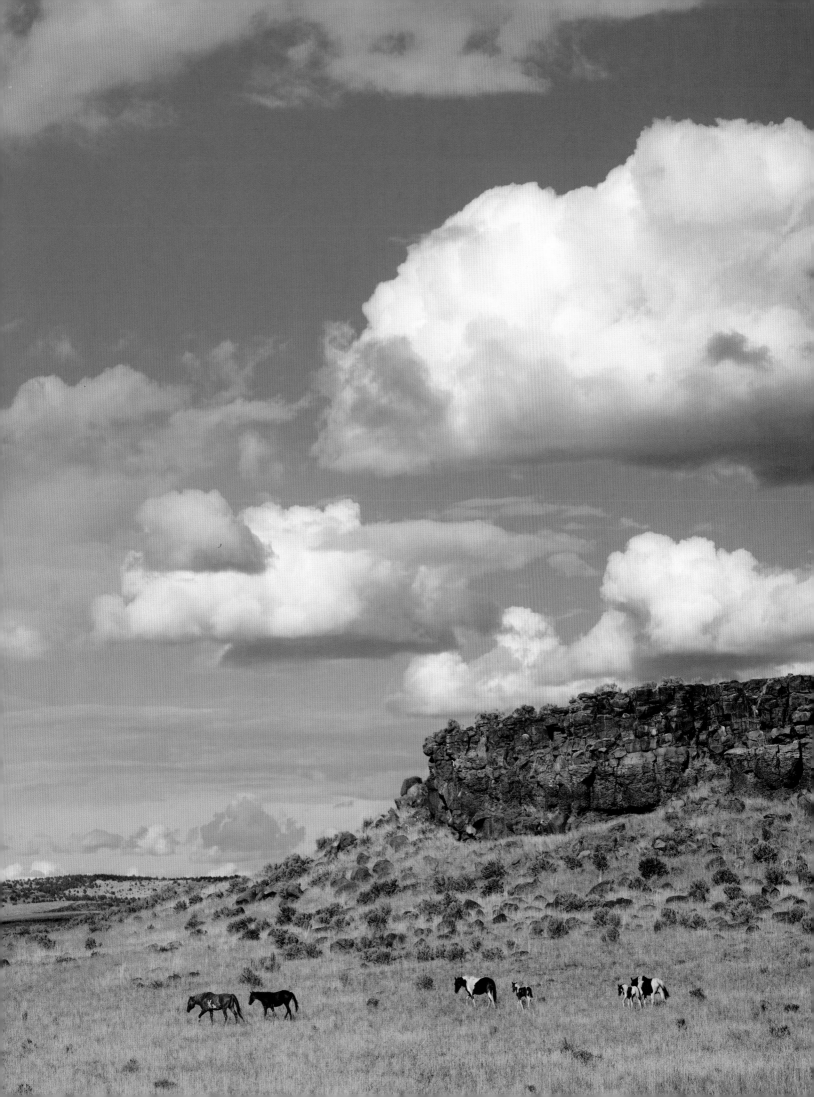

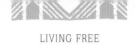

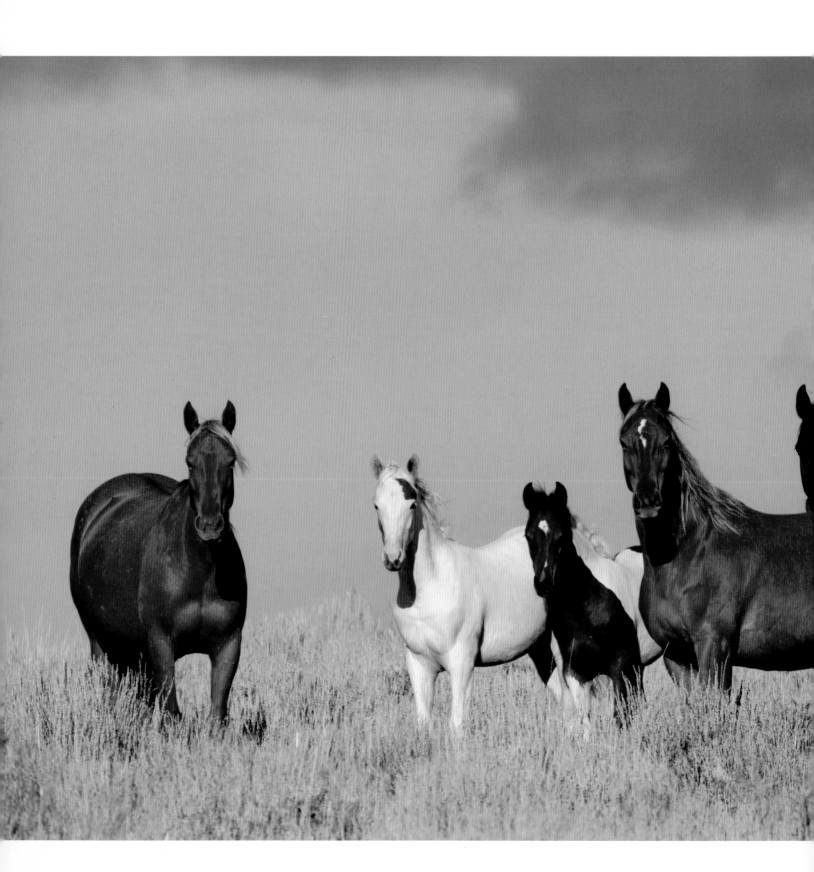

In the absence of territoriality, horses are able to move freely, but are strongly bonded within small social structures. They are therefore able to profit from better food sources during all seasons. This harem (or familial group) is composed of a dominant stallion (to the right), three mares and two foals.

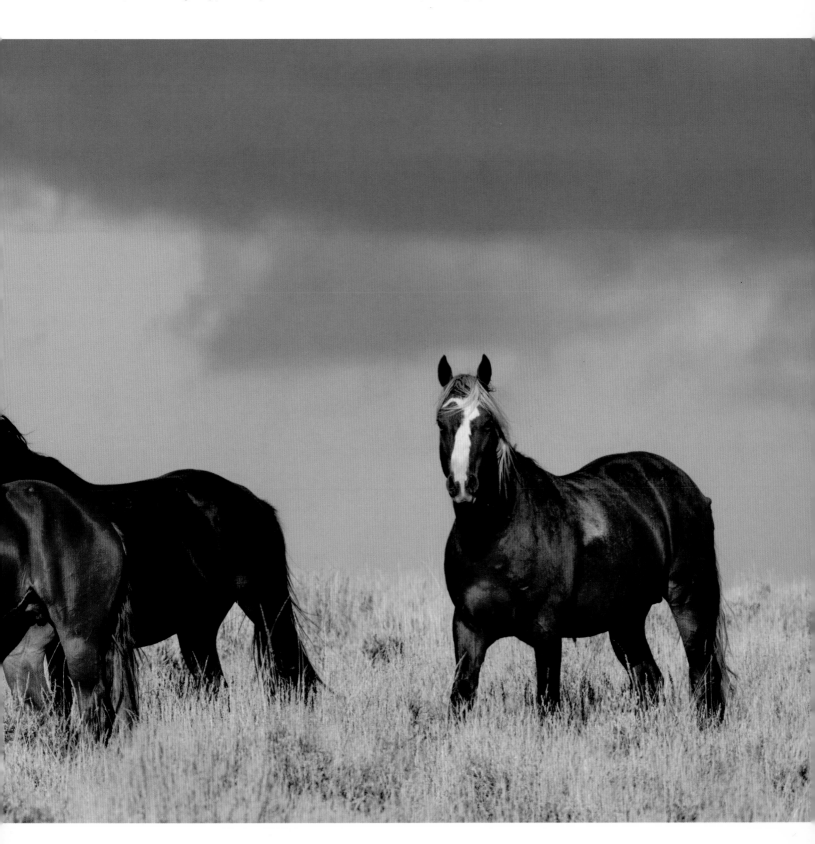

Social attachment, dominance hierarchies and the cooperative liaisons between unrelated individuals are the fundamental principles that guide the society of horses. The range necessary for foraging and shelter is dependent on the quality and quantity of available pasture land as well as sources of water and salt licks.

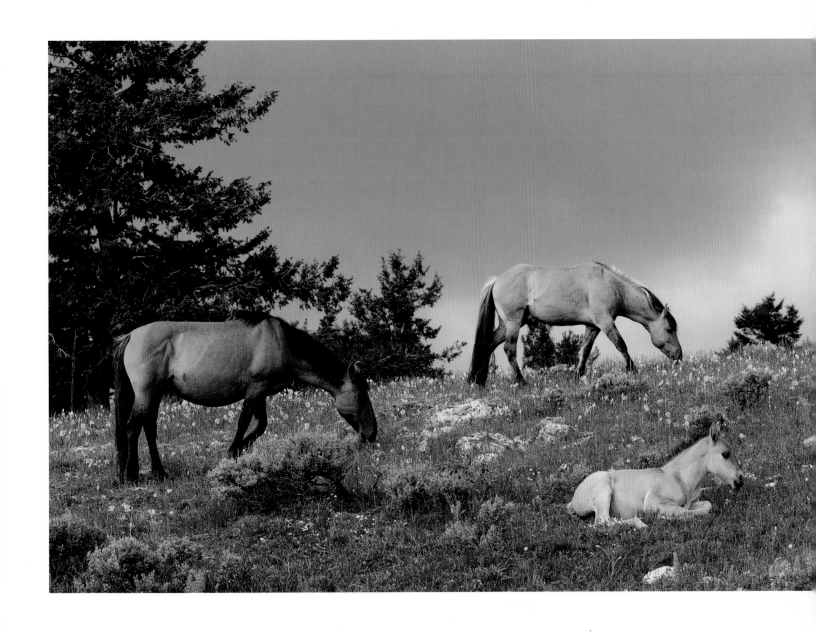

Activities within the group are synchronized. Whether it is the stallion and his chosen mare, or a filly and her young mate, certain individuals maintain amicable, close relationships and do not hesitate to graze together and to rest side by side, thereby reinforcing cohesion within the group.

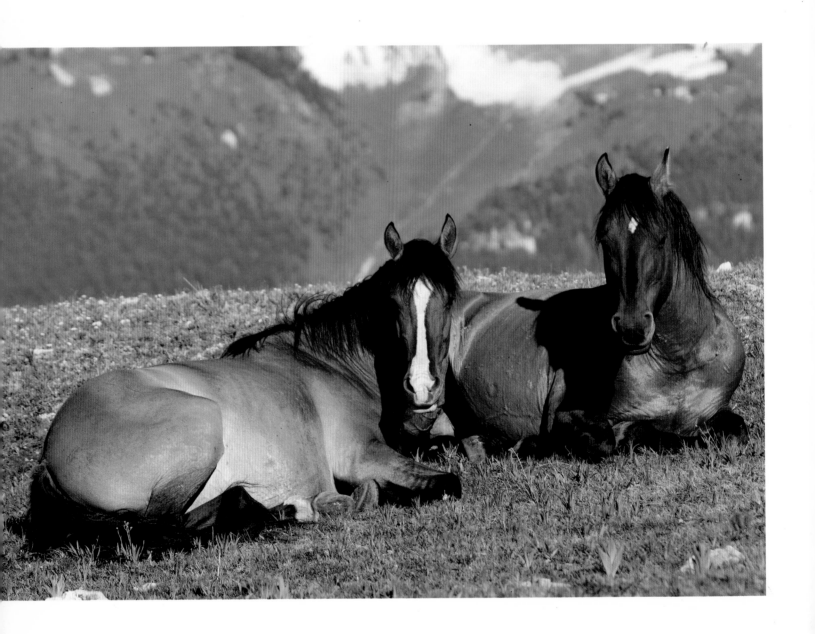

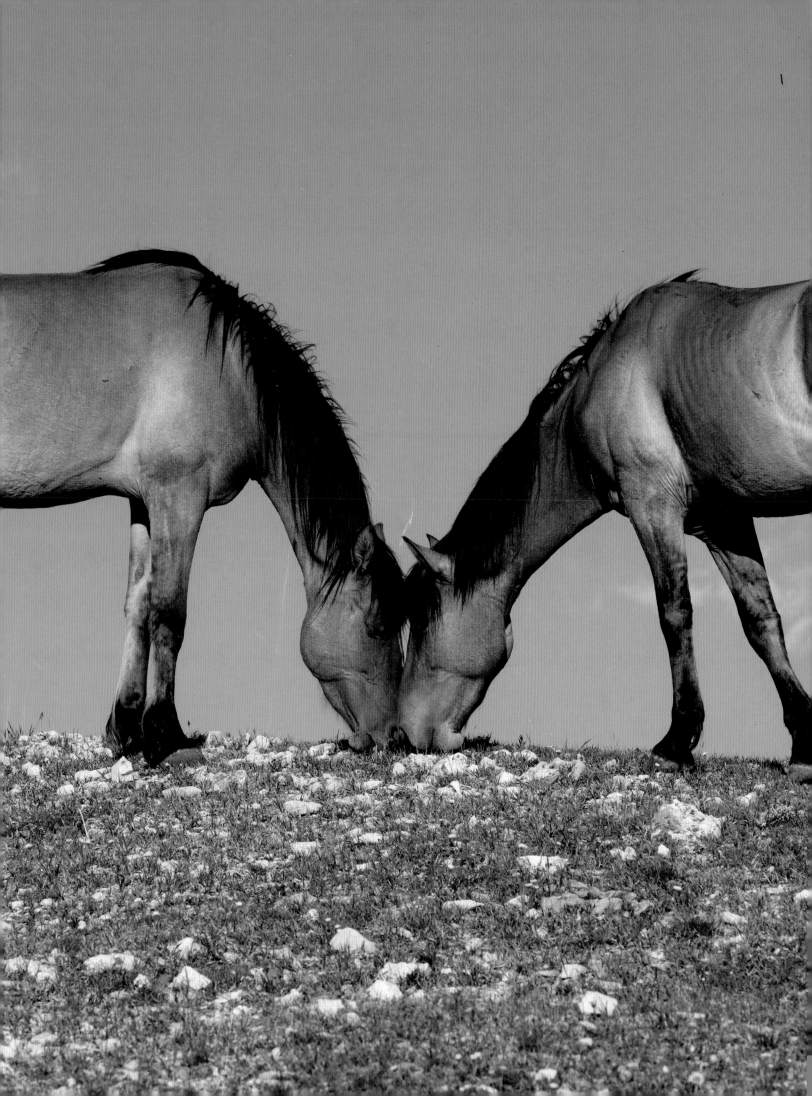

Springtime is a period of extreme tension. The harem stallions are incessantly fending off potential suitors, often much younger and less experienced than them. These chases and pursuits are made even more exhausting for the stallion since he must quickly return to his mares if he wants to avoid the intrusion of another "marauder" who could profit from his absence.

During the first few weeks, physical contact between the mare and her young is frequent and reinforces their reciprocal bond. We witnessed a rare scene: three-member social grooming. The young mother and her yearling daughter are mutually grooming themselves while the filly precociously attempts to groom her mother's neck.

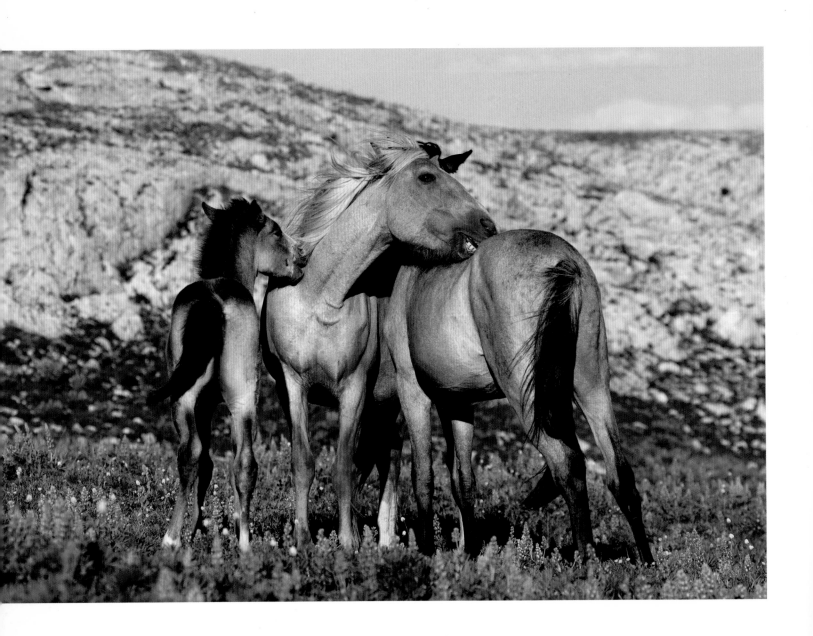

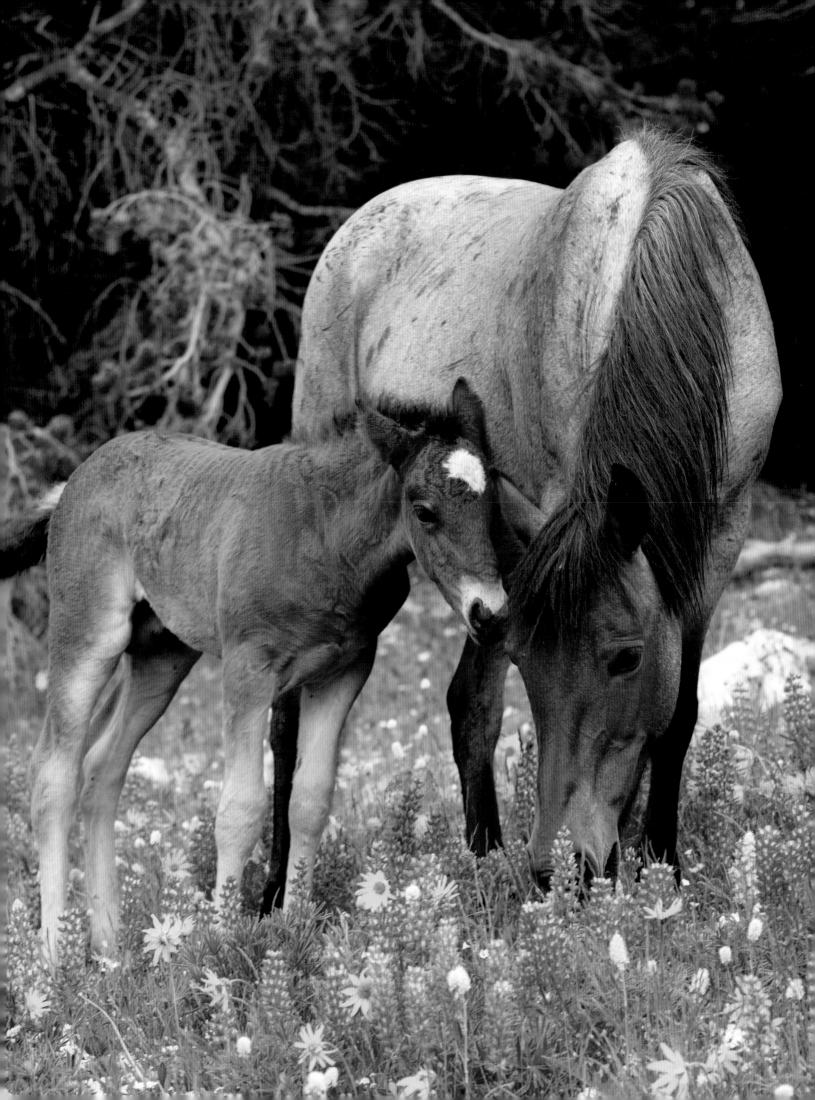

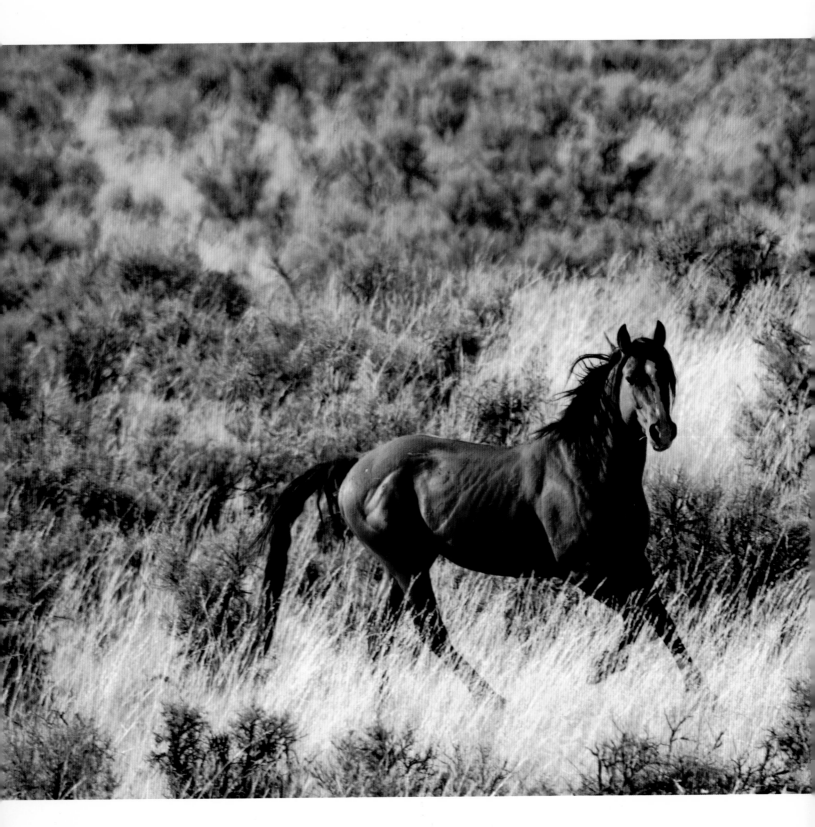

Elegant despite his reduced musculature, this bachelor bay gallops across a pasture of grasses dried from long, arid summer months. For several days, indifferent to our presence, he constantly escorted this harem in the hope of eventually mounting one of its mares.

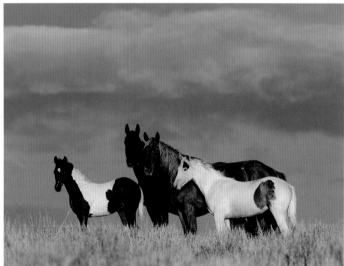

Violent combats between stallions are rare. Horses often engage in ritualistic behavior to intimidate their adversaries — eye contact, bowed necks, controlled kicks. These body gestures and attitude demonstrations, punctuated with strident squeals, are often sufficient to quell the confrontation.

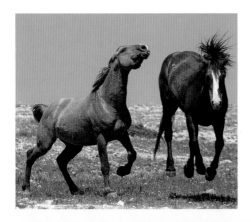 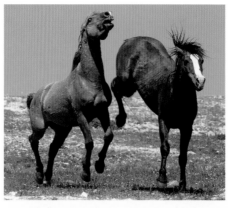 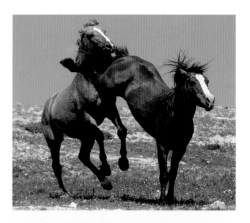

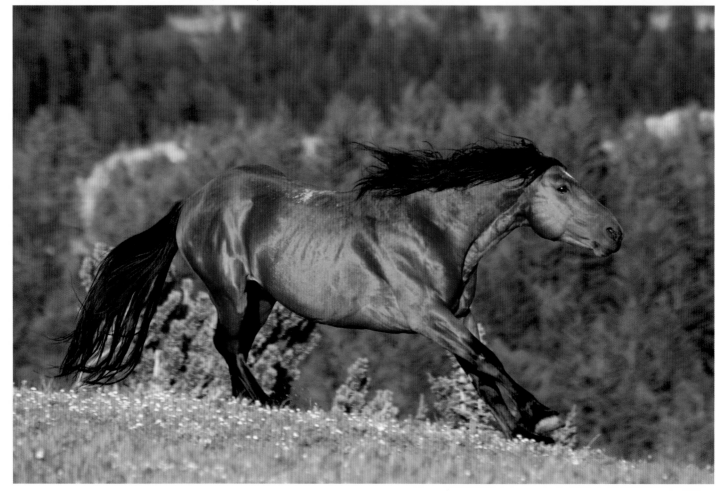

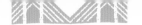

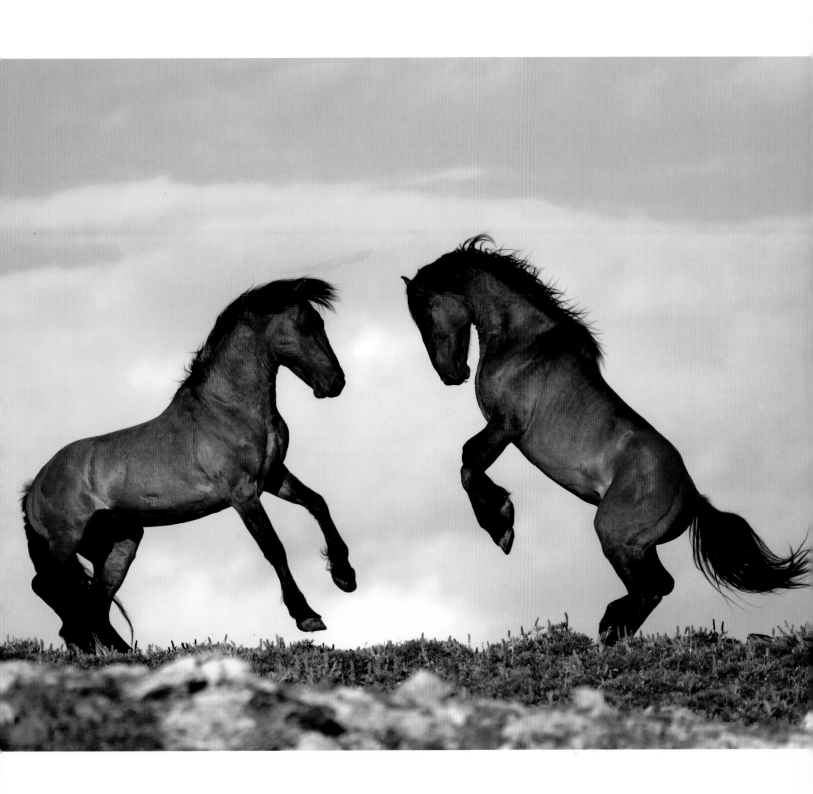

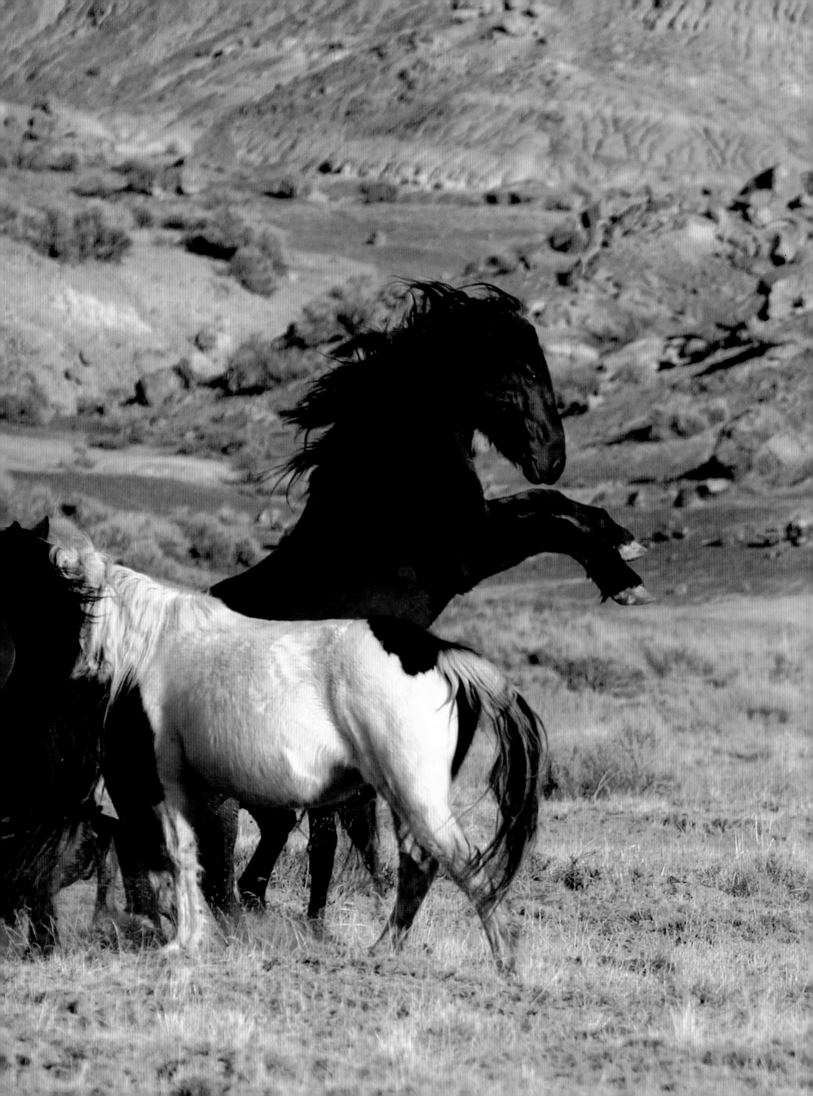

Body gestures and demonstrations enable horses to communicate among themselves. From the tip of the tail to the end of the ears, they put out a clear and precise message. Ears tucked back, neck bent forward and low with a horizontal head, the stallion distances the mares and foals from a rival, thereby maintaining the group's cohesion. This posture is called "rear guidance" or simply "leading." In more colorful language, it is described as displaying a "swan neck" or "snaking."

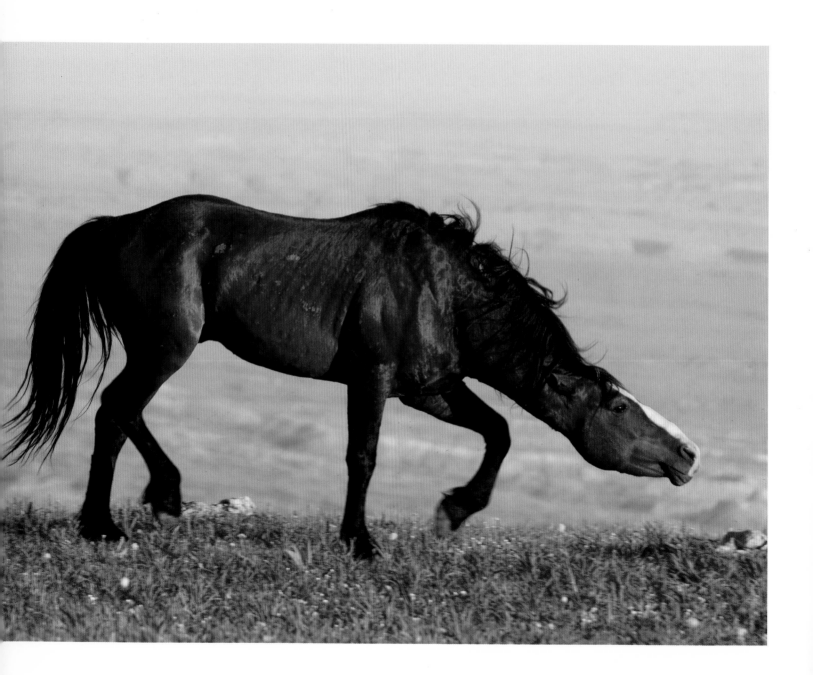

With extended and bent necks, and ears pointing to the front — a tense moment — these two stallions prepare to sniff each other. Contrary to the bachelor's posture (at right), the attitude of the harem stallion (left) reveals great confidence. The altercation will be limited to a mutual examination of the other's scent accompanied by ritual head-banging and head-raising, along with a few squeals.

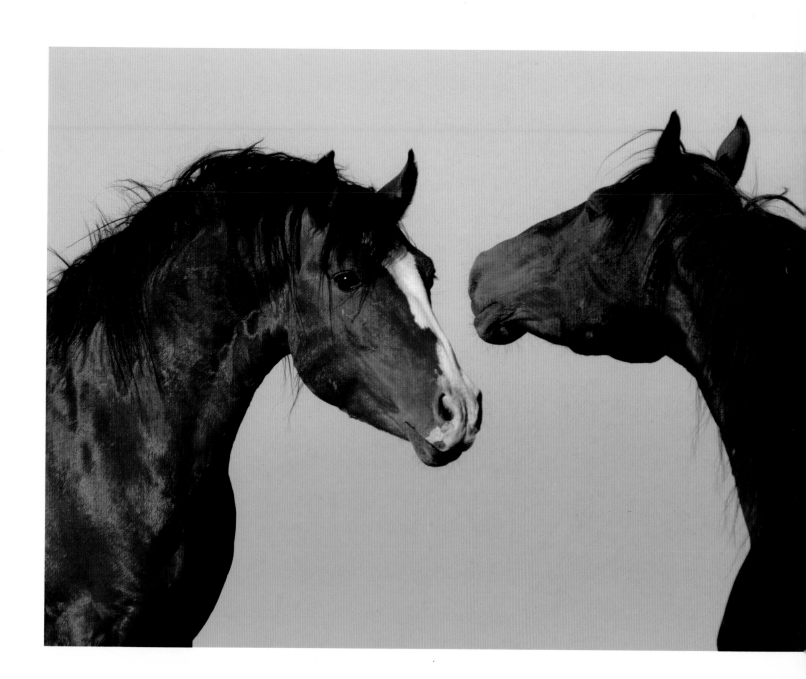

From Bruises to Battle Scars: The Amazing Resilience of Horses

Though battles are rare, when they do occur the combatants engage with all their might and fury. Wounds range from simple gashes to ligament tears, joint dislocations or even bone or jaw fractures. However, serious injuries are exceptionally rare. Less than 2 percent of the stallions we observed during our five years among them displayed deformities that would prevent them from maintaining their status as harem stallions.

Bigfoot, a well-known harem stallion with a deformed foreleg, is the exception that confirms the rule (opposite page). Every spring, Bigfoot galloped on three legs while defending himself against attacks from other stallions. His two mares recently died, and at the age of 25, his chances of being able to establish a new family are slim. Nevertheless, his spirit remains strong and he continues to ward off intruders despite his deformity. However, the risk of a fatal wound is a reality — as evidenced by the skeletal remains of stallions with obvious fractures. Following five years of research in the Granite Range of northwest Nevada, scientist Joël Berger estimated that 3 percent of stallions die as a results of battles.

Cut ears, dilated pupils, torn lips, strips of torn-off skin — all of these benign wounds will scar over and heal within about 10 days. The stallions' coats, pristine up until three years of age, slowly begin to carry, as days go by, the signs of combat — very much like body adornments. However, a torn, exposed muscle takes a bit longer to heal; as medical treatment is not available, the open wound will weep for about 20 days.

Horses tolerate pain as best they can. To recover, a severely wounded bachelor will isolate himself from the herd for a few days. Harem stallions, on the other hand, remain more steadfast. Even with a deep, open, bleeding 7-inch (18-cm) long gash, Geronimo (seen on pages 76–77) did not hesitate to pursue attacking bachelors merely six hours after the incident.

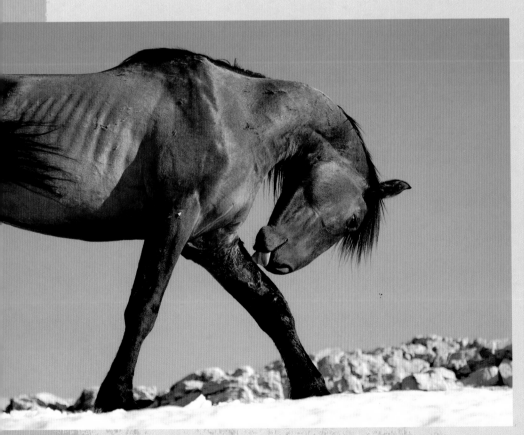

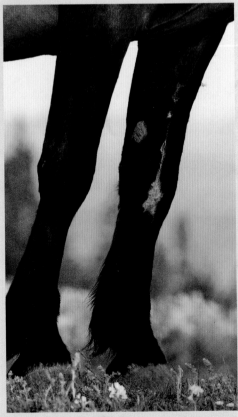

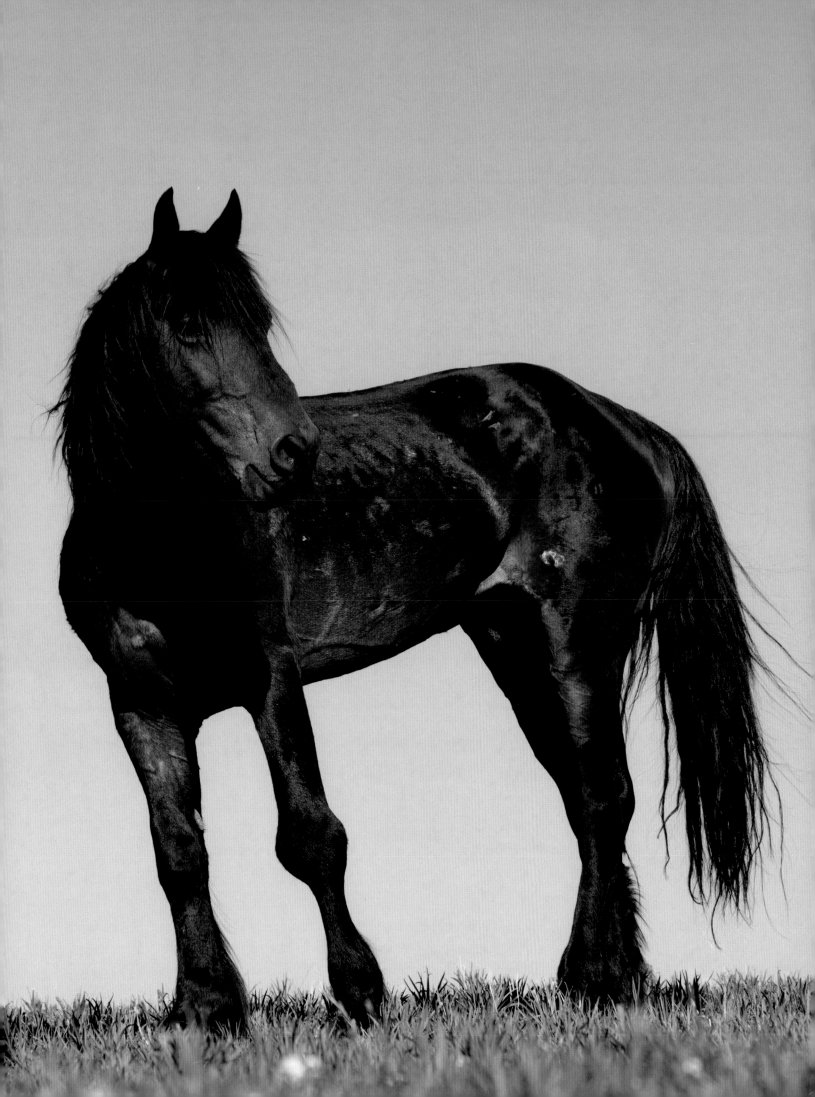

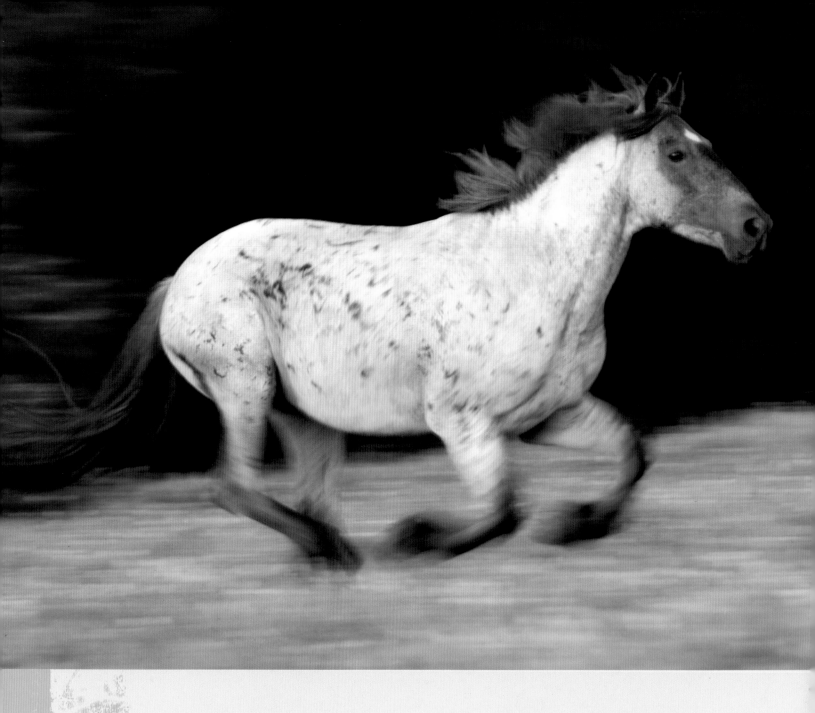

Mustangs benefit from a powerful immune system, as witnessed by how quickly the scarring process takes place.

Limping among stallions is frequent during springtime, a time of year when there tend to be numerous altercations. It is always surprising to see a freshly wounded stallion, unable to carry weight on his affected leg, ambling about a few days later, ready to again engage in combat.

The self-medication process in horses is not just limited to the ingestion of medicinal plants when suffering from stomach upsets. Mud baths accelerate the scarring process of minor wounds. Ice and certain mineral mixes appear to have equally therapeutic effects. One stallion we saw that had severely torn muscles and ligaments treated his ailment for a long time, letting icy water slowly drip over his wounded leg. A year later, although the torn muscles had not entirely regenerated, a fine layer of skin covered the old wound and the horse no longer suffered from limited movement (see page 74).

Another lame stallion took advantage of each visit the harem made to areas with medicinal mineral sources to use the soil to treat his injury. He mixed the soil with his saliva and applied it to his damaged joint, repeating the application about 10 times.

We followed Geronimo, a roan blue stallion, and his harem for five years. He is one of the most dominant horses of the herd and his mares have been faithful to him since the very creation of his harem. Self-assured and exuberant, he has such a strong animosity toward specific stallions — such as Bigfoot (bottom page) — that even his infirmity does not stop him from engaging in energetic pursuits.

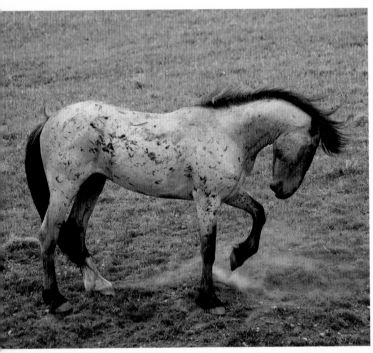

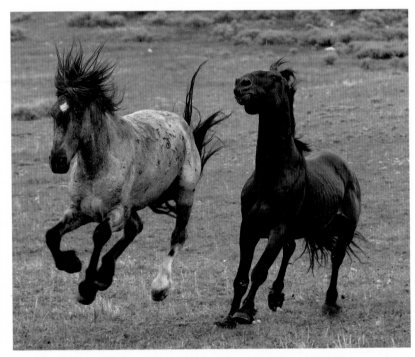

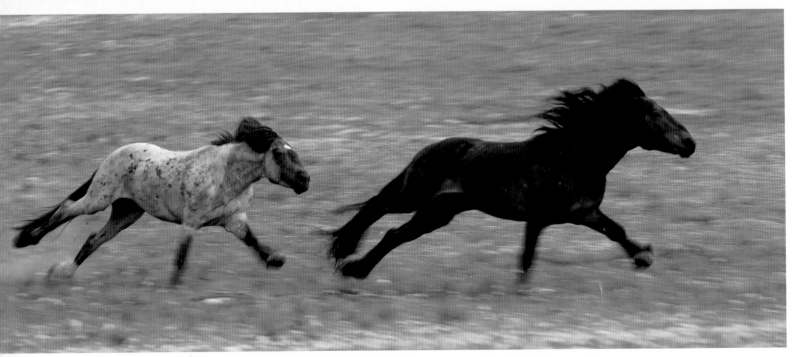

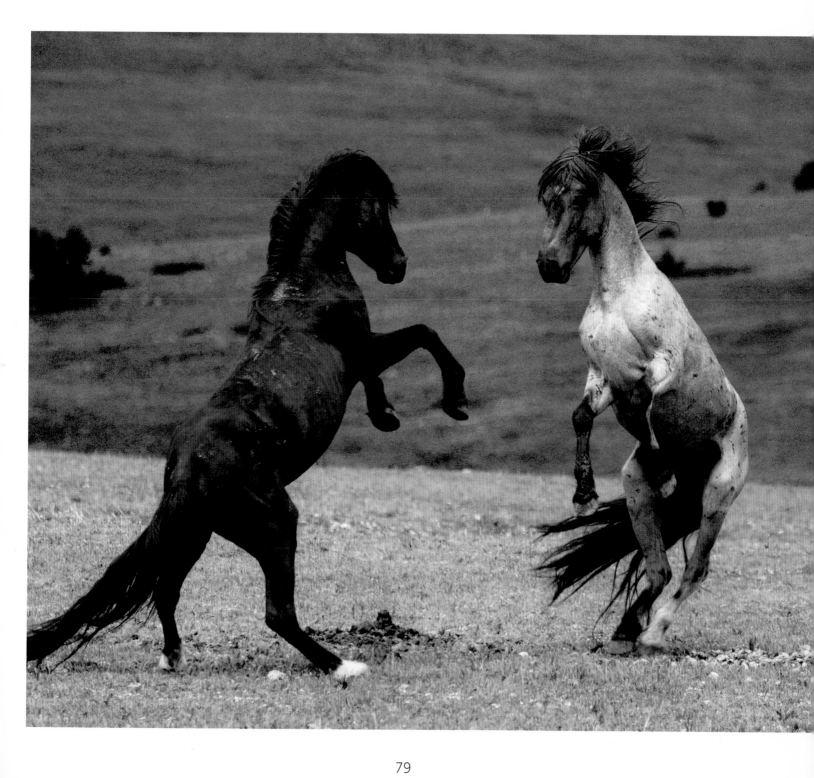

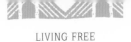

A serious battle unfolds on a rocky outcrop. The roan stallion (at right) has made his first female conquest and he intends to keep her. Given that the seductive filly was quite receptive, there were a number of other suitors to guard against. A winning stallion will energetically chase a defeated rival, often for a mile or two. A last painful bite to the rump is meant to further discourage any further challenges.

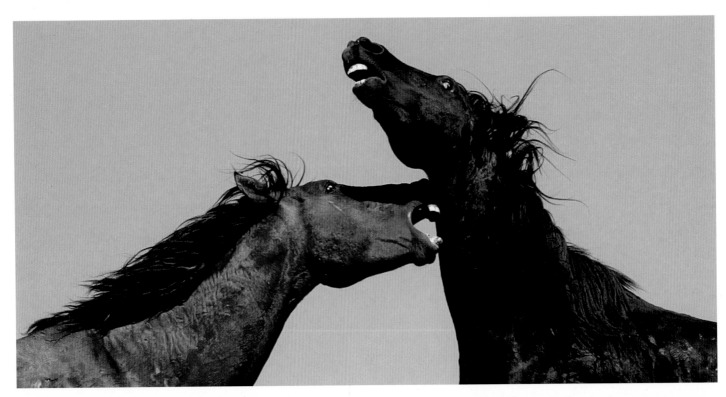

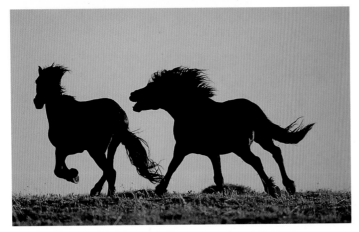

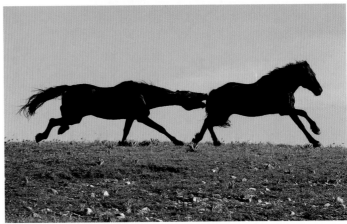

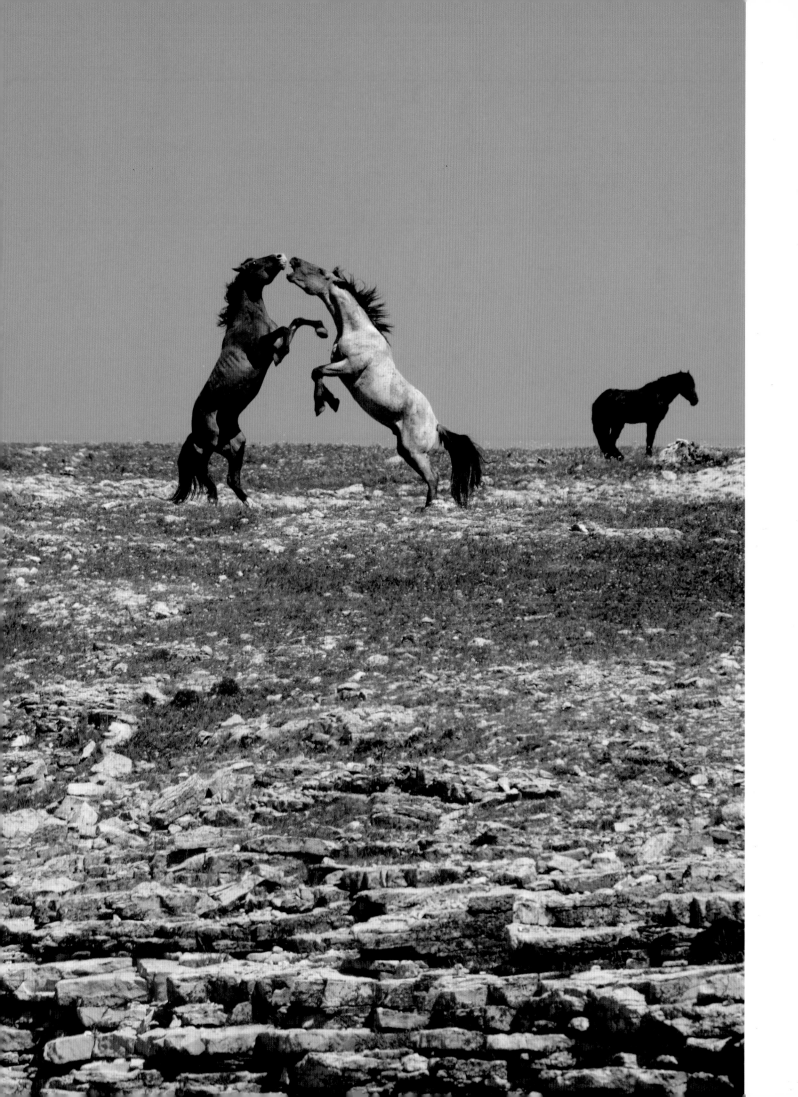

Mating generally occurs without incident. Contrary to what occurs in purebred horses, we never observed the mustang stallion bite his partner's neck during the mating process. Even inexperienced fillies or those recently acquired were never physically restricted in such a manner. This "deviation" in domesticated breeds could be due to the absence of experience in courting behavior. As it happens, purebred mares rarely have the opportunity of being exposed to a male presence, and often attempt to dodge their attempts to mount. Furthermore, in the wild, the fact that a young foal is witness to the mating process between his mother and the harem stallion plays a significant role in his sex education.

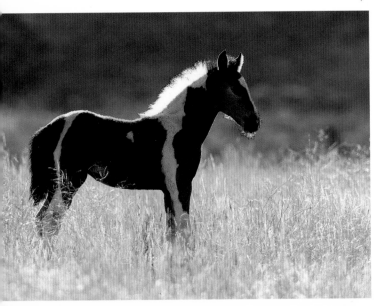
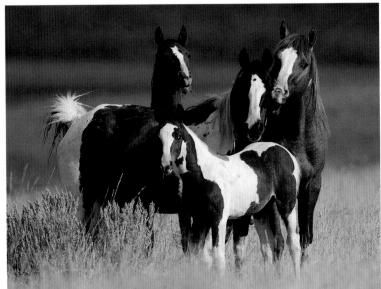
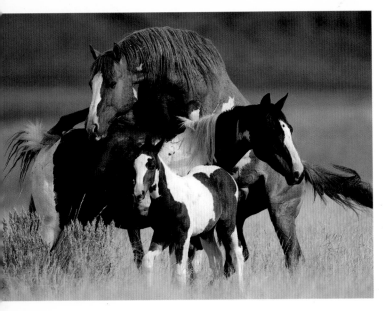
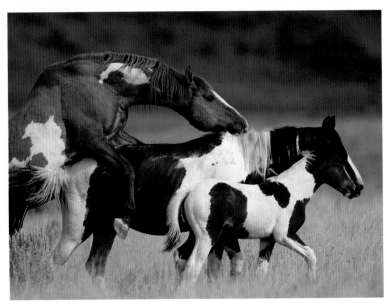

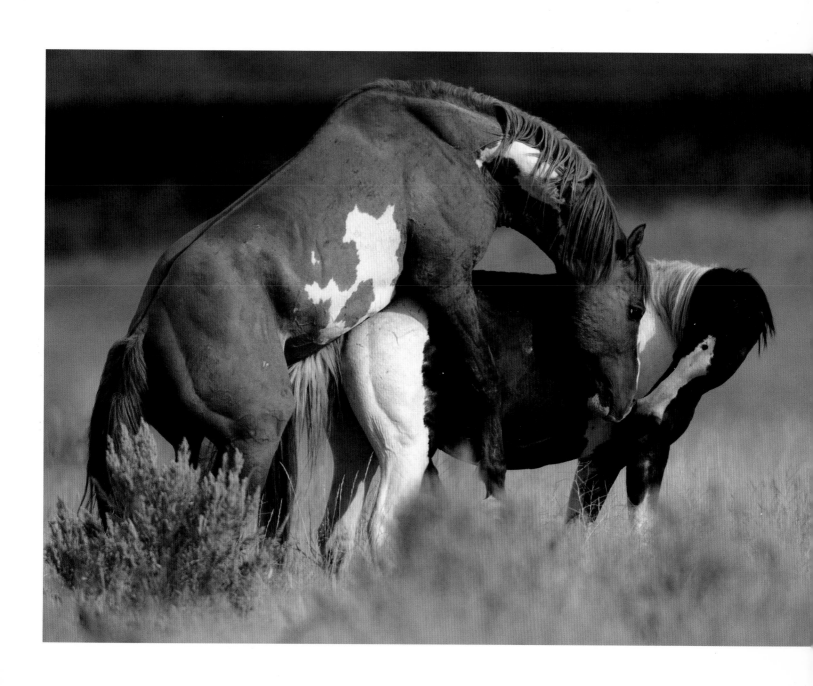

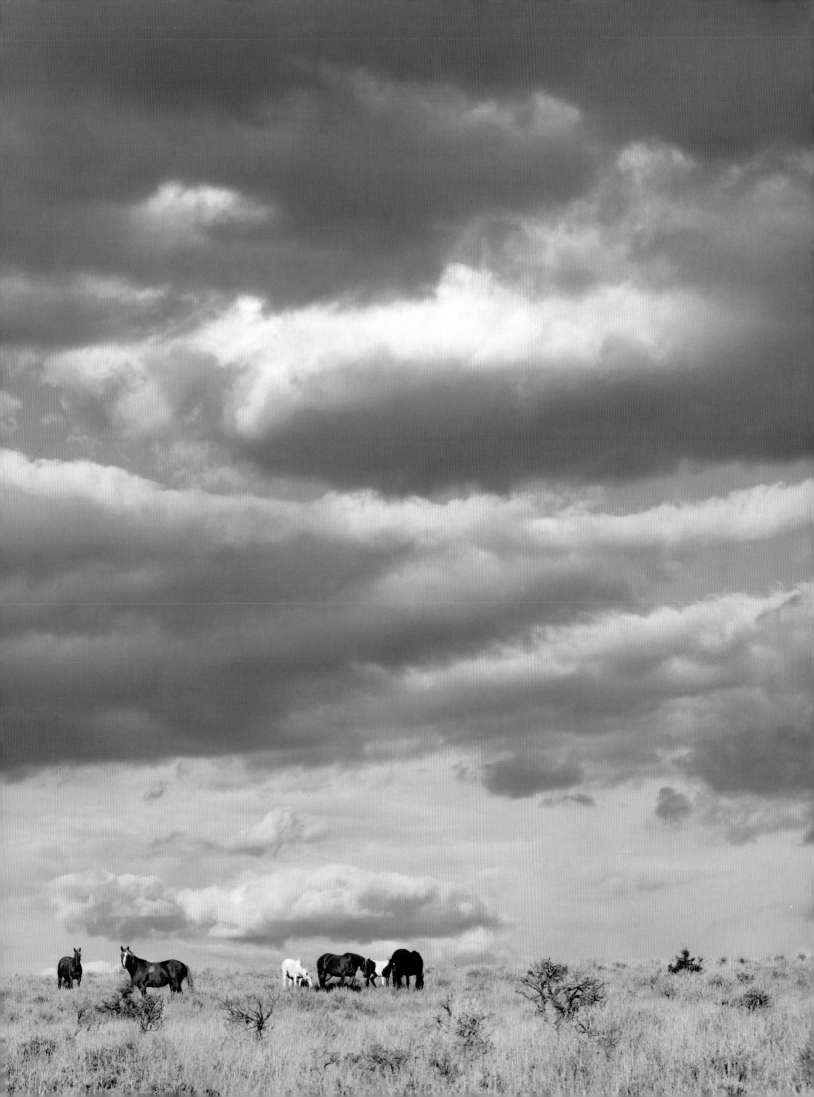

Foals

The mare's gestation period lasts about 11 months, but can range between 10 and 12 months. This significant variation is due to several different factors, both physiological and environmental. The weight of the mare, her physical condition and the stability of the harem all influence the length of gestation.

The better fed the mare is and the less she is stressed, the longer is her gestation period; on the contrary, thin, unsettled or transient mares carry their young for shorter periods of time. Some experienced mares may even delay birth by 48 hours if they sense an upcoming snowstorm.

BIRTHING

The majority of births occur between March and August, with peaks in April or May depending on location and climate conditions (dryness, average temperatures, and so on). At these times of year weather conditions are ideal for the newborn as spring and summer mean there is abundant grass available to maximize milk production in the mares. Fall or winter births are rare and greatly jeopardize the well-being of both mother and foal. (Curiously, "snow foals" are born already endowed with a thick, protective coat.) As round as whiskey barrels, some mares appear ready to explode three weeks before their due date, while others seem to simply have gained a little weight. A few days before giving birth, the mare's mammary glands are swollen and "wax" plugs cover her teats.

Among mustangs, mares generally prefer the security of the harem for birthing, though they do choose sites at the edge of the herd for the actual event. Only mares that are birthing their first foals or those that are poorly integrated into the harem isolate themselves for a day or two. The majority of births occur during the quiet of nighttime or at the break of dawn. Whether dense brush, rocky slope or broad pasture, the birthing places have little in common with each other except for their tranquil nature.

Labor

The process of giving birth, or parturition, is usually quite brief, lasting about 20 minutes. Some more experienced mares may have an "express delivery" that lasts just a few minutes. On the other hand, labor in poorly integrated mares may take several hours.

With the first contractions, the mare will display some nervousness. She'll lie down, then get up, all the while sweating profusely at her shoulders and flanks. Rupture of the amniotic sac ("breaking of the water") signals the imminent birth. The mare then lies down and begins her labor in earnest, staring back at her flanks while emitting sporadic, deep, resonant cries. The newborn's front hooves and head soon emerge. The next contraction frees the shoulders. After a short pause, the mare makes a final, definitive push to release her foal. Delivered of her baby, she then turns to her little one, deeply breathes in his scent, inhales his breath and begins to lick his body. If necessary, she will help to free him of the amniotic sac. The foal is far from quiet during this process: he moves his head, rights himself and immediately begins to assess his environment. He may even attempt to suckle at a dry teat! Lying beside him, the new mother will encourage and soothe him with soft cries and gentle body contact. Within an hour following the birth, the placenta will be delivered, though unlike other ruminants (cud-chewing animals), the mare will not ingest it. This large tissue-and-blood-engorged sac will become fodder for coyotes, foxes or crows.

Imprinting

The first few hours after the birth are critical to establishing strong bonds between the mare and her foal. After a short

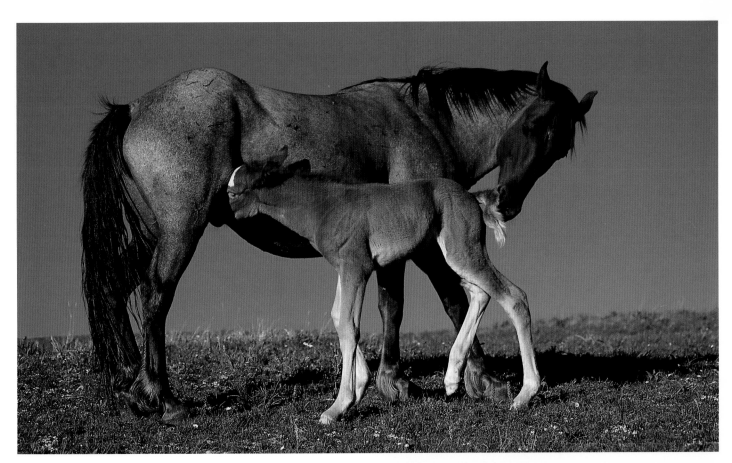

pause, the mother earnestly begins to fully groom her baby: she energetically starts licking his head, then down to his flanks and especially his perineal area. This massaging activity stimulates the foal's respiration and blood circulation. As springtime temperatures in the Rockies rarely surpass a few degrees above freezing, we can understand the mare's zeal in cleaning and drying her foal. This postnatal grooming process is essential to create a strong physical bond between mother and offspring; by depositing chemical substances in her saliva onto her newborn, the mare lays down something of a scent and taste ID tag on her young. Henceforth, even if the foal strays from her, the mother will be able to identify him by smell and not confuse him with other foals. At each feeding, she smells the perineum of her offspring in order to make sure of his identity. This behavior readily explains the rarity of adoptions in the mustang world, since a mare will vigorously reject a strange foal.

THE FIRST FEW STEPS

At this point, the newborn, for his part, has purely mechanical concerns: untangling his long stilt-like legs, hoisting himself on these faltering supports by first lifting his front end followed by his rear, and then facing the challenge of maintaining his balance by spreading his legs far apart.

Perseverance usually pays off and, though wobbly, he generally achieves his goal of standing up in about an hour. If he does not accomplish this or if it is taking him too long to do so, his mother helps him get up by gently lifting him by the neck. After about 10 minutes, his first steps are taken, followed by a series of stumbles and falls — of little consequence as the foal renews his efforts. He gets up again and manages to stay upright by leaning against his mother.

The location of the mammary glands is the second challenge that he must quickly address. Instinct directs him to actively locate a point of contact that encompasses his muzzle and cheeks on the soft, dark belly of his mother. Two

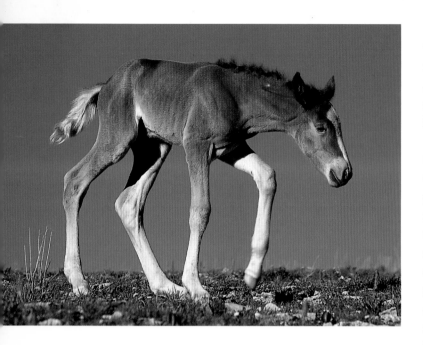

The mare forbids the stallion to approach her young during the first three or four days. If she decides not to interrupt her foal's nap, the stallion's attempts to make her move are in vain. Anticipating his approach, the new mother keeps her forelegs near the body of her sleeping foal and pivots around him, keeping her posterior toward the male in a threatening posture.

A mere week old, the foal suckles every 15 to 20 minutes, taking in about 10 quarts (10 l) of milk each day. Unlike other ungulate species, notably cows, the mustang's mammary glands contain very little milk, necessitating very frequent feedings (up to 60 or 70 a day). To request a feeding, the foal takes a predictable stance: he positions himself under his mother's neck, thereby blocking her from moving forward, and stretches his body to reach her teats. The mare then stops her grazing and sniffs her offspring to make sure he carries the proper scent. During the first week, the young mother will voluntarily interrupt feeding about half the time. She simply proceeds by displacing herself or by lifting her hind leg on the side of the foal. This tactic encourages her young one to follow.

The First Blades of Grass

At about three or four days of age, the foal begins to taste his first blades of grass. In regards to nursing, he now only suckles about 20 times a day. By observing the choices and avoidances of his mother, the foal develops a preference for eating certain plants and, we assume, learns how to avoid poisonous vegetation. During the first few months of life, the foal must spread his front legs wide apart to graze — in a manner not unlike a giraffe! The ingestion of maternal droppings coincides with the onset of plant consumption and continues until the age of two to three months. In our experience, we never witnessed a foal ingesting droppings that were produced by anyone other than its mother. The droppings, particularly those that are soft and fresh, appear to be particularly appealing to the youngster. It will squash, sniff, chew on some, spit some out, eat it again and swallow it. The ingestion of the mother's droppings contributes to the establishment of the foal's own gut flora — microorganisms in the intestines that aid digestion. Hence, the mare contributes these precious microorganisms and ensures her foal's intestinal well-being.

THE GRADUAL PATH TO SELF-RELIANCE

The mare acts as the privileged exploring ground of the young foal and is his very first playmate. He appears to be constantly with her, chasing and sniffing her flanks with his muzzle, from her neck to her teats. He nibbles at her ears, which then droop

areas of her body correspond to this innate search: her stifle and the inside of her back leg. Positioning himself at his mother's flank, the foal explores, retreats, returns … The mare, attentive to her foal, will nudge him with her head and guide him to her teats, which she clearly presents to him by slightly moving her hind leg on the side where he is searching. Finally, the foal succeeds! The teat is there, full of the first secretions from the mammary glands, known as colostrum, which he suckles with noisy abandon. Once he's done with that one, another teat is ready to satisfy his appetite. This initial feeding provides more than just nutrition, as colostrum contains antibodies that will protect the foal from infectious diseases.

At two hours of age, the newborn now responds to his mother's calls with weak whinnies. He rubs against her, but sleep quickly catches up with him and his oversized legs fold and collapse like a dramatic ballet dancer's. Spent, the mare takes advantage of this respite to lie down beside her foal. The foal will seek out her teat to snack at every 15 to 20 minutes or so. Soon, after first seeing the light of day, the motor coordination of his long limbs is nearly perfect. At dawn, the foal is able to run to his mother's side at the first sign of danger.

Feeding and Protecting

In the first few days, the mare is careful to not wander far from her young one and to brush off all intruders. As the foal has a natural tendency to follow his mother when she wanders, then he might just as easily follow any mustang, doe or even human being. In the beginning, the newborn may seek to suckle other mares in the harem. After having been subjected to several rebuffs, he quickly understands that the only open "milk bar" belongs to his mother. Therefore, a few days will go by before he selectively attaches himself to her.

like wet saucers. He pulls at her mane, bites her legs, shoves her backward and even bucks up at her. These first interactions with his mother are very intense, but they become less common as the weeks go by, and the foal slowly becomes more self-reliant and autonomous. Day by day, he draws ever widening circles around his mother. He begins to explore his environment with the tips of his forelegs and his mouth: rocky outcrops, ant hills, tree trunks, bushes, pine needles, droppings, sand — everything is subject to discovery. Nothing escapes his curiosity. Water, mud and snow hold a particular fascination. Adventurous little foals do not hesitate to join their mother in a bath, enjoying a wet soaking up to their stomachs. Mud makes strange sucking noises when his hooves dig in. When it comes to old snow patches, he need only lower his jaw to taste a cold, icy treat. His own body is also the object of curiosity and discovery; the foal learns to scratch himself behind his ears without losing his balance, and to coordinate his movements while rearing, bucking or rapidly turning. By imitating his elders, he discovers that rubbing his forehead, neck, back and haunches against tree trunks and large branches relieves body itching.

Gaining Independence

At the end of the first month, the foal begins to socialize, joining other young horses of the same age, or one of his seniors. At about two or three months of age, the mare's vigilance regarding her foal lessens. The responsibility of locating his mother and of staying near her now entirely depends on the foal. If he loses track of her, the young mother is happy to respond to his calls, though several minutes may pass by before she neighs in response. Foals are particularly vulnerable if in a deep sleep. If he is slow to wake up when the stallion wishes to move his harem, the stallion won't hesitate to bite the foal at the base of his neck to speed up its movement.

Education: A Complex Task

The social standing of the mother, her temperament and her qualifications as a teacher appear to have a great influence on the foal's future. The best young mother is often a lead mare from a dominant and stable harem with a knack of being able to correctly analyze situations. She is able to attain a solid balance between close surveillance of her offspring and its need for independence and discovery. The most privileged foals, who benefit from the best conditions from the start, including a plentiful supply of milk, are also the first to leave the harem and to reproduce. Even if the mother remains the primary focus, all members of the harem participate in the education of the young mustang. Their attitudes define the rules and set limitations. However, the role of the stallion should not be underestimated; occasionally inflexible and authoritarian, he also takes time to respond to game playing or social grooming of his offspring. Some stallions even find themselves being particularly attentive to their foals.

In certain families where there are no other yearlings or juveniles, the foal is an "only child." It therefore has little choice but to turn to its parents to relieve pent-up energy. The stallion then displays a surprising tolerance and joins in play without hesitation. He accepts the fact that the young foal will knock him around or tug at his mane with its teeth. When the stallion decides to put an end to this, he simply lifts a leg or

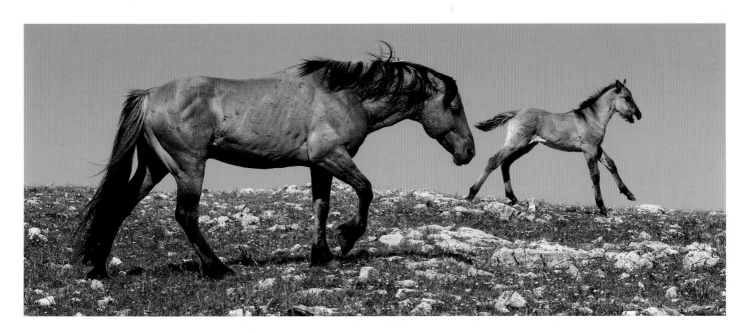

Driven by the harem stallion, an errant foal hurries to join its family group.

puts his ears back as a warning signal. As the weeks go by, the foal's attraction to young horses from other harems or even for unknown stallions keeps on growing. While still being attentive, the parents give permission for the foal to wander off a dozen yards or so, in order to get to know young mustangs from nearby bands of horses. When the foal ventures outside of the surveillance zone or when an unknown stallion threatens it, the male parent quickly intervenes to return its wayward offspring to the security of the harem.

LEARNING THROUGH PLAY

At one or two weeks of age the foal quickly searches for the company of other young horses, and at one month, it spends as much time playing with its companions as it does being alone with its mother. In between the long periods of sleeping and grazing, game-playing typically happens early in the morning and after sunset, when the air is fresh. As a veritable "school of life" that echoes most adult behavior, play facilitates structuring of social behaviors and helps the foal integrate into the harem. The young mustang incessantly repeats different friendly, aggressive or sexual postures while gauging its partners' reactions. Simultaneously, the foal perfects its physical performance and sharpens its reflexes.

A Difference in Genders

Identical at first, the play behavior between males and females becomes differentiated at one month of age. The male foal plays more often and for longer periods of time than the smaller female, and his games are usually more vigorous. Given a choice, he selects a same-sex companion with whom he will be able to pit and measure himself against, and chooses his favorite game: a junior version of stallion battling. Rearing up, biting necks and manes, pinching forelegs, shoving, chasing one another at triple the normal speed … All these movements, lifted from the repertory of "grown-ups" are repeated incessantly. These simulated fights prepare him for actual future conflict. The young female, on the other hand, prefers to romp about and throws herself into free-flowing gallops punctuated by energetic kicking. Galloping and chasing through groves or among old fallen tree trunks that act as natural obstacles are other forms of much appreciated playtime.

Kindly Elders

Overflowing with energy, foals, especially the young colts, do not hesitate to wake up their elders. If hair pulling and ear nibbling do not do the job, the foal sets his foot on the back of the resting horse and nudges him until, at wits' end, the elder rises. A young filly, for her part, will content herself to tenderly groom her young brother, though the male yearling will respond to this invitation by battles a little bit too strong for her. However, roughhousing and pinching do not intimidate this mischievous foal and, after a short chase, he tries yet again. The male yearlings and three- to four-year-old stallions are gruff as playmates, but will still assume a protective role. In dangerous situations, they may insert themselves between the foal and the intruder, and during stormy winter weather they will shelter and protect young ones by using their bodies as barriers.

The Discovery of the Social Order

The foal is quick to acknowledge the authoritarian nature of the stallion. It approaches the head of the family with its neck extended and its tail tucked between its legs, while emptily chewing — a posture of appeasement that signals to the stallion: "I am small and weak — do not harm me." This rhythmic opening and closing of the mouth, (known as teeth clapping or champing) is not solely reserved for the stallion. The foal may indeed use the same approach with its own mother, any adult of its harem, an older foal, a yearling or horses from a neighboring harem. This submissive gesture is meant to inhibit the receiver's aggressive reactions. An older mustang may often have recourse to use the same form of expression, for example when a sexually mature filly is being wooed by a strange stallion, or when a young male, even at four years of age, confronts the dominant stallion of his harem.

Distressed Foals

Should it become separated from its mother, the foal experiences a true physical distress. In our experience, adoptions are very rare, and we have concluded that the younger the adoptee is, the lower are its chances of survival. On the other hand, it does happen on occasion that a stallion will allow a foal or an orphaned yearling to follow him, particularly if it is a young filly.

WEANING

Contrary to the brutal and sudden weaning process in domestic horses, the young mustang undergoes a more gradual weaning. It occurs during the winter and spring that follow the foal's birth. The mother presents less and less access to her teats and will eventually rebuff her foal quite aggressively when it is about eight or 10 months old. Occasionally, weaning only occurs a few weeks before the next birth.

If the mare remains barren, her foal may profit from maternal milk for longer — even up to four years of age! Though this will not serve to complete the yearling's dietary requirements, this "bonus" will appease it psychologically.

Becoming a Stallion:
A Turbulent Adolescence

Adolescence is undoubtedly one of the most exciting stages in the life of a stallion. In the space of a few years, he will make three crucial steps: leave his birth harem, integrate into a group of bachelors and then concentrate all his efforts to conquer a mare in order to establish his own harem and reproduce.

APPRENTICESHIP TIME

Between the ages of two and three years, the young stallion expends a great deal of energy and actively finds others in his family with whom he can engage in simulated fighting. If there are no playmates in his own group, he won't hesitate to seek out other harems to measure himself against mustangs of his age. Because of this, young stallions therefore spend much time midway between harems, engaged in friendly and noisy play. At this age, biting is still subdued, often just mimed, movements are exaggerated and many energetic head-to-tail lunges are evident as budding stallions try to nip at each other's withers.

Meeting with "Grown-Ups"

Whenever a group of celibate males, or bachelors, arrives on the scene, the young stallion seems very interested in them. He will observe them attentively and after a few minutes, unable to hold back any longer, will move toward the group. The bachelors immediately form a tight circle around the visitor, each attempting to familiarize himself nose to nose with his scent. This olfactory exchange results in lively interaction and shrill whinnying, as the celibate stallions continue to sniff the sweat and genitals of the budding stallion. If he feels too invaded, the young stallion will quickly return to his familiar harem, though he won't hesitate to repeat the experience. In due time, these encounters will help intensify his rapport with these adults. Sometimes a bachelor stallion will entice a juvenile into friendly play, a kind of choreographed ballet, where aggression seems channeled. As long as the young stallion is still welcome in his harem and uses

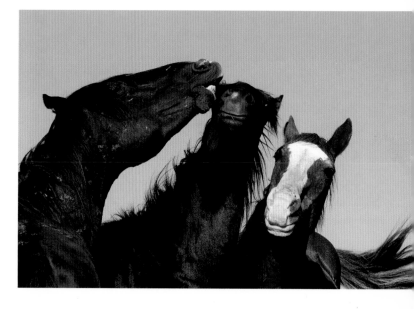

his playmates to unwind, he is likely to delay his inevitable departure. Usually, though, young males leave their familial harem for good around three years of age to join a group of bachelors.

Excluded from the Harem

Although the separation can be gradual and voluntary, it is also often the case that the harem's stallion no longer tolerates the presence of his offspring, who is now in full puberty. The colt then becomes the target of bites, hoof kicks and fierce pursuits, especially during mating season in the spring — times of extreme tension among stallions. Even overtures of appeasement on the part of the young male are not enough to calm the patriarch. The aggression continues until, forced and contrite, the young male leaves the harem.

Finding himself alone from one day to the next, exiled from his family because of rising levels of testosterone, he leaves in search of other "companions of fortune."

THE BACHELORS

Upon being accepted into a structured band of celibate males, the young stallion, now called a bachelor, usually starts at the lowest level of the social hierarchy. If he is the offspring of a dominant mare, he will rapidly affirm himself in the group. The majority of bachelors in such groups are between three and five years old. Older individuals simply remain bachelors and seem to not be sufficiently motivated to form their own harem. An older, harem-deposed stallion may integrate with a band of bachelors for a while before leaving for a solitary life. On rare occasions, the group may acquire a yearling, even a mare of exceptional status.

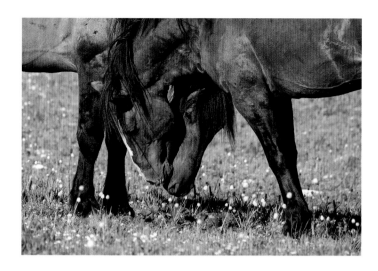

From Learning How to Fight …

During his two to three years with the band, the bachelor improves his fighting techniques and intensifies his territorial behavior. From simple play fights to more serious confrontations, the young stallion becomes an athlete. His musculature strengthens, his reaction speed improves and his actions are more precise as he grows in both sharpness and audacity. All his moves are endlessly repeated: strikes to the rump, harmless kicks to the posterior, kneeling on his hind legs and "boxing" with his forelegs … This continues until play intensifies and becomes more aggressive, and bites are no longer simple feigned gestures. His flanks, rump and neck become covered with scars, and chunks of his earlobes are even torn off!

… To Competing with Piles of Droppings

Encounters are often little more than demonstrations of rank. When two or more bachelors squabble or one approaches the group, interaction often turns into a manure contest: after some preliminary mutual sniffing, punctuated by strident squeals, the rivals move toward the nearest pile of droppings and defecate jointly or in succession. After the first stallion has deposited some droppings, the others sniff it as a group. A second stallion then follows suit. When he has finished, he may even stroke the pile with his hoof and kick out his rival's droppings. The stallion that leaves his "calling card" last is the most dominant. It's not clear if he simply wants to mask the other stallion's scent or to ensure

his scent predominates at a place of high social value. It is also fairly common that a dominant stallion drives the other bachelors by signaling with his neck, just as he would with a group of mares, or even mounts a fellow male.

The Bachelor Club

Standing side by side along a ridge, ears pointed and manes swaying in the wind, these side-lined athletes spend a great deal of time observing the movement of harems. Sharply focused on attractive mares, they are sizing up their future rivals for the right moment to launch a raid.

With freedom to move around as they wish, their very own organizational rules, lively and pugnacious, with loud, playful whinnying and ongoing manure competitions, these young stallions disturb the social order of harems and are not unlike gangs of juvenile delinquents! Basically they only seek one thing: to end their boyhood days and head their own harem as soon as possible. Depending on each bachelor's temperament and maturity, as well as the time of year, such groups readily split up and form new alliances, later regrouping with the same band. The number of adherents to such open clubs generally ranges from two to six members. Bachelor groups clearly rank below harems in terms of right of entry to important locations (watering holes, salts licks and so on), while families essentially have open access.

This transitional phase is crucial for young stallions. They learn how to position themselves relative to other bachelors and gauge each other in terms of strength, domain and daring. This apprenticeship prepares them for their future role without the risk of incurring serious injuries. Without this physical and psychological initiation, the chances of them successfully acquiring a harem of their own are very much diminished.

After leaving their own "business cards," two stallions concentrate on sniffing a dung pile. Intended to intimidate others, the defecation ritual allows opponents to assess one another.

ESTABLISHING A FAMILY

For a bachelor, gaining access to a mare must be a real dilemma. On one hand he is anxious to gain female attention as quickly as possible; on the other, he wants to avoid the altercations that may lead to serious injuries. These two opposing ambitions probably account for the fact that a young stallion rarely achieves his goals before reaching his sixth year.

Abduction, Seduction or Patience:
Three Strategies for Success

A bachelor can attempt an abduction, in which case he will have no alternative but to confront the harem stallion one-on-one in battle, with all the attendant risks of defeat. He can also try to seduce a filly or young mare anxious to leave her birth harem. While this option poses less risk of physical injury, he will have to confront many other suitors. Obtaining a mare immediately in this manner is generally only possible for a dominant stallion, who has been raised in a dominant harem and whose mother is of high social status. Individuals of lower status often form an alliance for the purpose of seducing a mare, with two young stallions from the same band of bachelors actively cooperating to capture her. In this case, though, even if the two woo the mare and succeed in enlarging their harem, such an arrangement is invariably transitory. After just a few months, the sharing agreement is no longer practical and the developing conflict grows until one of the two stallions is defeated.

A third tactic a young stallion can use in his pursuit of mares is to become a harem "satellite." He will trail a harem for weeks and months on end, following its every move, regularly provoking the lead stallion for one-on-one combat and keeping potential rivals at bay. If the harem stallion is aging or wounded, this war of nerves will eventually take its toll and result in one final duel, after which the old stallion is replaced. A more subtle approach for the young stallion is to gradually integrate himself into the harem. Always following a few yards behind, the bachelor will become an "assistant" of sorts: first in line in case of danger or an approaching intruder, and chasing fillies and yearlings who have strayed from the harem. This arrangement is of considerable benefit to the lead stallion, who is not tired out by as many duels and pursuits, can stay closer to his mares and has time to feed and rest. Moreover, a harem guarded by two stallions (a multi-male harem) is better protected against followers and predators. If the young stallion wisely accepts a subordinate role, he also enjoys some advantages. The lead stallion will tolerate his pairing with the younger mares in the group or with visiting fillies. In the long run, chances are also good that he will inherit the harem.

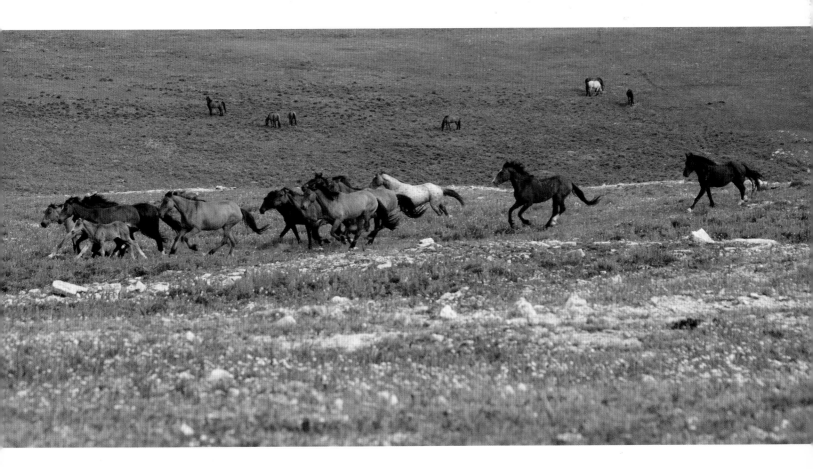

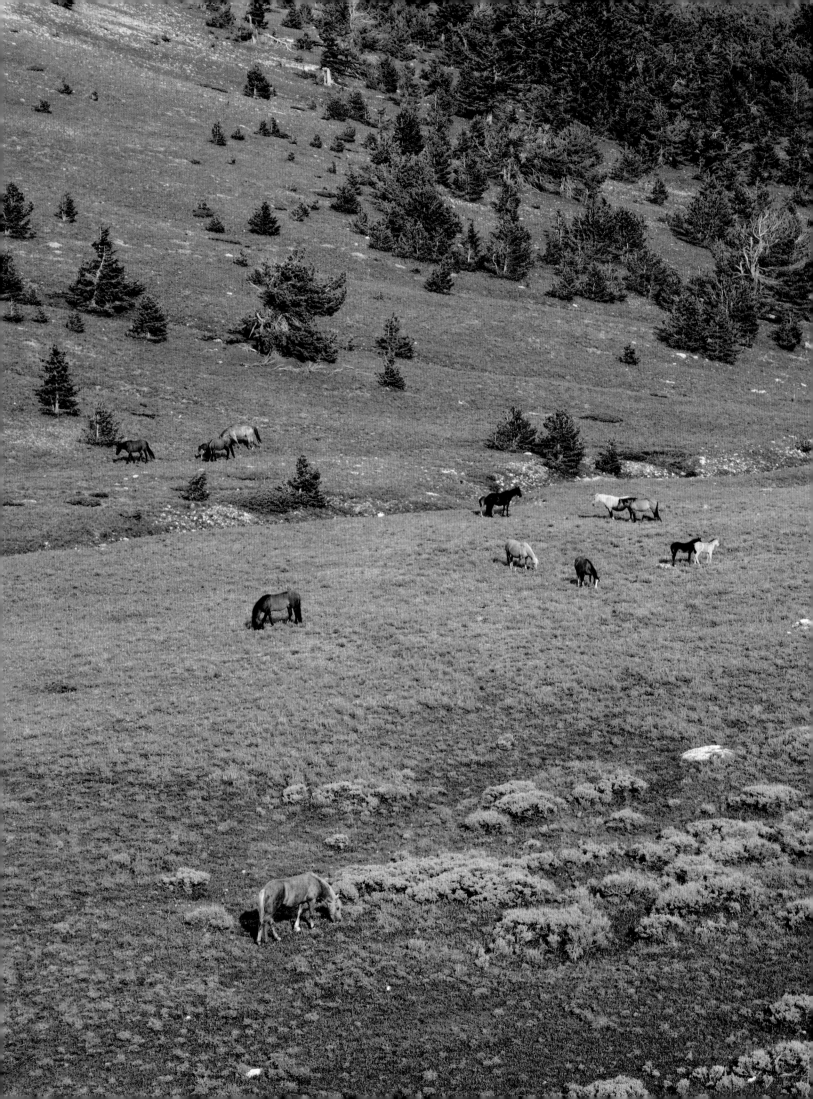

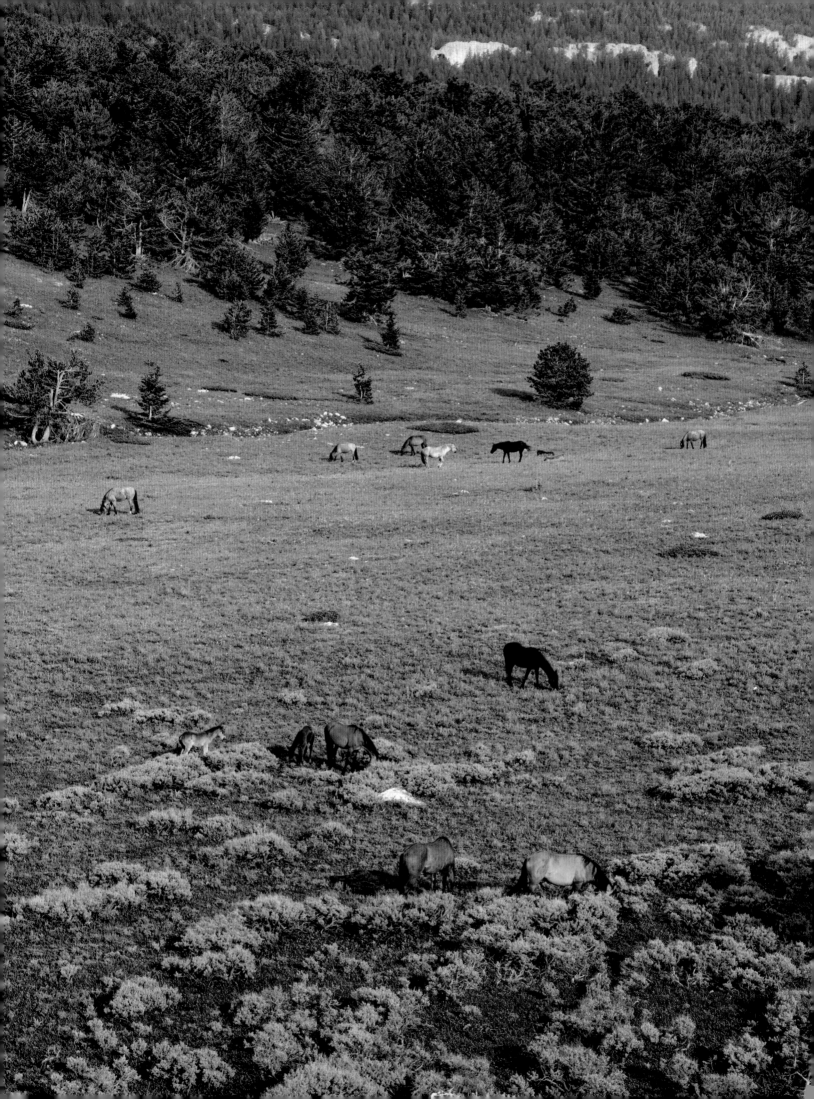

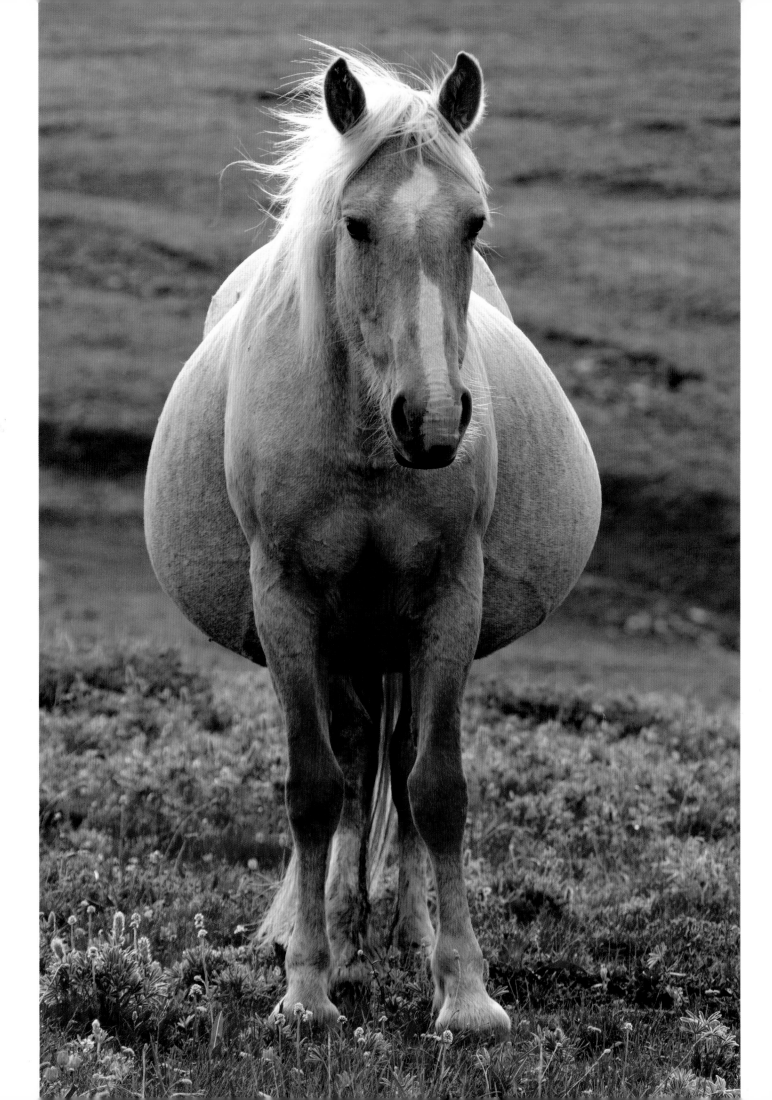

A week before giving birth, Yakima (the lead mare of Geronimo's harem) displays a considerable girth. The birth of Chippewa, her foal, will occur during the night, at the edge of the harem. While awaiting birth, pregnant mares indulge in relaxing naps in the warmth of the springtime sun.

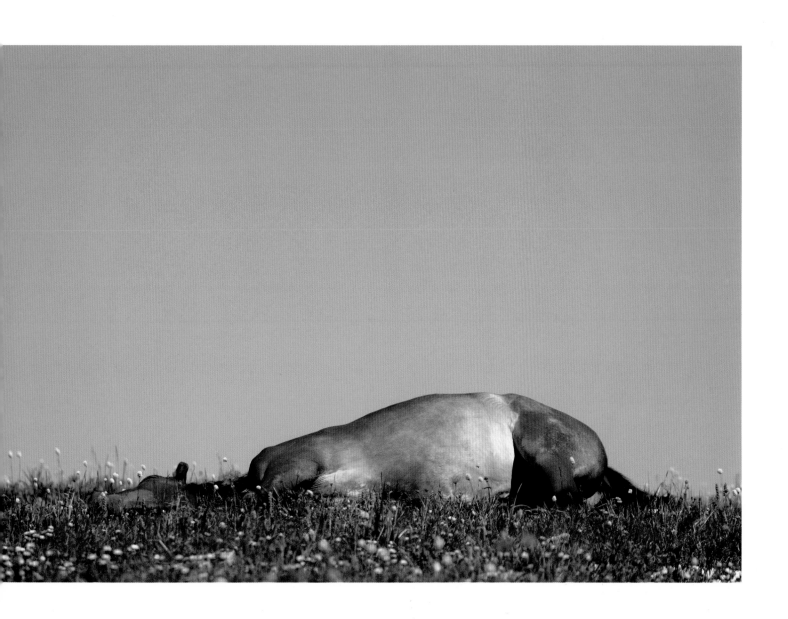

Chippewa's First Day

With startled eyes, a long, thin muzzle, and a prominent blaze on a roan coat, Chippewa has arrived. He is the son of Yakima, the lead mare, and of Geronimo, one of the herd's most dominant stallions.

On this June dawn, the first rays of sunshine bathe the freshly grown prairie grasses, just barely free of snow. Spring, which arrives late at this altitude, has begun to paint a few light green colors among the masses of white American firs, which hang onto the slopes, forming tight rows. In this sparkling environment, a gentle breeze wafts up from the valley below carrying with it scents of sagebrush and juniper.

At six o'clock in the morning, Chippewa stays close by Yakima's flanks and traces all his footsteps under her teats. His walk is already quite synchronized. Very taken by the newborn, the two young harem half-brothers (which are the spitting image of one another) try to nudge and sniff him. Chausette, the hardier of the two, approaches a resting Yakima and lifts a foreleg to her neck. She immediately gets up, causing the troublemaker to retreat. While she is up, the "twins" again approach her, as if attracted to a giant magnet. The new mother is content to extend her neck, mimicking a menacing posture. After about 10 minutes or so, she will again nurse Chippewa and, visibly spent, stretch out one more time. Throughout the morning, feedings will occur at intervals of 10 to 20 minutes, alternating with periods of rest. The length of feedings varies considerably, from a few seconds to several minutes.

Chausette attempts a different approach five or six times. Once he was rebuffed a bit roughly by Yakima. He does, however, succeed in sniffing the mare's teats without actually having the nerve to nurse.

3:15 p.m. Chausette nibbles Chippewa's ears and sniffs his genitals. The foal wakes up and stretches. The "twins" want to engage him in horseplay. Yakima stretches her neck while pushing her ears back, displaying incredible tolerance toward them.

4:05 p.m. As if spring-loaded, Chippewa begins his first gallops as a young mustang by running circles around his mother. When all is calm, the maximum distance between mother and offspring is never more than 10 feet (3 m). At each awakening of her offspring, Yakima calls him to move a few steps before giving him the go-ahead to nurse, while at the same time lifting her hind leg to facilitate the process and remaining completely still. Sated and exhausted from his first escapades, Chippewa is quick to lie down to rest on the warm grass. Yakima stays close by. She grazes close to his sleeping little body while waiting for him to awaken. Other members of the harem must be patient and have little choice but to graze close by. All efforts on the part of Geronimo to move his harem are futile as long as Yakima refuses to wake her youngster. Her anterior hooves are firmly planted an inch from the sleeping foal, and she presents her posterior to the stallion. Wisely, he does not pursue the matter.

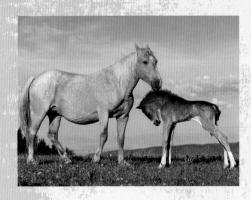 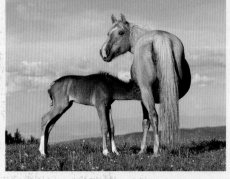 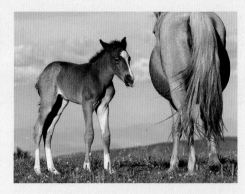

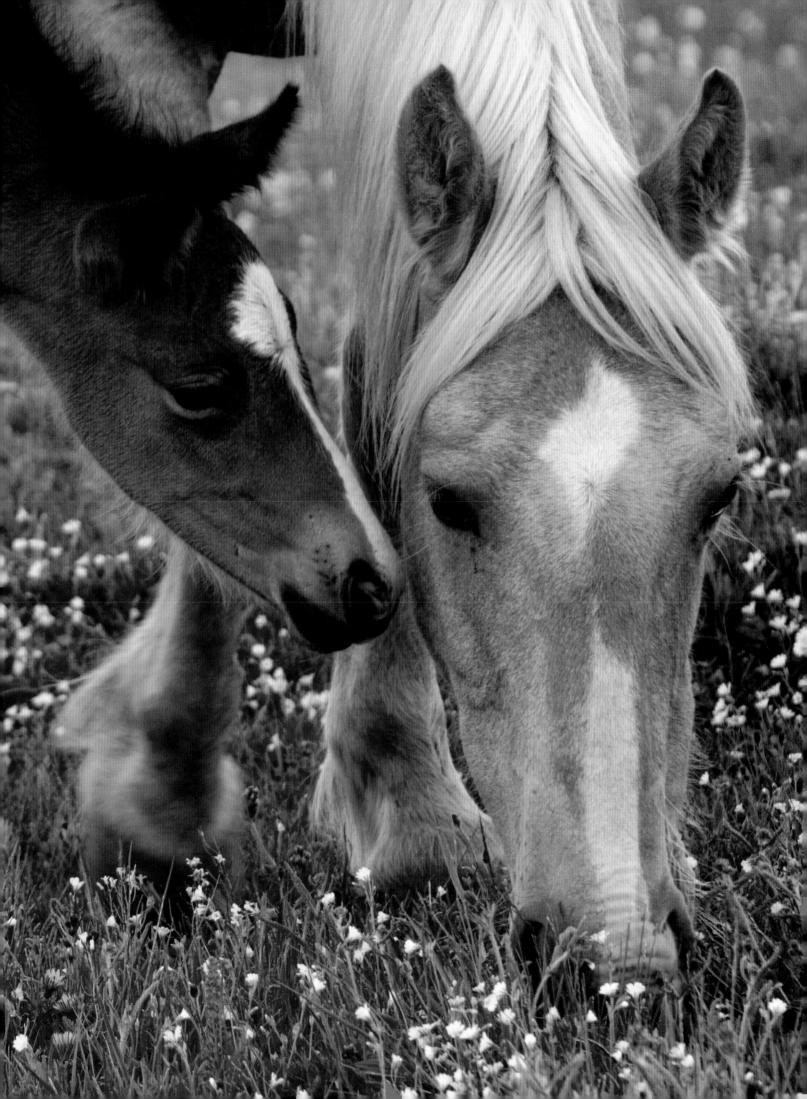

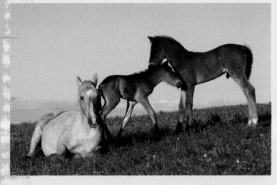

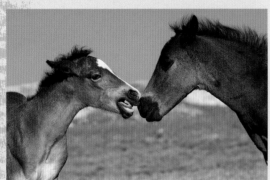

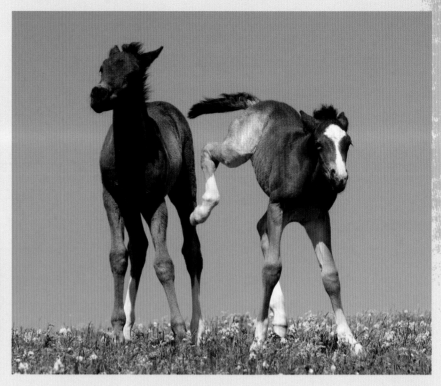

6:22 p.m. After having quenched her thirst, Yakima decides to move to another pasture. A large fallen tree limb blocks the newborn's way. Chippewa approaches this unknown object while rocking his neck up and down. The mare notes her foal's reaction. While softly whinnying to encourage him to follow, she climbs over the branch and continues to urge him on. Chippewa jumps clumsily over the obstacle and arrives safely on the other side.

8:28 p.m. A wapiti has just left the edge of the group's perimeter, a few hundred feet from the harem. Not very common at this altitude, this ungulate is unknown to horses. Yakima is in a state of high alert and blows loudly through her nose. In a split second, she's off at a gallop with Chippewa close by and the rest of the group following.

8:50 p.m. Calm once again, the mustangs graze in the lupines while the "twins" attempt to race and shove one another, their black silhouettes outlined against the last lights of sunset — from pale pinks to mauves and flamboyant reds. Slowly, as time goes by, the colors of the horses fade and their body contours dissolve.

The following day, the proximity of other harems does not bother Yakima, though she still prefers to stay at the edge of the group. The mare and her foal are much more active than the night before. Chippewa now positions himself correctly for nursing: he keeps at an oblique angle to his mother's flank. By the third day, the distance between the mare and her foal is close to 15 feet (5 m). Yakima, however, has a hard time keeping track of her offspring, who constantly extends the length of his gallops. Bounding, twirling, fast starts and rearing … Chippewa readily gives free rein to his youthful exuberance. Three days after giving birth, Yakima no longer rebuffs Geronimo's advances. At once intimidated and intrigued, the foal does not cease in his romping and frolicking.

And so begins the life of Chippewa, the young mustang.

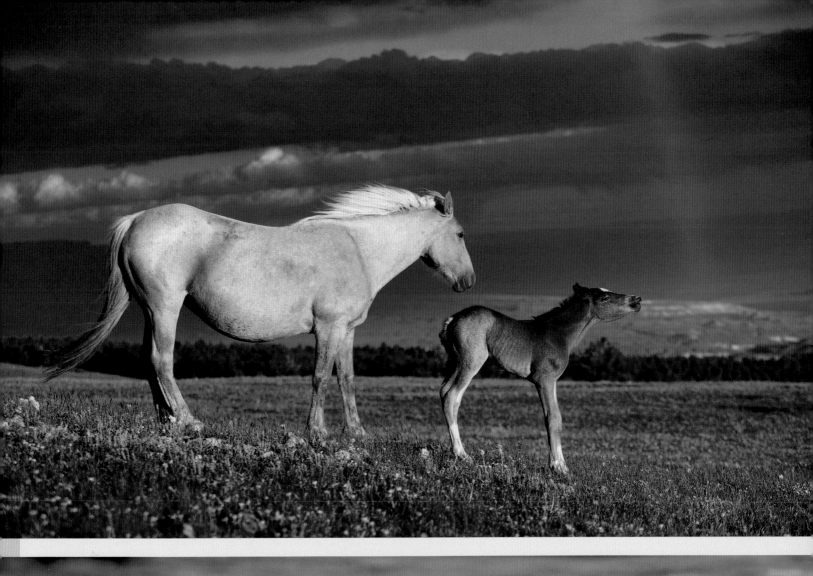

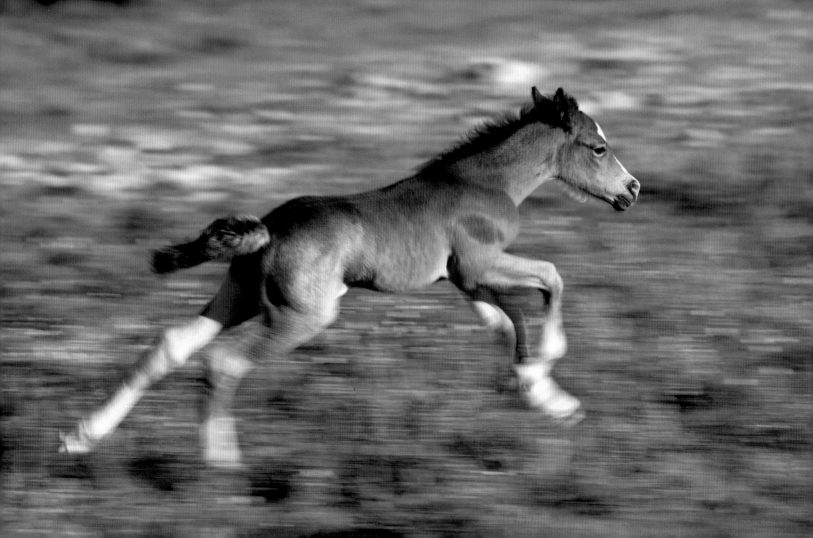

Sprinting gallops, a youngster's jumps, breathtaking turns, rearing and kicks … Both sudden and unpredictable, these foals' games reach an extraordinary intensity during the first summer to the point of being a true challenge for photographers to capture.

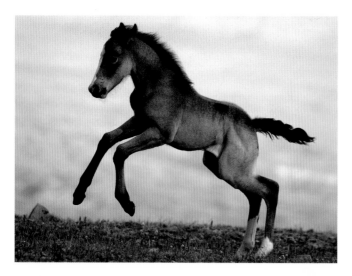

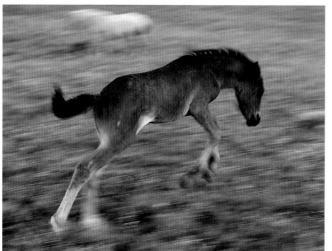

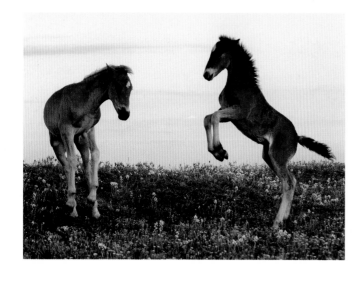

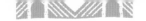

During the first four weeks, the foal is entirely dependent on his mother, who not only needs to feed him but who is also his first social partner. The foals nibbles at his mother, shoves her, bites her ears … The physical contact with his mother gives the foal a sense of well-being and security, which contribute to his development.

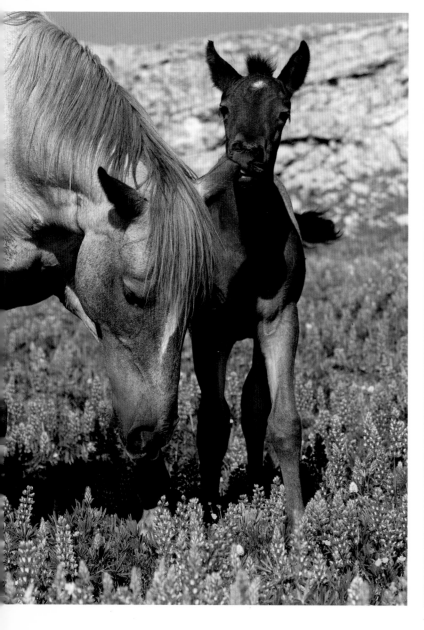

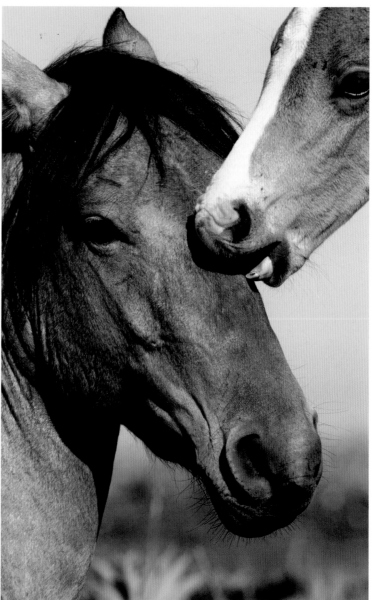

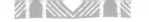

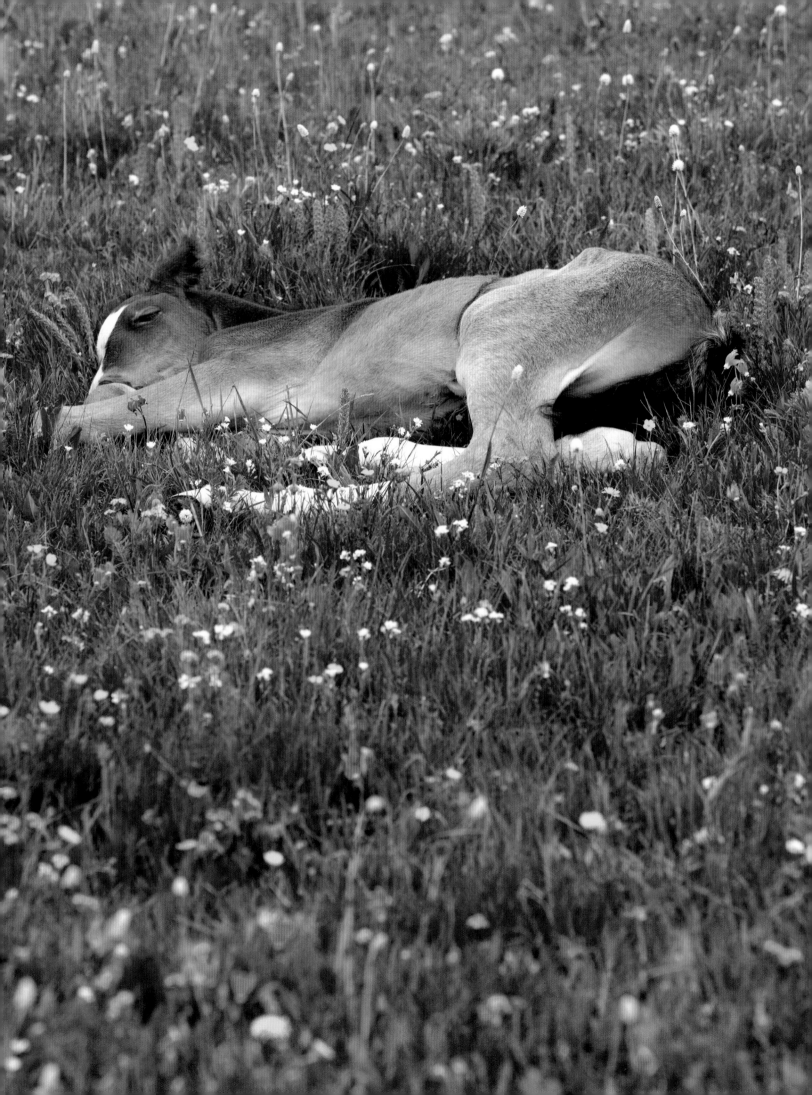

The life of the foal is full of discoveries, emotions and physical exertion. To recover from this, nothing beats a good nap on a large flower bed. However, when the stallion suddenly moves his harem to distance his fillies from a rival, the awakening is almost too chaotic.

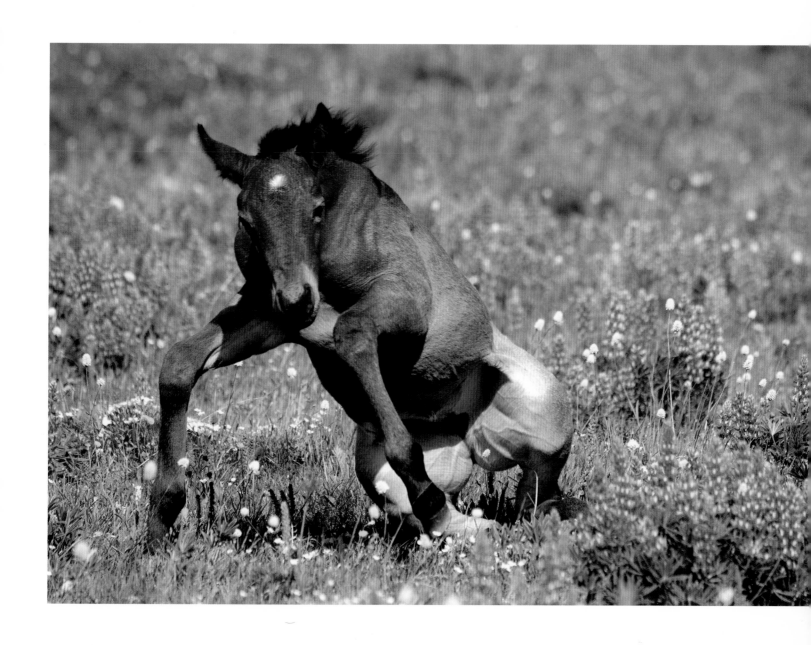

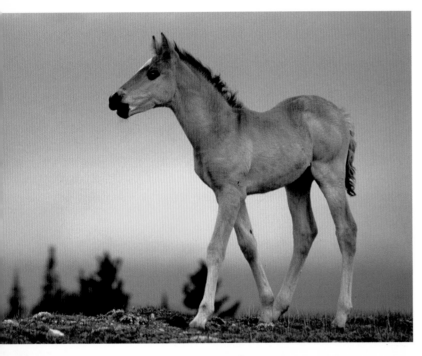

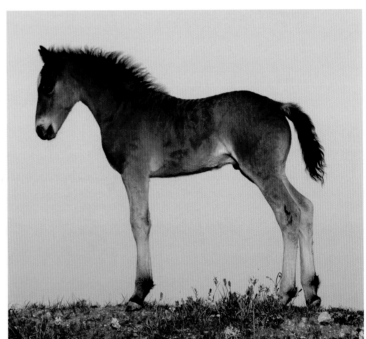

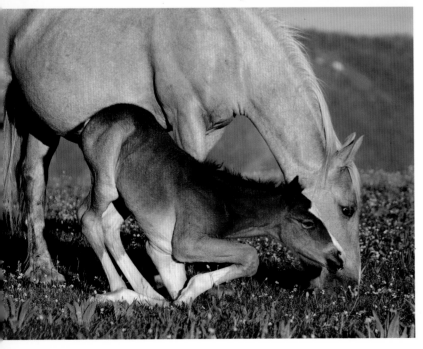

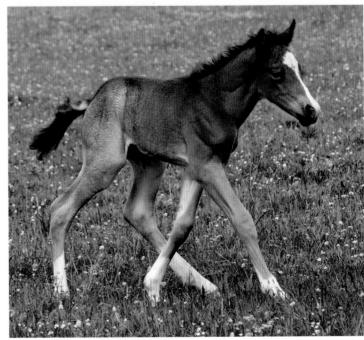

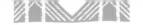

Though the foal may have a small body, its legs already measure 90 percent of their final length. A mere few hours after its birth, it is therefore able to escape quickly with the harem in case of danger. If the coordination of its four limbs sometimes poses a problem, notably during the first week, it quickly learns how to make good use of them without losing its balance. So scratching her temple becomes an easy gymnastic activity for this young female.

When approaching his mother, the stallion, an older foal or any strange, older horse, the foal repeatedly opens and closes its mouth — a behavior known as teeth clapping or champing. This chewing motion, always directed toward an older individual, is generally viewed as a submissive behavior or an act of appeasement. And it is not reserved only to foals. We regularly observed a young four-year-old stallion champing in the face of the harem's stallion.

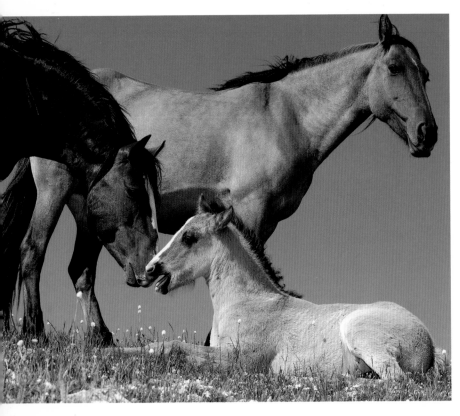

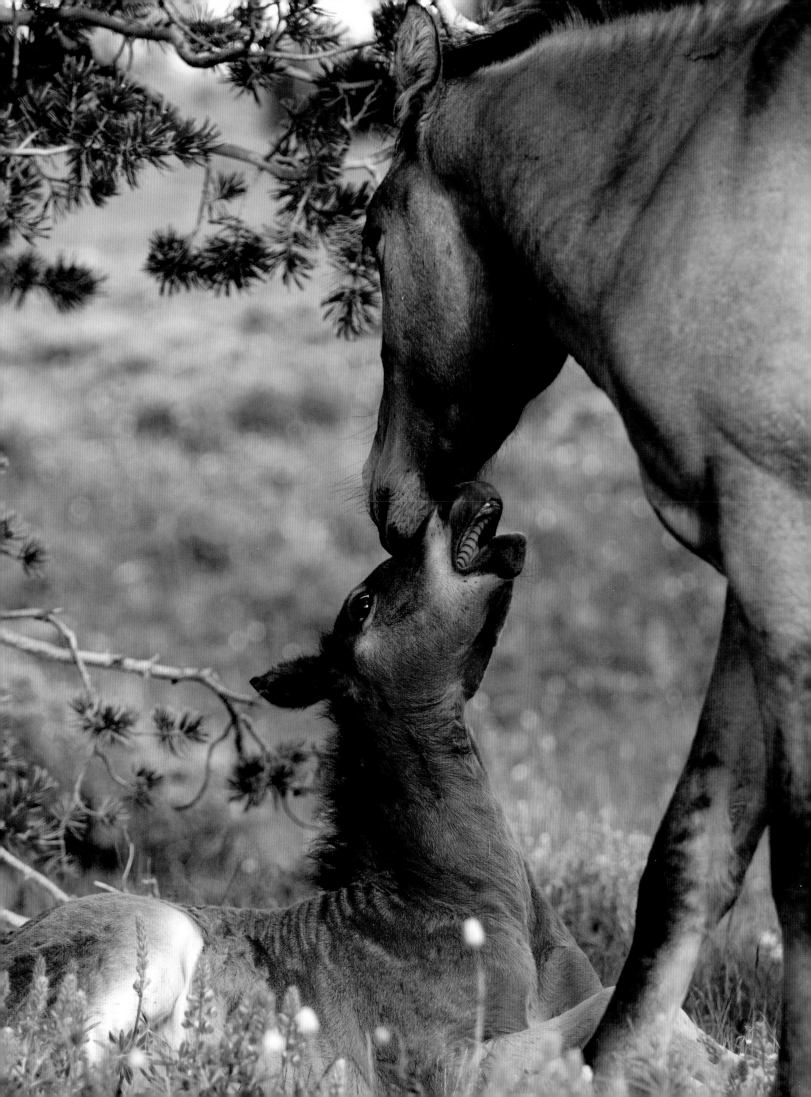

In the day-to-day life of a foal, everything is a new discovery — an accelerated form of apprenticeship tightly linked to survival. From mouth to hooves, the foal explores its environment, appreciating the prickliness of pine needles, the feel of wood or the taste of lichen. When it comes to arnica flowers, they do seem to taste better on the other side of the tree trunk!

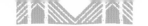

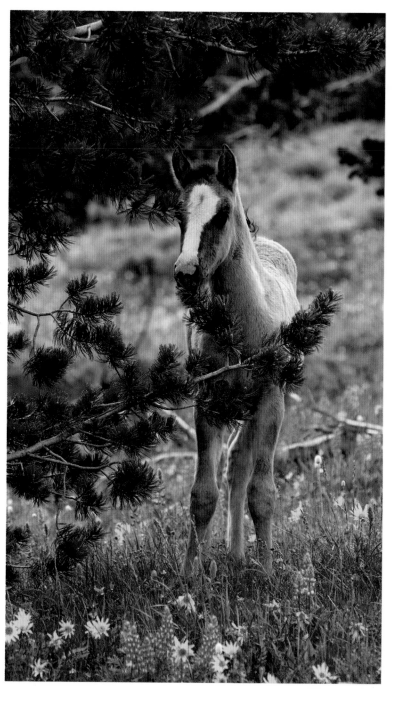

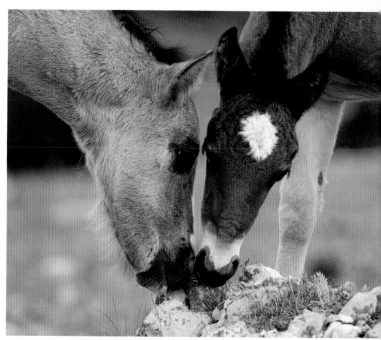

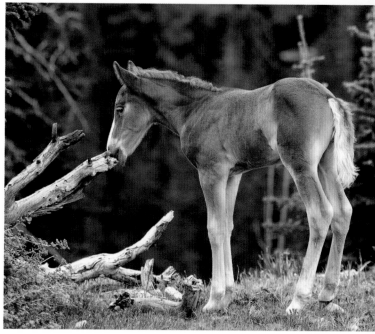

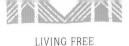

While the filly, bitten and roughhoused by her offspring, displays a maternal tolerance and is content to lift her leg as a warning, we were often surprised by the benevolence of certain stallions. It is not rare to witness their positive response to the grooming needs of their foals and that they allow their manes and tails to be yanked without showing irritation. On the other hand, this resting stallion does not wish to be disturbed by his daughter, who is approaching him while chewing.

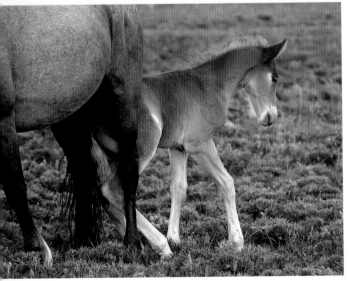

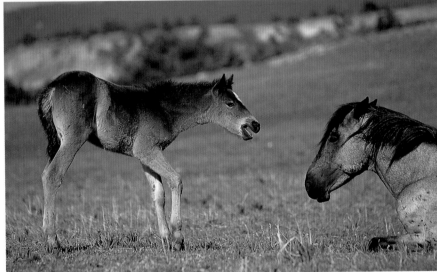

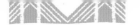

Mutual grooming between foals usually begins at about three or four weeks of age, and acts as a prelude to playtime or a social encounter.

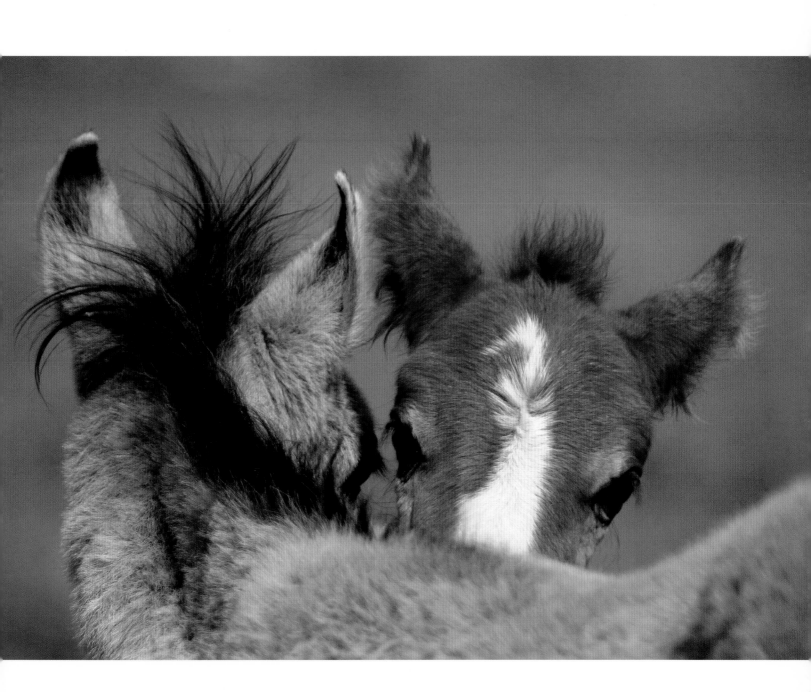

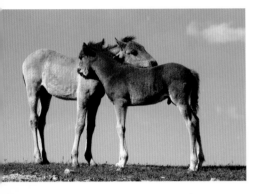 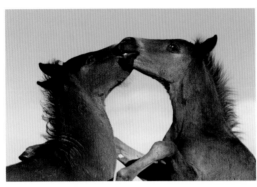 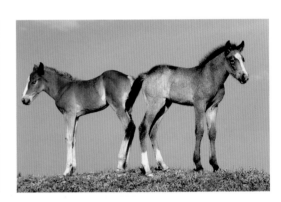

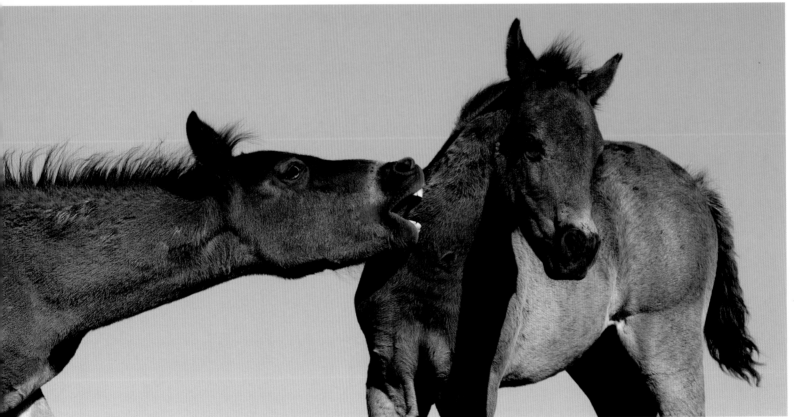

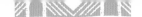

*Perfectly tolerated by the harems after several weeks of our presence, we had the best seats in the house
to observe and follow the foal's development. During their second week of life or even at the end of their
first week, young mustangs begin to participate in social game-playing. At once turbulent and audacious,
these mini-stallions sniff and bite one another while attempting to pinch each other's legs. These exercises,
repeated constantly, are not insignificant. They are an imitation of the fighting skills seen in adult males.*

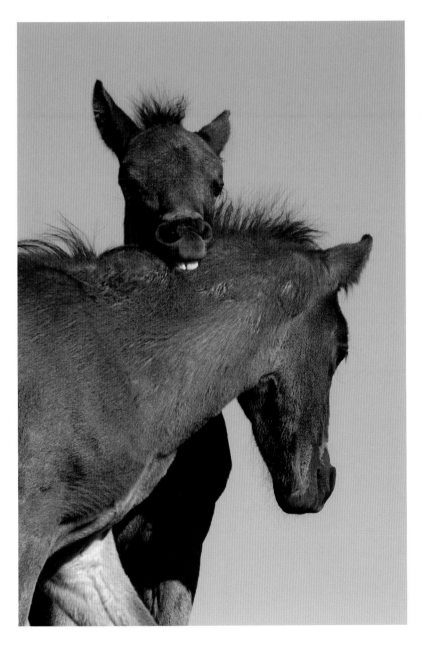

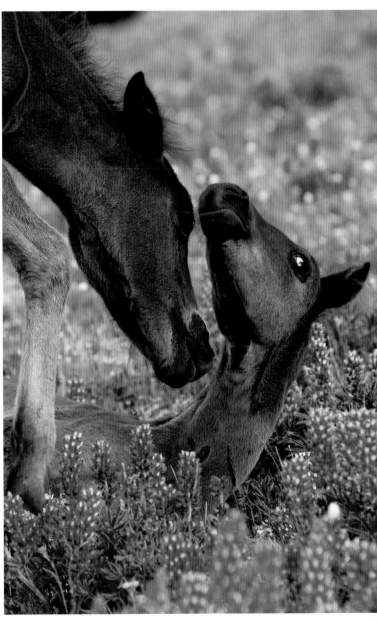

The Story of Little Gray

June 4. Leftover snowdrifts, the growth of grasses during the night … The mountain slowly rids itself of the signs of winter. After several rainy days, the clouds have dissipated. Little Gray is born on this morning. From the outset he appears weak, but soon becomes lively. Either by luck of the draw or by a physical deficiency, certain foals appear less well equipped to deal with life, and Little Gray, from Geronimo's harem, appears to be one of them.

June 10. Just when we are delighted to see Little Gray gain some strength, a disagreement erupts suddenly and violently between several harems. While Geronimo is busy chasing a rival, a black bachelor kidnaps one of his mares. The stallion immediately jumps in to recover his mare and engages in combat with the kidnapper. Followed by her victorious stallion, the mother manages to reach the safety of her harem. In the confusion, however, Little Gray, her foal, is fixed in place. Distressed and anguished, he whinnies several times. His shaky legs can barely carry him. Geronimo, however, has moved his harem too far, beyond a hill. The foal cannot hear his mother's call. She makes several attempts to rejoin him, but the stallion, bearing witness to the drama, tries to keep his mare close to the harem. Upset by his failure, the black bachelor remains motionless about 50 feet (15 m) from Little Gray, but displays no aggression toward him. In the hope of regaining entry to his own harem, the isolated foal moves toward another harem grazing on a nearby crest. The intimidating mares immediately rebuff the young stranger.

Heavy clouds soon appear in the sky and the wind doubles in strength. Alone in the world, Little Gray is left to fend for himself against wind, rainfall and thunder. The bachelor protects himself from hard falling hail under a lone pine tree. Trembling and soaked to the bones, Little Grey follows him and collapses at his side. Soon the storm passes, though the sky remains cloudy, and when nightfall approaches, the foal is still separated from his mother. Without her, his chance for survival is jeopardized. To our amazement, the bachelor is gently pushing Little Gray in front of him. This strange duo follows the length of the valley for a few hundred feet, then moves in the direction of a crest, behind which is Geronimo's harem. Perceiving his rival, the bachelor nimbly separates from Little Gray and returns to the valley, leaving the foal behind. Geronimo rapidly returns Little Gray to the harem. His sufferings done with, the foal proceeds to nurse. The warm milk and the presence of his mother are of great comfort.

The incident did not last longer than two hours. However, the separation was visibly traumatic. After this mishap, all of the foal's liveliness seems to have evaporated. He walks with his head hung low, glassy-eyed, ignoring the horseplay of other foals and seeks instead to often lie down and sleep. His stomach has ballooned out and he has digestive problems that debilitate him. However, the attempted kidnapping of the mare has made Geronimo irritable; he constantly moves his harem and does not tolerate any wandering. Each time that Little Gray falls asleep, the stallion wakes him and does not hesitate to bite him if he is slow in getting up.

June 18. A week has passed. Little Gray no longer suffers from diarrhea, but he has lost weight and his ribs form a zebra pattern on his flanks. On top of it all, he is limping on his hind leg.

June 25. The foal no longer limps and he appears to have gained weight. At nightfall, he gallops for a few dozen feet and rears up on two occasions. Hope returns.

June 26. Little Gray, carefree and perky, is frolicking in a grove of pine trees. Everything appears to be going very well. However, the harem is once again destabilized, this time by the presence of Chinook, a newly integrated young filly. The dominant mare graces her with a bite on her flank when she passes a bit too close to her. Chinook slips away and quickly overtakes Little Gray who, all excited, follows a few feet behind her. Annoyed, the filly gives him a swift kick, which lands squarely on his side; then he is shoved backward. As best as he can, he gets up, though he now has a noticeable limp. His physical and psychological condition soon deteriorates.

Little Gray died during the following winter.

Yearlings or sub-adults sometimes take care of younger mustangs and participate in their education during playtime. More precocious from a sexual standpoint, this little male chestnut (below) rubs against his one-year-old half-sister and attempts to mount her. Quick and lively, this young foal (left page) coaxes his mother to play.

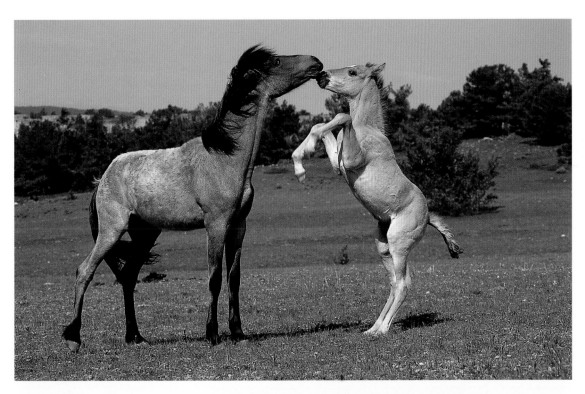

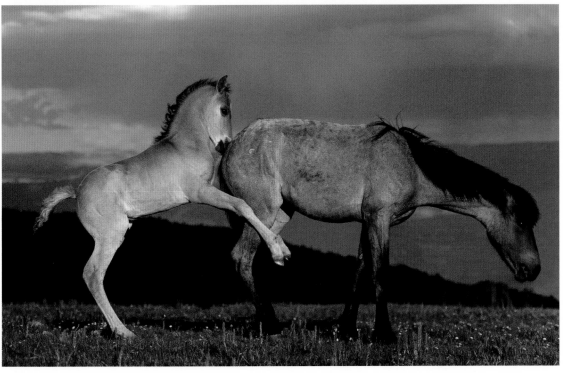

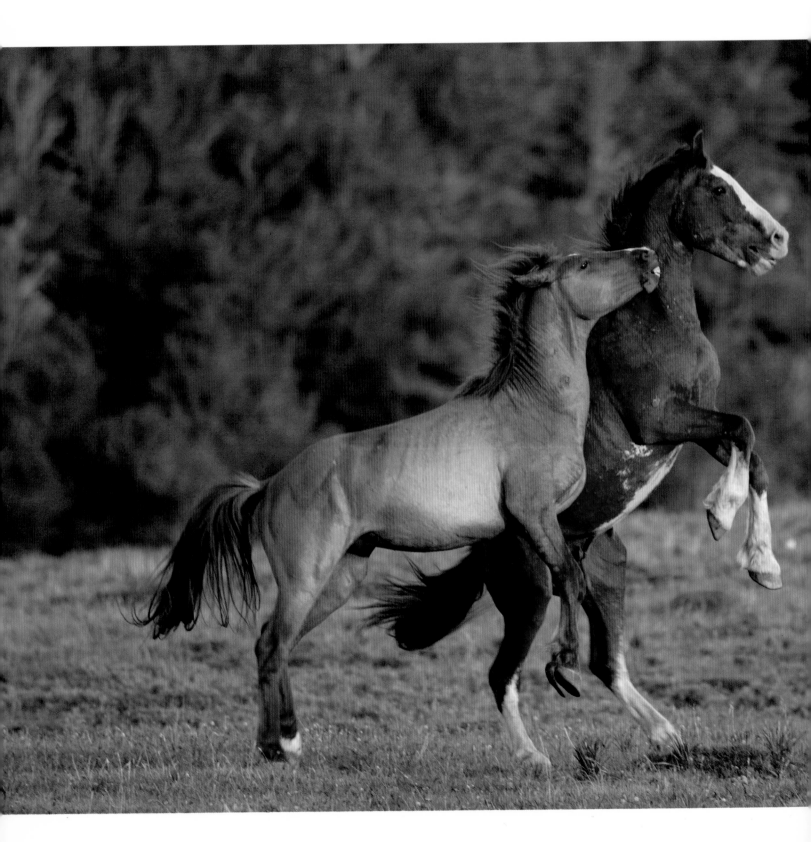

During the passing years, we became fond of Caporal, a 26-year-old stallion who just lost his last filly. A battle brings him in opposition to a four-year-old chestnut stallion — still a bachelor. The slow and controlled contact suggests an absence of aggression. The two stallions take pleasure in their brawling while the novice profits from these encounters to refine his technique for future battles.

The majority of encounters between stallions are parades of intimidation. The rivals meet at a pile of droppings on a hilltop, then defecate so they can gauge one another. A quick exchange of body sniffing punctuated by yelping and eventual rearing, and the two stallions go their separate ways and disappear at a fast gallop. While bachelors prefer to wander freely, harem stallions always return to their mares.

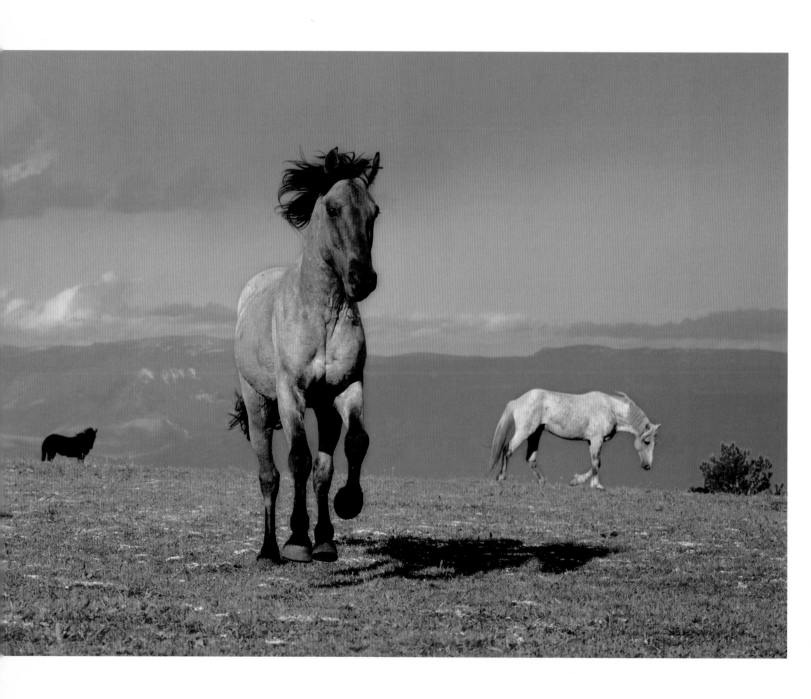

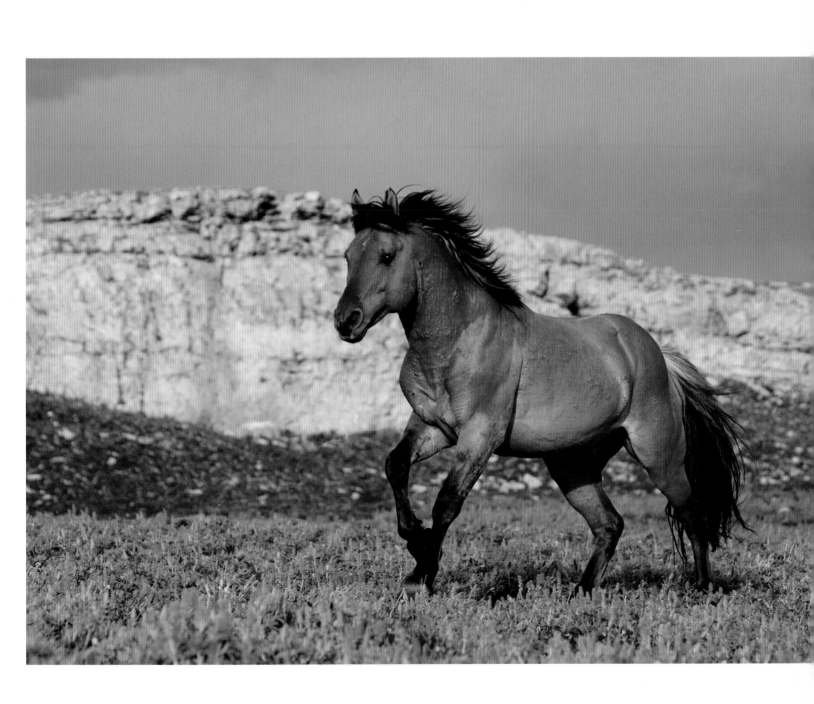

We observed a roan chestnut bachelor who became separated from his band of bachelors meet a two-year-old male palomino that was still living with his family. After some nose-to-nose contact, the roan stallion "engaged" the young male in a friendly game — no sign of any biting or kicking with hooves. In this ballet-like combat, the more experienced bachelor appears to be taking care not to be too injurious or too violent toward his young partner.

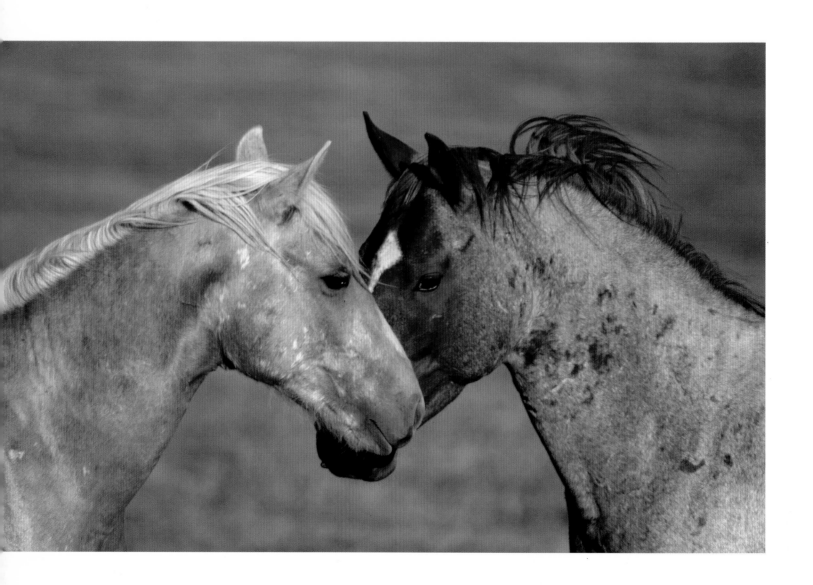

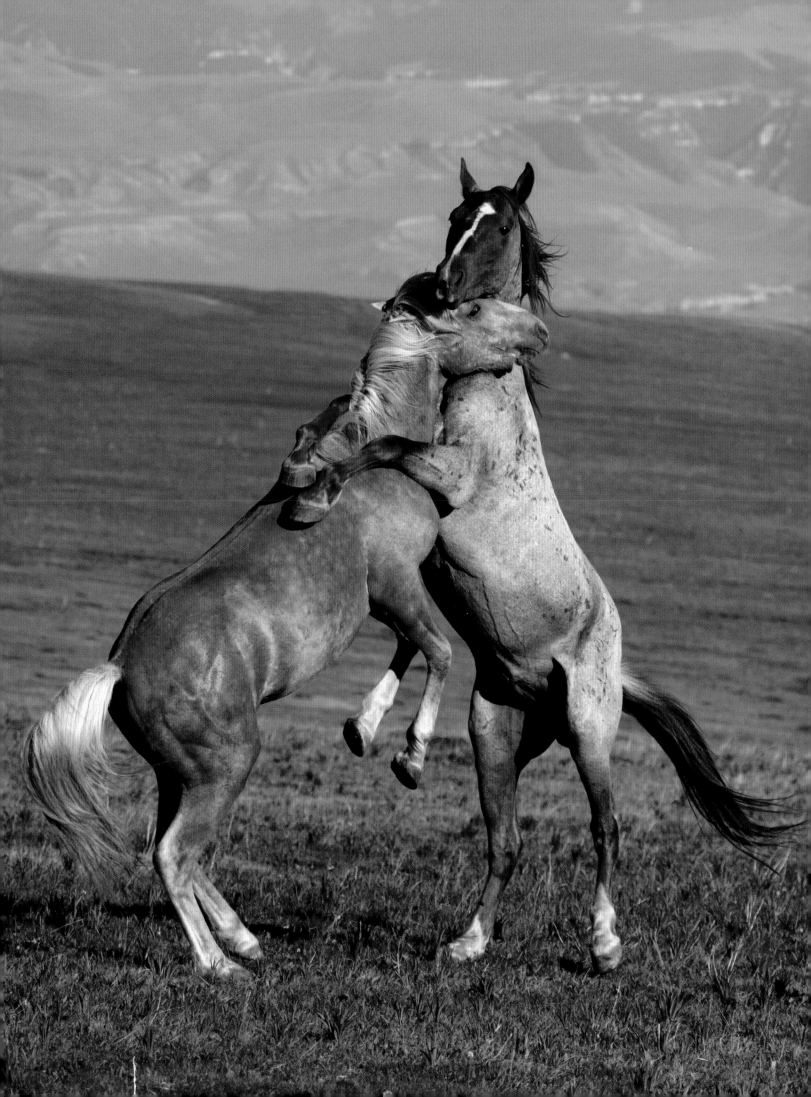

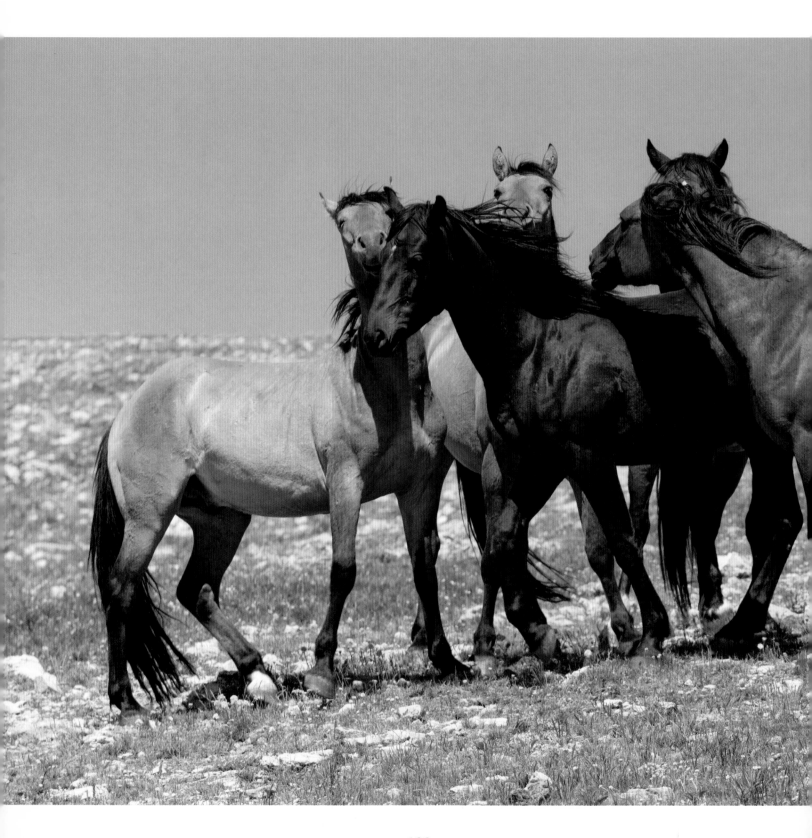

This group of bachelors greets a new "recruit." Sniffed from all sides, and shaken up by the ruckus, the young stallion soon becomes the principal center of attention. Driven either by jealousy or a desire to appropriate, these squabbles will go on for several days. A dominant bachelor will not hesitate to give him a shove from the rear, as if he was one of his mares.

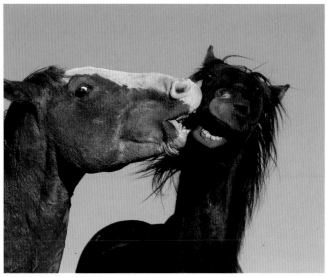

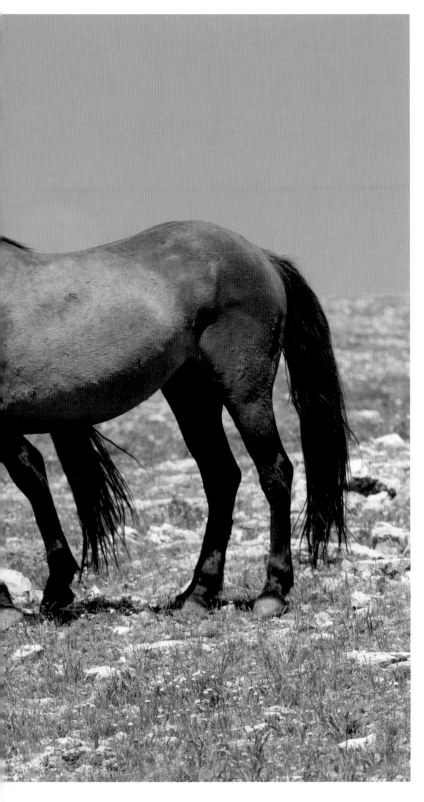

The Black Jacket Gang

During mating season, the reaction of a harem stallion to the presence of a band of bachelors is unmistakable and instantaneous. Wherever they may be, these troublemakers are never welcomed. Generally, the harem stallion confronts them by galloping forward at high speed. The bachelors can avoid all contact by escaping or join in altercations ranging from simple sniffing, to examining droppings, to a more demonstrative confrontation.

In the Arrowhead mountains of Wyoming, a band of bachelors composed of three black stallions — nicknamed the "Black Jackets" — were in the habit of stopping for a drink of water at a small watering hole, usually at midday. The terrain's topography was in their favor, creating an element of surprise, and the bachelors could create enough of a hullabaloo to draw harem stallions into chasing them off, leaving others behind to corral the unattended mares.

A single such event like this is enough to create a chain reaction that destabilizes seven or eight harems. If a bachelor succeeds in isolating one or more females during the chaos, the mare's unwillingness to follow him generally upsets the game plan and the bachelor often must beat a quick retreat under the threat of one or more harem stallions, still irritated by the disruption.

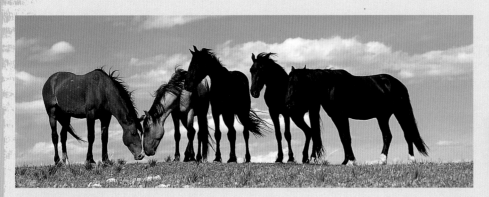
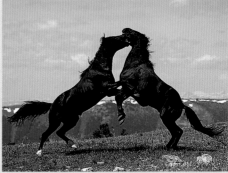
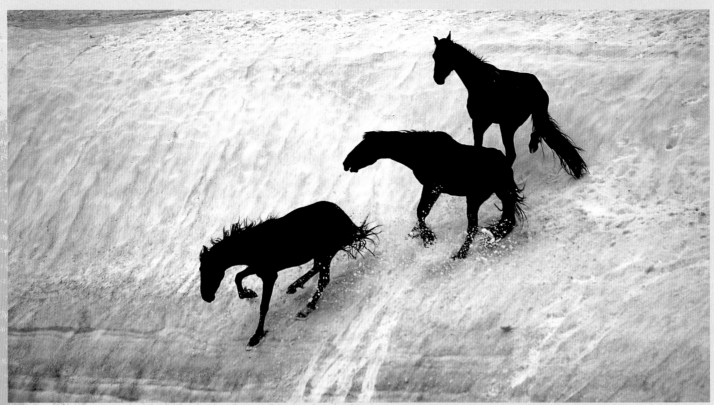

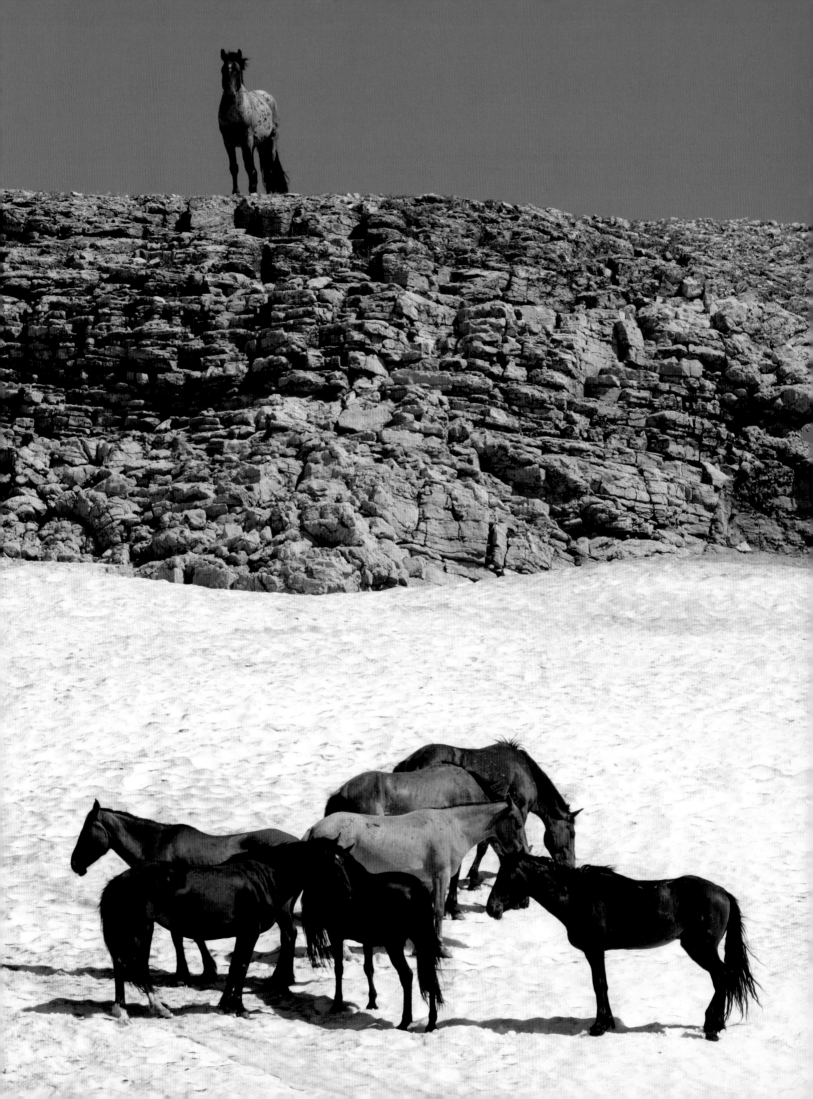

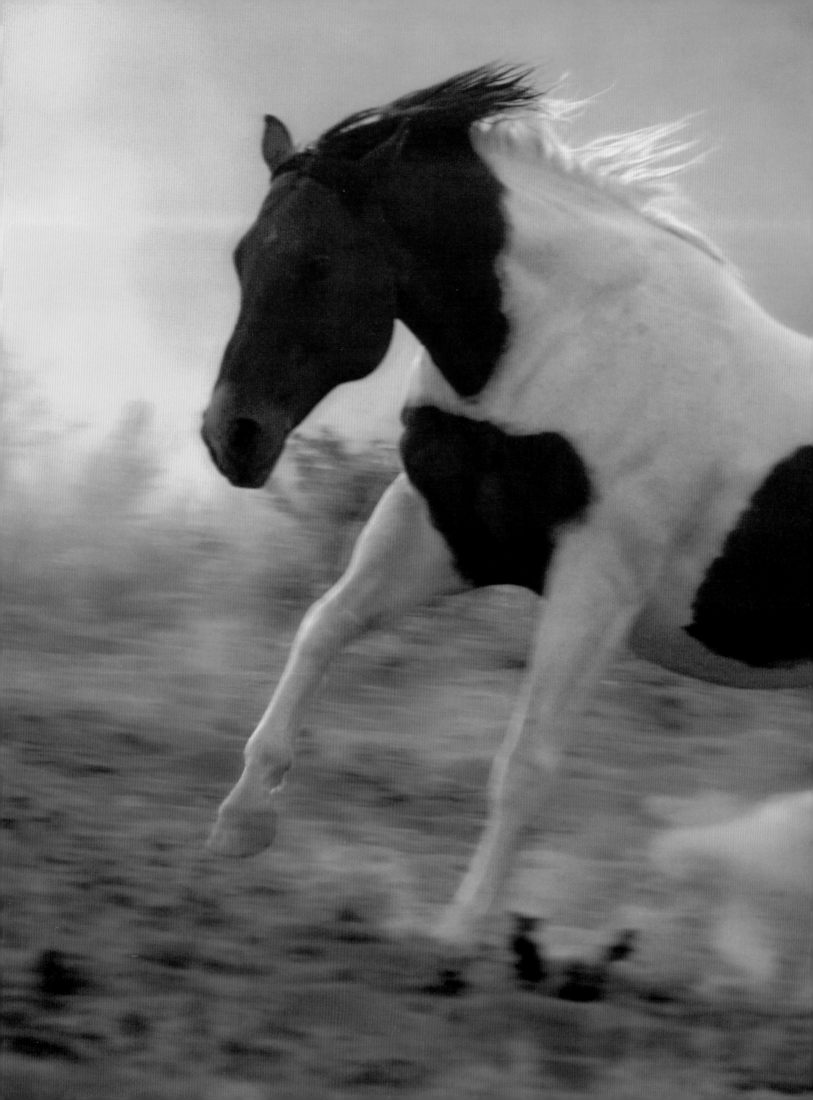

On a sunny July morning, we were privileged to witness a battle, lasting more than 18 minutes, between two three-year-old juveniles. Biting, kneeling and fight-flight followed in an ordered sequence. After having fought to their hearts' content, spent and exhausted the young athletes separated to rejoin their respective groups and quietly resumed their grazing. These games prepare them well for future battles, though they will have to wait another two to three years before even hoping to conquer a mare.

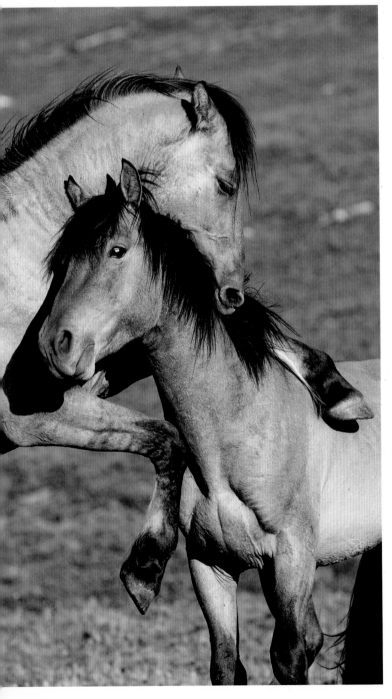

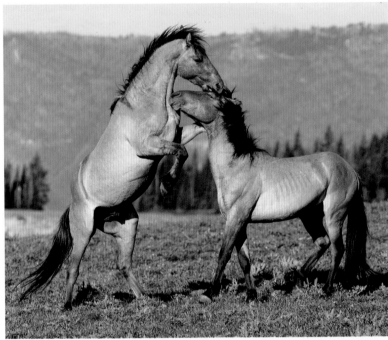

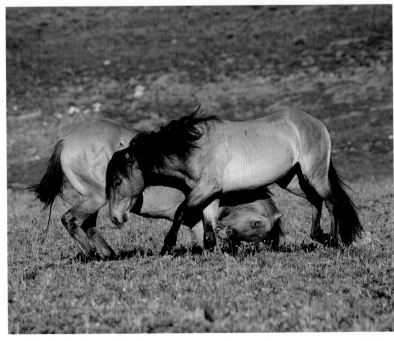

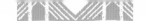

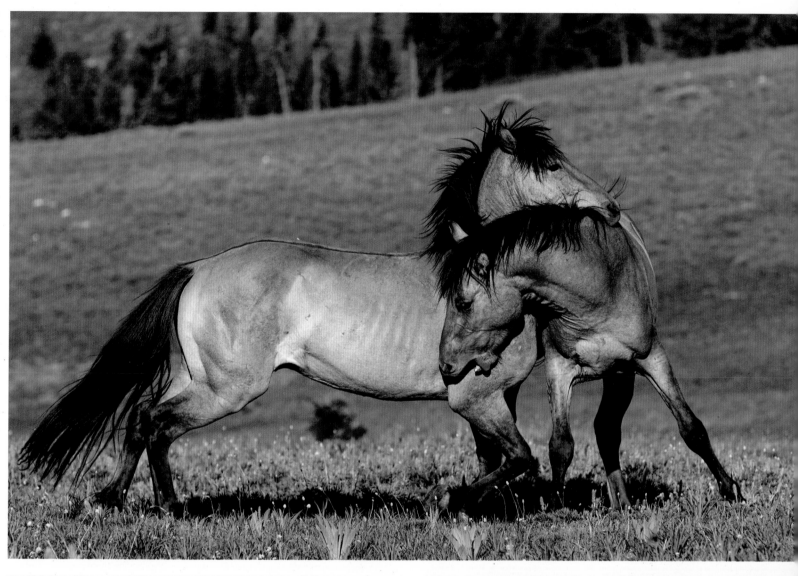

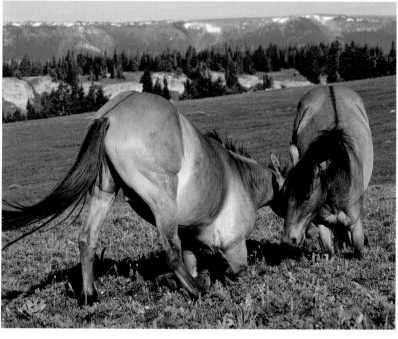

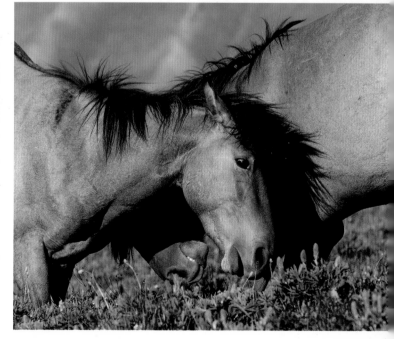

The Times and Trials
of a Maturing Stallion

Fjord, a stocky Spanish mustang, heavily muscled and with a bay dun coat, finally conquered a mare. But having lost her after a few months, he rejoined a group of bachelors.

At five years of age, he had a particularly aggressive temperament and never hesitated to fully throw himself into defying harem stallions much larger than himself. Though he certainly had the required strength to fight them, he never did manage to properly conquer a female.

Certain harem stallions harbored a particular hatred for him and whenever Fjord appeared, they would immediately chase him for long distances. When he was six, Fjord took it upon himself to follow a harem composed of a 23-year-old chestnut stallion, a roan mare and her foals. The young stallion, overflowing with energy, came closer and closer to the harem and the clashes grew in frequency and intensity. Though often quite brief, these battles were extraordinarily violent. The old stallion, larger and sleeker than his rival, was still in tiptop physical condition, blessed with years of experience. At one time he even attempted to shove Fjord to the bottom of a cliff, but in his zeal and with Fjord having guessed his move, he tripped and just barely avoided what may have been a fatal fall. During the entire summer, the two protagonists collected more and more battle scars. By fall, the situation had not improved. The old stallion had not managed to rid himself of his "rival," though the frequency of their run-ins appeared to have lessened.

During the following spring, the old chestnut stallion finally lost the war. At seven years of age, Fjord was leading his wooed mare, who did not appear too happy to be at his side. Not yet able to contain his overflowing energy, the stallion frequently jumped into the fray, often leaving the mare and her foals behind.

One day in June, observing a squabble between bachelors several hundred feet away, Fjord was beside himself with excitement. Frothing at the mouth, his muscles stretched to the extreme, he yelped loudly before joining the melee at full gallop. Upon his return, Geronimo, one of the area's most dominant stallions, had recovered the roan mare and, without hesitation, had mounted her three times. Fjord, clearly not preoccupied with the welfare of his mare, followed another harem along with three other bachelors. The next day, he tried to recover his mare, but she systematically turned to Geronimo. Finally, five days after losing her, the impulsive warrior walked beside his old rival, the now 24-year-old stallion. Thus ended the first tentative efforts by Fjord to form a harem. What an awful lot of energy and time invested to find himself still a bachelor!

Two years later, somewhat sobered, Fjord found himself in the company of two mares, mother and daughter, both being wooed. Having now become a harem stallion as well as a father, he avoided straying too far from his harem.

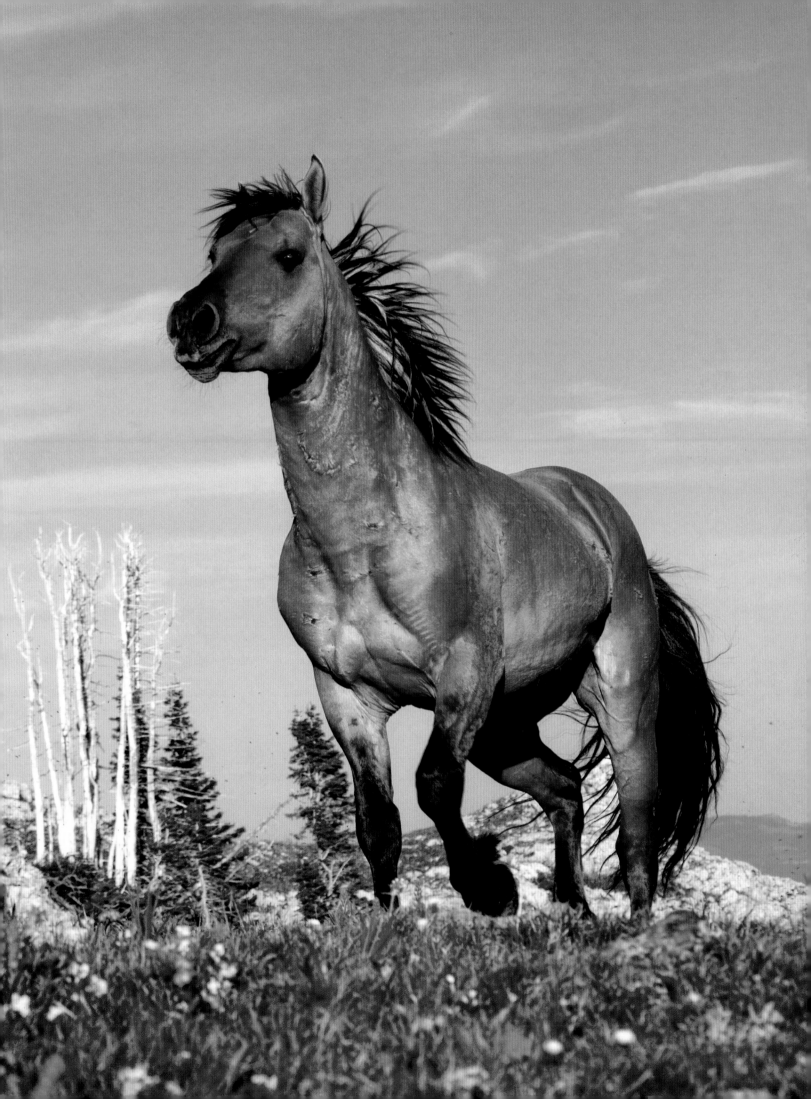

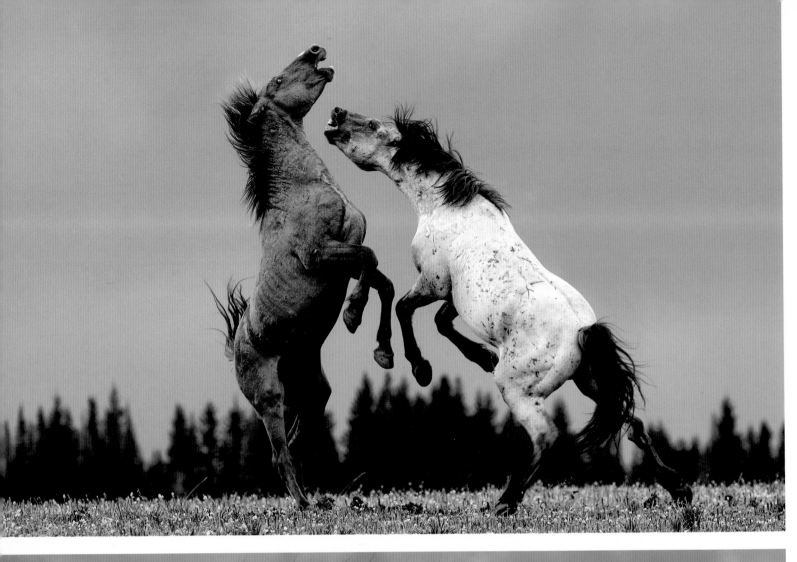

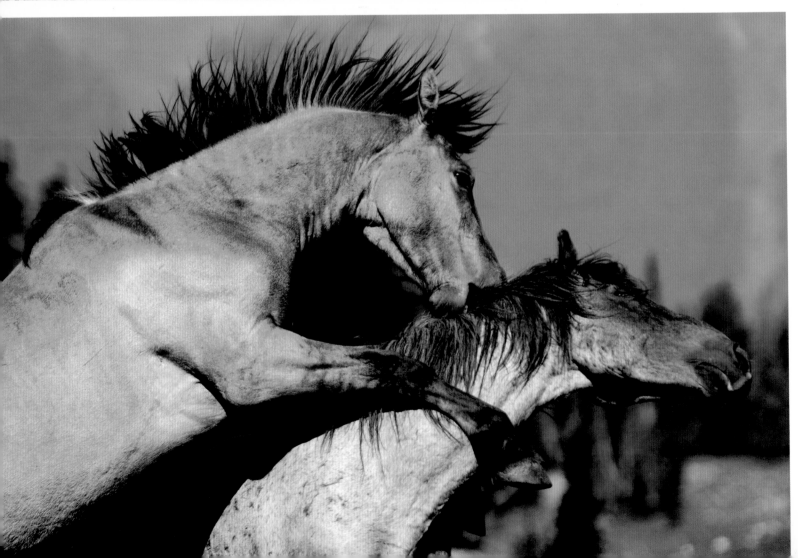

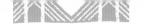

Battles among stallions are the main events during the mustang mating season. From the ritualistic games among bachelors, to trials with elders, to the very serious battles among mature stallions, they are unpredictable and can happen at the spur of the moment.

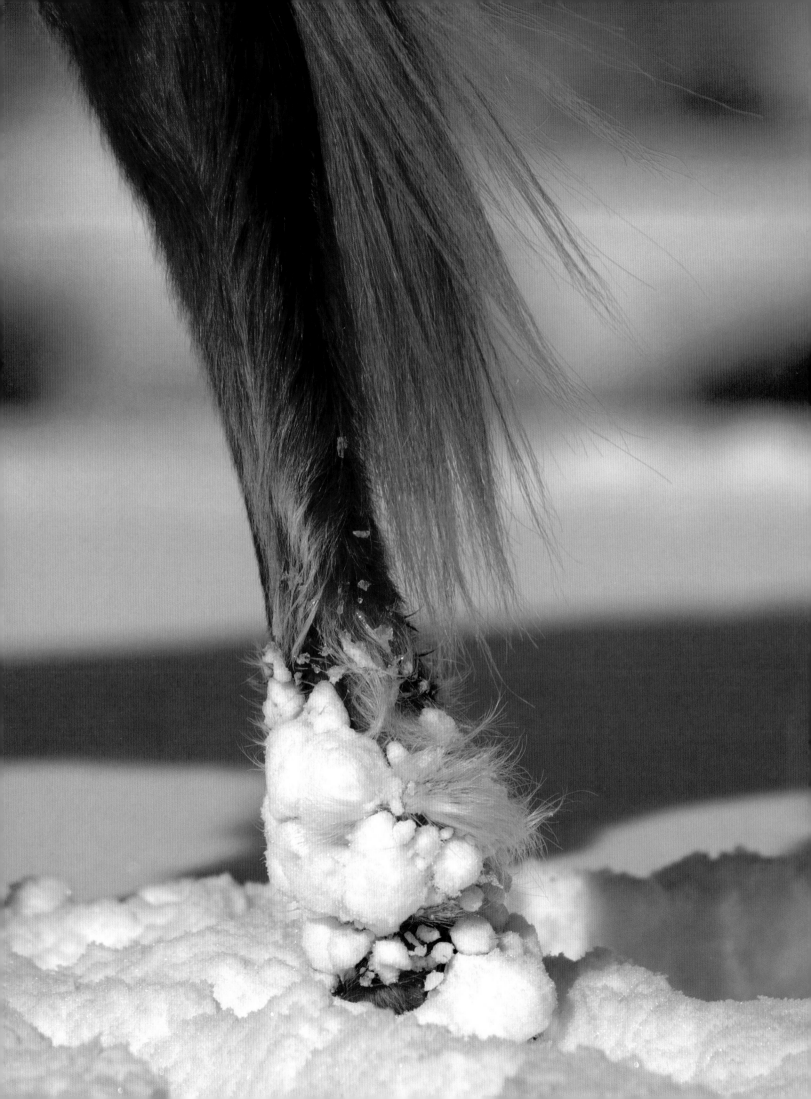

The Life of a Horse

The Colors of Land and Sun

Mustang coats display a wide palette of colors. Distinctive characteristics, — including coats with white patches, long stripes, blazes and other head markings, scars as well as the outline of a mane — allow you to distinguish between individual horses and recognize them from a distance.

Thanks to genetics, the basic coat colors of most mustangs are brown, chestnut and black. Among the Plains peoples, notably the Blackfoot and Comanche, pinto and appaloosa horses were prized because of their distinctive markings, which held a great deal of symbolic significance. Unfortunately today, the number of pintos and appaloosas is much reduced.

EVEN-COLORED COATS

The most common coat color is bay (brown body hair with black "points" — mane, tail and lower legs), followed by chestnut (both hair and points), and black. Shades of bay and chestnut cover a range from light to dark brown, to mahogany, caramel and copper tones. Uniformly colored mustangs were often derived from U.S. cavalry horses and purebreds, while gray shades trace their heritage to the Arabian, Andalusian and Percheron breeds.

The Spanish mustang is unusual due to its more basic coat colors, including bay dun and grullo (mouse gray), accented with leg stripes, a dorsal ray and sometimes even a cross stripe. Their coats can also be buckskin (yellow coat with black points) and dun, which can be yellow but also a clear chestnut shade; dark brown with bright leg stripes and zebra stripes.

Very attractive, palominos have golden yellow coats with a white or flaxen mane and tail. An even lighter shade of this horse is a pale cream color with blue eyes, known as a cremello. Finally, roans have a mix of white hair in their basic bay, chestnut or black coats, resulting in either a blue roan (mixed black and white hair) or a red roan coat (mixed bay or chestnut and white hair).

PATCHWORK COATS

The wild pinto, which most people view as the quintessential Native American pony, is now found only in a few regions. The name "pinto" is derived from the Spanish term for "painted." Pintos have basic black or dark colored coats with large white patterns, and are divided into black pintos, chestnut pintos, palomino pintos, dun pintos, and so on. Several distinct patterns exist, the most common being tobiano and overo, which are determined by the distribution of white patches. Tobiano is the most widespread coat pattern among pintos, with very regular, almost vertical patches over the back and down to the flanks and buttocks, as if a bucket of paint had been poured over the horse. The pinto's head and chest are usually colored, while its legs are almost always white. The mane and tail are bicolored.

The overo pinto is less common. It is covered with generally horizontally-oriented white patches that have a highly irregular outline and which rarely extend along the dorsal line of the horse. The head is mostly white, and it often has blue eyes and irregularly colored legs and feet. Much prized among Native Americans even today, the now rare "Medicine Hat" is still used on ceremonial occasions. These piebald horses have very distinct patches: one around the ears and top of the head (known as its "war bonnet"), monocle-like circles around its eyes, as well as patches on its chest, along its sides and at the base of the tail (its "shield"). These horses were thought to possess supernatural powers rendering them invincible to arrows and bullets — powers also transferred to their riders. Owning a sacred horse like this was a privilege usually reserved for warriors, chiefs and medicine men.

Some pinto mustangs exhibit another color variety: the sabino. This is characterized by white legs to just above the knee and shin (as if the horse was wearing knee-high stockings). The head, including its nose and mouth, is covered by a large patch of white, and the belly and sides are covered with irregular white spots, with prominently indented edges. This type of coat is reminiscent of Argentinian criollo horses, which, like mustangs, are the descendants of colonial horses brought to the Americas in the 16th century.

APPALOOSAS: SPECKLED HORSES

The appaloosa mustang is distinguished by its speckled coat. Some of these horses seem to carry a spotted blanket on their backs and hips, while others are splattered with dark spots over the entire body (leopard spots). A variant of the latter, called a snowflake pattern, consists of light spots with white tips against a dark background. Another variety recalls a cape or a white cover (snowcap) thrown over the horse's back and rump. The marble coat is ruddy in color but infused with white, giving a frosty or "icing sugar" look to the back and sides of this dark horse.

Although similarly coated breeds occur in other parts of Europe and Asia, we must emphasize that the appaloosa mustang is the signature horse of the Nez Perce peoples of Idaho, who developed it during the 18th century. The breed's name is derived from the Palouse River, which runs through the rolling hills of Washington and Idaho. Much sought after by neighboring tribes, these horses served as a form of currency and contributed to the economic and cultural development of the Nez Perce. Unfortunately, today the original appaloosa is gone. The 1,100 horses that survived the flight of Chief Joseph and his band to Canada in 1877 were seized by General Howard as spoils of war, who ordered them slaughtered or sold, resulting in the rapid loss of this unique line of horses. Only the remnants of their coats persist genetically within the American appaloosa breed today — a Western workhorse derived from quarter horse, purebred and Arabian lineages. The Nez Perce band is currently trying to reconstitute this emblematic breed, called the Nez Perce horse, by cross-breeding appaloosas with the Central Asian Akhal-Teke.

More intrigued than fearful, this group of mustangs, consisting of a chestnut, a bay and two tobianos, slowly moved toward us.

The Horse and its Environment

Like all living creatures, the horse perceives its environment through its senses. The information obtained is then assessed to allow the horse to react to the situation. As a social animal, a horse is equally adept at evaluating signals given by other horses and able to react accordingly.

FIVE SENSES ALWAYS ON ALERT

A horse's senses always operate in unison. The animal therefore might first be alerted to potential danger by sight, try to identify it by scent and point its ears for any recognizable sound. Mustangs sometimes have difficulty in recognizing outlines against the light and, if the danger does not appear imminent, prefer to move around it to get a better scent.

Sight

Millions of years of evolution have given rise to an animal at home on the plains, with limited natural defenses, but fast on its feet and quick to spot predators in such an open environment. As a result, the horse's vision is well developed. The eyes, located on both sides of the head, are prominent and mobile, each covering a monocular angle of 180 degrees. This provides the animal with panoramic vision extending about 350 degrees and allows it to detect the slightest movement. Nonetheless, this lateral location of the eyes also creates several blind spots, notably a narrow band toward the back, as well as directly in front and under the chin. This limitation is partly compensated for by a very mobile and flexible neck, which allows the animal to turn its head backward in just a fraction of a second. The horse's fine sensitivity to movement compensates for its visual acuity, which is considerably poorer than that of the human eye.

Unlike the wide angles of binocular vision found in predators, that of the horse does not exceed 80 degrees. When directed downward, the horse's central binocular vision is fine for distant vision and depth perception. When moving forward without constraint, horses see the terrain ahead clearly, but not as well overhead, almost as if a visor was blocking their field of view. Color perception is also poorly developed in horses, but their night vision is excellent.

Hearing

Exceptionally mobile, a horse's ears are easily directed toward any noise like independent parabolic antennae. With one ear pointed forward and the other sideways or backward, the animal is very attentive to all sounds in its immediate environment. The sense of hearing in horses, while not as good as in dogs, is far superior to that of humans. With maximum sensitivity between 500 hertz and 16 kilohertz, mustangs can discern a wide range of sounds, be it the rustling of vegetation due to an approaching predator, the alarm cries of prairie dogs or sounds made by other horses.

146

Smell

It is difficult for humans, with their limited sense of smell, to appreciate the horse's olfactory universe. Among horses the sense of smell plays a major role in communication, individual recognition, analysis of excrement, identification of a foal by its mother, hormonal scents, and so on. Their sense of smell is also very important in distinguishing plant aromas, locating salt licks or sensing the first signs of fire. During periods of food shortage, mustangs can also find roots by smell and thereby locate vegetation under the snow.

Taste

As in humans, the horse tongue has taste buds sensitive to salty, sweet, sour and bitter flavors. Taste is directly linked to smell whenever both senses are utilized, be this when cleaning a newborn, sensing a receptive mare or eating vegetation. It also seems that the Flehmen response (a grimacing facial gesture) facilitates the transfer of odorant chemicals to the vomeronasal organ, a specialized sensory organ.

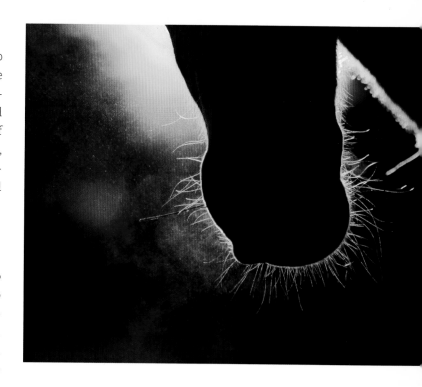

Touch

A horse's skin is remarkably sensitive to tactile stimulation. The mere touch of a fly on a mustang's shoulder, for example, will elicit a shudder. The most sensitive tactile areas are the lips, the tip of the nose, the eyelids and the ears. This tactile sensitivity is evident during comforting activities like scratching and social grooming.

PRONOUNCED SENSITIVITY

Humans communicate visually through body language and facial expressions facilitated by numerous muscles. Far less obvious, horses utilize more subtle signals to exchange information with other horses. This near constant state of communication in mustangs seems to extend from the tip of the nose all the way down to the tail. A slight flicker of the ear, a quiver of the nose, a wave of the tail — nothing escapes attention. It is not surprising, therefore, that horses readily detect human emotions like fear, anger or excitement. They are aware of our slightest changes in position, as well as such micro-indicators like changes in muscle tension. Our body odors also divulge our state of being — these olfactory signals may barely be detected by other humans, but are readily perceived by a horse.

Proprioception

Similar to touch but not as simply defined, this sense helps horses determine their position, orientation and movement in their immediate environment and aids in maintaining balance. It also provides the animal with feedback about muscle tension and the articulation of its joints. Unlike individual sense organs like the nose and eyes, or some defined region of the brain, this sense involves the entire nervous system. Feedback of this sort also helps horses determine the nature of the ground beneath their feet.

Barometric Sensors

As genuine walking barometers, mustangs can readily sense changes in weather, which undoubtedly involves detecting variations in atmospheric pressure and humidity. Similarly, sensitivity to electrical and magnetic fields is probably also linked to some aspects of spatial orientation or anticipation of natural disasters.

One lead mare habitually left the high alpine terrain up to 15 hours prior to the arrival of bad weather. In one particularly tempestuous spring, she led her harem to a sheltered valley some 10 miles (16 km) away a full 24 hours before a massive snow storm, presumably to avoid any risk of hypothermia for her three-day-old foal. The harem did not return to the alpine meadow for another three days until the grazing grounds were once again accessible.

147

Daily Activities

Mustangs divide their daily activities in a way that meets all their basic needs: foraging, water, rest and onward movement. As a consequence they spend between 80 and 95 percent of their time eating and sleeping! Spending some 15 hours a day feeding is a consequence of their relatively small stomachs.

On average, a stallion feeds about two fewer hours than a mare, leaving plenty of time for his role as guardian of the harem and attending to his masculine duties: chasing and pursuing, confrontations and leading his group. Pregnant mares graze extensively, both for energy demands during gestation and to nourish their foals.

The second favorite activity among horses is resting. Foals spend the most time sleeping, but adults also need between five and six hours daily.

Horses divide the remaining time each day between various other activities, including being on watch, grooming and traveling. The latter is a favorite mustang pastime and is usually done at a walking pace, two or more hours per day. It is not unusual for them to travel 3 or 4 miles (5 or 6 km), and sometimes more than 10 miles (16 km) during periods of drought or in semi-arid terrain. Travel and other activities are not limited to daylight hours. During mating season, stallions can be very active even in the dark, and some exhibit fresh wounds in the morning after violent confrontations the previous night.

FEEDING

While all ruminants (cud-chewing animals) have an efficient digestive system, horses are better adapted for survival in dry regions. Since they subsist on a diet rich in fiber but poor in quality, horses must devote about 60 percent of their time to feeding. Grasses and grains comprise about 60 to 80 percent of the basic mustang diet. During the short spring bloom, they also graze on the flowers of arnica, dandelions and lupines. They show considerable individuality in this regard, which may explain why foals tend to show the same dietary preferences as their mothers. Winter rations are considerably more limited, and the now rare grasses are supplemented by roots of *Eurotia lanata* (commonly known as "winter fat") and astragalus, which mustangs dig up with their hooves. Toward the end of the season, woody plants like saltbush and prairie wormwood are no longer snubbed. If a food shortage persists, the mustangs will even feed on juniper branches.

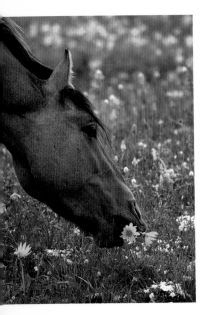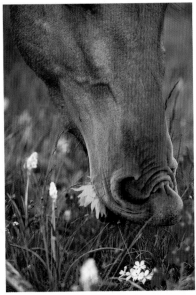

NAP TIME

Because they are prey animals, mustangs don't have the luxury of extended periods of respite, as do predators, and so

never spend more than five or six hours resting — roughly 20 percent of their daily activities. Moreover, for adults these rest times are really more like naps, as periods of deep sleep are quite rare. Only foals can actually rest for a dozen hours a day. Before doing so, they sniff the ground, and then, with partly bent legs, they turn around in a circle and lower themselves down. Once on their sides they fall into a deep sleep remarkably fast. Once asleep, they move their hooves, whinny, suck on an invisible teat, wiggle their ears and roll their eyes under their lids — in short, they dream! While cerebral activity may be high, their bodies remain limp and their muscles are slack. Periods of deep sleep shorten as the foal grows larger, lasting over three hours for newborns and shortening to no more than half an hour when they reach eight months of age.

Periods of rest and relaxation also vary with the seasons and circumstances in their environment. During periods of high tension between harems, for instance, resting is frequently interrupted. During cold weather, the animals rise early to take advantage of warming sunlight. Long siestas and catnaps are most common during the hottest summer days, when horses group together under shade trees or on breezy hilltops, where harassing insect bites are easier to cope with. Long periods of rest also tend to be more frequent during the second half of the night. Upon awakening, horses yawn and stretch by extending their necks forward and lowering their backs to extend their hind legs.

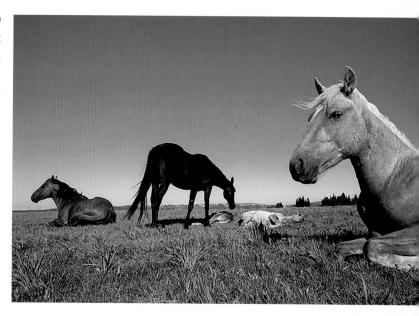

Sleeping while Standing

A horse can nap while standing by holding its neck horizontally, with ears backward, eyes fully or partly closed, and relaxing its muscles. Horses can do this thanks to a system of ligaments and tendons that lets them lock their shoulders. Their hind legs are locked in place by a similar mechanism at the stifle; and thanks to other ligaments, the kneecap is set into the lower end of the femur, thereby keeping the leg rigid. This way the animal can alternatively relax one rear leg or the other without losing balance, thus remaining stable on three legs. Foals attempt to stand in this "tripod" fashion when they reach the age of three months, but still have difficulty locking their hindquarters.

Sleeping Lying Down

When horses lie on their bellies to sleep in cattle-like fashion, they curl their legs under their bodies, lower their necks and incline their heads with chins to the ground. This is not a very comfortable position for adult horses, and they will only do this for about 20 minutes at a time. Horses typically transition from a nap to a light sleep, from which they emerge quickly in case of danger, and then jump to their feet in the blink of an eye.

When lying on its belly, a horse can glide from light to deep sleep, during which its neck muscles relax, and the weight of its head rests entirely on its lower jaw. It lies with ears rapidly flapping forward and backward, cheek muscles contracting, eyelids clenched and uttering an occasional whine. In this rather precarious position, the head invariably slips to one side, causing the whole body to follow suit, and this usually awakens the animal with a start. Adult mustangs only enjoy deep, recuperative sleep in short, five-minute intervals, maybe a dozen times over 24 hours. Stallions generally sleep less frequently than mares. The exception to this is during mating season when, overcome by fatigue through constant tension, fighting and altercations, a stallion may temporarily lower its guard.

Sleeping on One Side

Harem stallions rarely lie on their sides with legs fully extended, since this position leaves them particularly vulnerable to rivals and predators. The few seconds needed to awaken and jump to his feet might well be fatal. On the other hand, adult mares, yearlings and young adults enjoy short periods of deep sleep while lying on their sides; this is also the favorite position for fillies when "catching some zzz's."

DRINKING AND BATHING

Surviving as they do in often inhospitable environments, wild horses must rely on often hidden water sources, be they small streams or artificial ponds, for one of their basic subsistence needs. Unlike cattle, which spend much of their time near water sources, mustangs rarely spend more than 10 minutes in quenching their thirst (and bathing if the water is

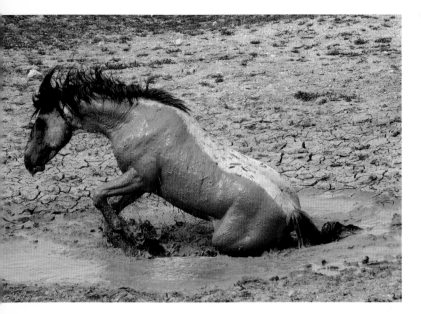

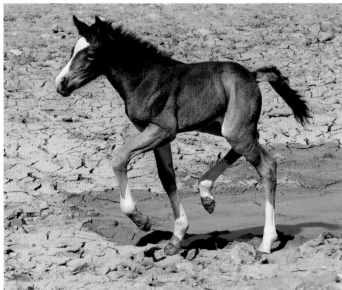

deep enough). Eager to drink, lactating mares are often the first in line, typically consuming 5 to 6 gallons (19 to 23 l) daily, but as much as 15 gallons (57 l) during the summer.

Bathing

Unless they are distracted in some way, horses bathe in a very ritualized manner. After drinking, they seek out a spot deep enough to immerse themselves completely while still standing. They first sniff the water and then pound its surface forcefully with a forelimb before rolling into it sideways, always keeping the head above water. The reason for the water pounding action is unclear; perhaps it represents some ancestral precaution to fend off dangerous reptiles. In any case, mustangs seem to derive great pleasure out of bathing.

Stallions bathe more often than mares, but during periods of great heat, bathing is a pleasantly refreshing activity for all members of the harem. When first starting out, foals approach the water very timidly and only dip their hooves into it. However, once their mother enters the water and immerses herself, the foal might venture in with her as far as its belly.

Mud bathing is particularly appreciated when mustangs have been irritated by insect bites. Like a skin balm, the mud seems to ease the pain and to accelerate scarring of superficial wounds. Not all mud sites seem to have these properties, however; those with a high lime content are sought out. After covering themselves in mud, the animals let it air-dry and blow off naturally rather than rolling over to slough it off.

THE DUST BATH

A water bath is generally followed by a roll in the dust. The preferred spots for this are typically rounded patches of dirt

that the horse has cleared of stones and rocks by scratching at the surface with its hooves. Such areas are located near watering holes, as well as around grazing meadows, salt licks and pathways. Before lowering itself, the horse first sniffs the soil to detect the scent of any prior users, then lies on one side, rolls over, and vigorously rocks on its back to dust it and its flanks. If this works, it will get up and repeat the action on the other side. Dust readily clings to the horse's wet skin, which then dries very quickly. When fully dusted, the horse gets up, shakes itself vigorously and rejoins the harem. Rolling in the dust after a bath is like a chain reaction that all members of the group partake in.

Social Dusting

Serving both as skin care and back massage, dust baths are not just carried out individually, but serve a major social function among mustangs. Scents left in the dirt by previous horses probably serve as important communication signals. Although all horses partake in this activity, stallions do it the most, and when several members of a harem dust themselves in sequence, the lead mustang always goes last. By covering the scents of the individuals in his harem, he reestablishes dominion over the group, particularly over any younger males. This also holds true for bands of bachelors — the last to dust himself is always the individual with the highest status in the group.

THE PASSAGE OF THE SEASONS

Even in the wild, horses have distinctive habits, but as they do not follow any fixed timetable, they constantly adjust activities to changes in their environment. For instance, in early

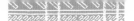
June they usually take their first rest period between 7 a.m. and 8 a.m. when the air begins to warm up and in preparation for their trek to a water source around midday. A few weeks later when temperatures are scorching, they drink mostly at night, early in the morning or late afternoon, and often drink a couple of times a day. At the beginning of fall, drinking and bathing times shift to late afternoon, and throughout the winter, mustangs use most of their short treks to feed. Social interactions among harems are greatly diminished in the wintertime. Playtime among young horses is also much reduced during the cold months in order to conserve precious energy.

Seasonal Migrations

Weather and terrain permitting, groups of mustangs will migrate to higher elevations in the spring in search of richer pastures. Dominant harems and bands of bachelors are generally first up the slopes. Even in semi-desert areas, more precipitation falls in the mountains. Alpine meadows burst out with carpets of wildflowers in springtime, a veritable godsend for the mustangs, who take full advantage of the opportunity. Dandelions, arnica plants, lupines, pasque flowers and forget-me-nots abound, a plentiful but fleeting feast of vegetation that soon wilts under the scorching summer sun and dry conditions. The migration reverts with the arrival of autumn and, with the coming of the first winter storms, harem after harem returns to lower elevations and foothills. Even harsher weather will drive them into the valleys. Only a few bands of bachelors opt to remain in sheltered areas at the higher elevations, but when snow levels reach a foot or two deep and foraging becomes too difficult, even these "mountaineers" retreat. In very rough terrain where vertical migration is not possible — in the salt flats of Nevada, for example — horses move along slowly in search of less hostile regions.

The Benefits of Summer Snow

Summers are scorching hot in the American West, but temperatures can be dramatically different depending on the altitude. Mustangs don't like extreme heat (nor the inevitable

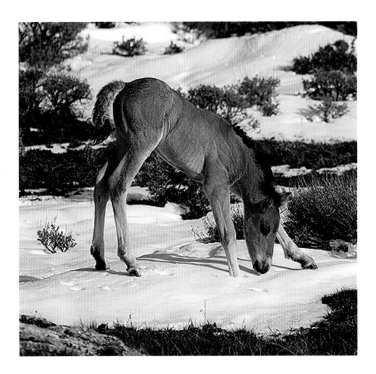

insect bites that come with it), and usually spend the hottest time of the day on a windswept cliff or under shade trees. Horses that can migrate to higher elevations during the summer take advantage of snow patches, which in favorable locations can last as late as early July. These are visited frequently as long as they do last, since the old snow quenches thirst, is refreshingly cool and keeps blood-sucking insects at bay.

Rather than rolling over to slough it off, harems spend much time on these patches of snow — as long as two hours — barely moving. Standing like this on the slopes, they eat large amounts of snow and then rest with their heads just an inch or two above the sparkling surface, something that seems to give them considerable pleasure. Most of the time the horses will just let the snow melt in their mouths, chew it a bit and drink in small amounts, letting the rest drip to the ground. They may also ingest snow by letting it run down their noses. This strange habit is accompanied by rhythmic suction-like sounds, not unlike those made by releasing a plunger.

During these adult quiet times, the younger horses prefer to step and slide on the snow, like novice skiers.

Mating Season

Spring is a season full of energy, and mares emit scents that make a stallion's blood boil. Not only must the stallion seduce his beauties, he also needs to take heed in guarding them, which is not easy as there are many eager competitors to fend off. Between April and July, the life of a stallion is replete with actions intended to intimidate his rivals. All rituals are amplified now: behaviors, threats, fights, travels, pursuits, and so on.

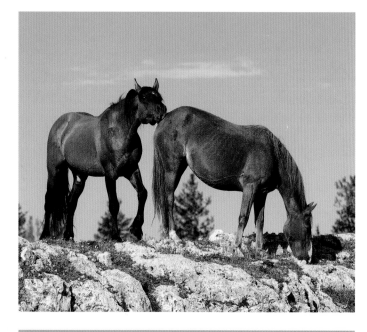

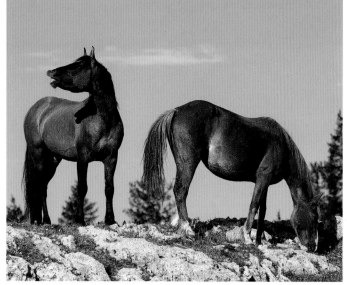

INTOXICATING SCENTS

Stallions have a very specific way of identifying receptive mares. When a female urinates during mating season she will also attract the stallion. After he smells the damp soil, he sniffs the air and forcefully raises his upper lip to expose his teeth. This behavior, common among ungulates, is called the Flehmen response. Covered with olfactory cells, the stallion's vomeronasal organ can assess the mare's odorants and evaluate her hormonal status. Often the stallion samples the air several times before urinating on the same spot. In this way, he neutralizes the mare's pheromones and signals to other stallions that she is his property. The Flehmen response is later repeated when the stallion sniffs the mare's genitals before trying to mount her. The Flehmen response is triggered in a variety of circumstances, including when a stallion sniffs a mare's droppings, any pile of droppings, his own urine or a strange new scent. The response is also not confined to stallions; fillies learn it early on and mares use it regularly to analyze any new odors.

"HORSE FEVER"

The end of a rest period, the noises made by a mare while urinating, a coupling in a nearby harem, a struggle with a rival — all can trigger sudden arousal in a stallion. Without hesitation and accompanied by strident cries, he displays a full erection and, after a few sniffs, mounts his mare.

Displays and Courtship

Before her first mating, a young filly is often nervous and timid. Faced by untimely advances from the stallion, she

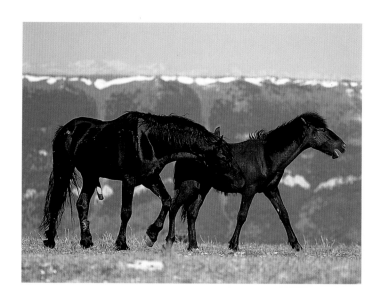

may be interrupted by a series of Flehmen responses before he finally mounts her, surrounding her abdomen with his forelegs. Following the act, the mare takes one forward step, making the dismount easier. Relaxed, the stallion remains nearly completely still and then he smells the ground while exhibiting another Flehmen response. The mare, meanwhile, distances herself from the scene and nurses her foal. Both intrigued and concerned about this encounter, the young foal is quick to feed to be comforted — a typical reaction to stress. The young mother's heats (or post-partum estrus) occur on average about 5–12 days following the birthing process. During the rest of the year, the majority of mares remain in a state of ovarian inactivity.

What the Mare Wants …

A mare that is not yet receptive adopts reactive postures to the stallion's approach, and there is no misunderstanding on his part. With ears pointed backward she displays a menacing posture, and by pointing her rear end toward the male, she is ready to deliver a swift and very accurate kick. If her suitor chooses to ignore these warning signs and persists in trying to mount her, he will see a hoof coming at him at a lightning speed, resulting in a burning pain to his stomach or shoulders.

If he tries to mount an unwilling mare, the stallion will be "rewarded" for his efforts with a swift kick to the genitals. This pain is so acute that he will be incapable of moving for several seconds.

may even start to making chewing motions (champing) as a sign of submission. As he tries to turn her around or sniff her, she continues to sidestep him. Although the filly is strongly drawn to the stallion, she does not want to be taken by force. For this reason, she begins to trot ahead of her "suitor" or delivers a kick to fend him off the moment he reaches her side. Such indecisive behavior — combining invitation with rejection — no doubt prepares the mare for gradual acceptance of the stallion. The stallion, therefore, has little choice but to be patient and to persuade and reassure her through sniffing, gentle grooming and licking. Periodically he rests his head on her croup or her back to get her used to his touch. This eventually leads to a gradual and mutual intensification of "amorous" rapport. These tender connections also pave the way toward the mare's loyalty in future. In contrast to this, pairs that have known one another for several years generally forgo these preliminary niceties and mate without clashing. After a brief nose-to-nose familiarization, the experienced female will turn around so the stallion can mount her.

The Coupling

If she is raised in a stable harem, a young, receptive filly will often offer herself spontaneously to the stallion. The female's fertility period, or estrus, follows a cycle of three weeks, with the exact periods of heat ranging between five and nine days. The stallion is constantly sniffing the droppings and the genitals of the mare in estrus. To show her consent, the mare will stand still, lift her tail to the side and set her rear legs firmly to the ground as the lips of her vulva undergo spasmodic motions. Accompanied by passing small amounts of urine, this "winking" or "flashing" is a signal the stallion is quick to recognize. With his neck arched and nostrils flared, he emits guttural sounds, approaches the mare, sniffs her sweat and licks her genitals. This investigation

MORTALITY AND PREDATION

The causes of death among mustangs are varied: a lack of water and food shortages due to drought, as well as the rigors of winter that every year eliminate a number of animals, including the young, the sick or the old. Particularly vulnerable up until the age of one, young horses can succumb to illness and wounds, exposure to weather, falls, poisoning through ingestion of toxic plants, and so on. Likewise, the consequences of separation of a foal from its mother can also prove fatal.

On mountainous terrain, lightning may haphazardly strike horses and even wipe out an entire harem. Summertime fires also pose a menace. Though mustangs may be very familiar with their terrain, they can also fall prey to errors of judgment. Blackie's harem became victim to circumstance in this way, trapped by rising water on an islet in the middle of a canyon with sharp slopes. The isolated horses ultimately died of hunger.

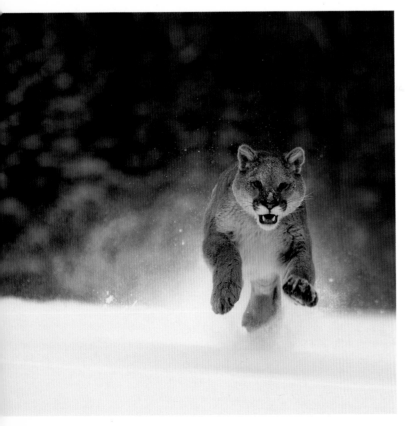

RAVAGES OF THE COUGAR

In regions where horses live side by side with cattle, ranchers are usually diligent in eradicating predators such as coyotes, wolves, bears and cougars, which are killed indiscriminately. Areas reserved solely for mustangs are open again to the return of the cougar (also known as the puma or mountain lion), the predator best adapted to these dry and hilly lands.

In the Arrowhead Mountains of Wyoming, cougar attacks on wild horses were first recorded in 1999. In 2002, of 32 fillies attacked, 12 survived — a loss of 60 percent, not all of which can be attributed solely to predation, however. Still, cougars have become highly adept at preying on young horses. Two years later, we witnessed a veritable slaughter when one or more of these wildcats attacked on open, unobstructed terrain. Young horses disappeared one after another that summer, to the point where even the strongest harems could not secure their progeny. Of 28 foals, only one survived to celebrate its first birthday. The yearlings weren't spared either. A five-year-old stallion was also attacked by the predators and barely escaped, suffering deep wounds.

Survival Strategies

Mustangs have learned to live with the menace of predators, though the behavioral counter-response has taken some time to occur. Harems no longer sleep without a guard on duty, and the adults, notably lead mares and dominant stallions, are much more prudent and vigilant, responding by fleeing at the slightest suspicious sound or movement. Even

a simple rabbit foraging for food in a nearby pine grove or the passage of a herd of deer along a hillside are enough to disperse one or more harems.

BEARS, WOLVES AND COYOTES

The black bear always triggers a state of maximum alertness — even panic — among mustangs. This scavenger eagerly assumes the role of "cleaner," and removes the carcasses of horses that died either of old age or by accident. Coyotes, however, are a threat solely to the sick or the newborn. When a coyote trails behind at a close distance, horses are generally content to just keep an eye on it until it disappears, and then they resume normal activities. The presence of a wolf, on the other hand, elicits much more fear. A veterinary student recalled that while she was observing a harem one fall evening, the horses did not react to the calls of neighboring coyotes. Twenty minutes later, however, as the howl from a lone wolf pierced the air, the mustangs raised their heads in unison. With pointed ears and nostrils flared, they searched in vain to catch sight of any movement in the underbrush. When a mare snorted loudly through her nostrils, the entire harem galloped off at top speed. Moments later, all the horses had disappeared, leaving nothing behind but a faint trail of dust.

TINY BUT BLOODTHIRSTY

Horseflies, flies and midges by the millions constantly harass mustangs during the summer months, and can ingest up to 1 pint (500 ml) of blood daily from one horse! Nervous head shaking, incessant tail swatting, social irritability, interrupted nursing — nothing is surprising as the horses run amok. Even galloping at top speed and rearing up is not enough to rid themselves of these minuscule attackers. Mustangs have developed quite a few strategies to fight off these insect assaults as best they can, including feeding at night or in the early hours of the day. The warm daytime hours are then reserved for napping, preferably on a windy, crested hill or under the cover of a shade tree. By positioning themselves headfirst on the ground, members of the same harem leave their tails free to act as "fly swatters" for their neighbor. Resting on a patch of snow also offers true relief, since the cool temperatures help to keep the flies at bay. Unfortunately, as everyone tries to rest on the snow, the patches become crowded, and these coveted cold surfaces decrease day by day as summer progresses.

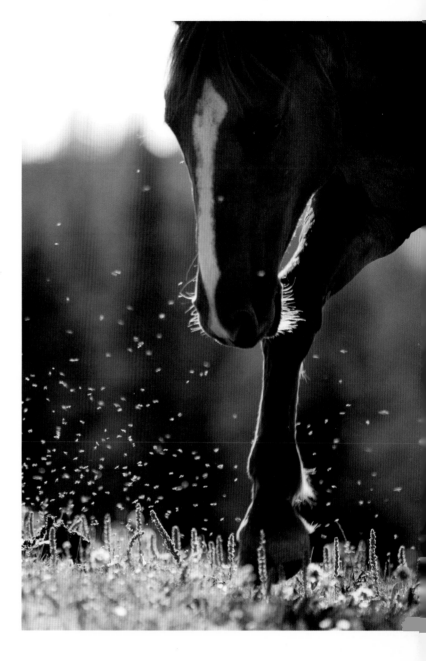

POPULATION CONTROL BY HUMANS

In the absence of predators, the government agencies that manage mustang populations regulate them every four years. They do this by directly removing a number of horses during roundups or through large-scale campaigns of chemical contraception. The rationale is to minimize competition for food with cattle or other wild ungulates, and to minimize soil degradation and environmental erosion. Compared to such human interventions, natural predation has the enormous advantage of not dislocating harems, nor of solely targeting young horses (45 percent of annual births on average) and not disrupting the reproductive physiology of mares. Finally, natural predation is "free" — a strong argument in this debate, which pins government agencies against American taxpayers.

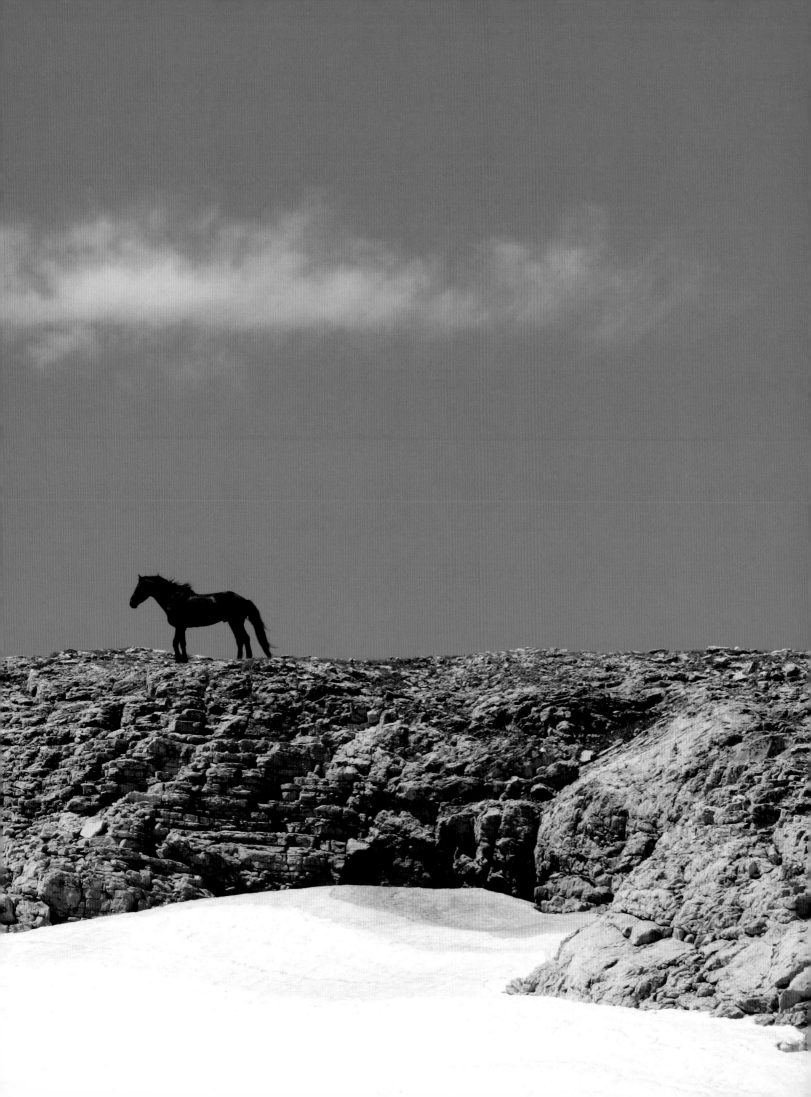

Heavy winter coats protect the mustangs from the frigid polar blasts that come down directly from Canada. Below, a grullo (mousy gray) mare is accompanied by her young, 20-month-old chestnut who sports a light-colored mane. The images at right, from top to bottom, show an apricot-colored juvenile male, a cremello mare and her foal, and a jet-black stallion.

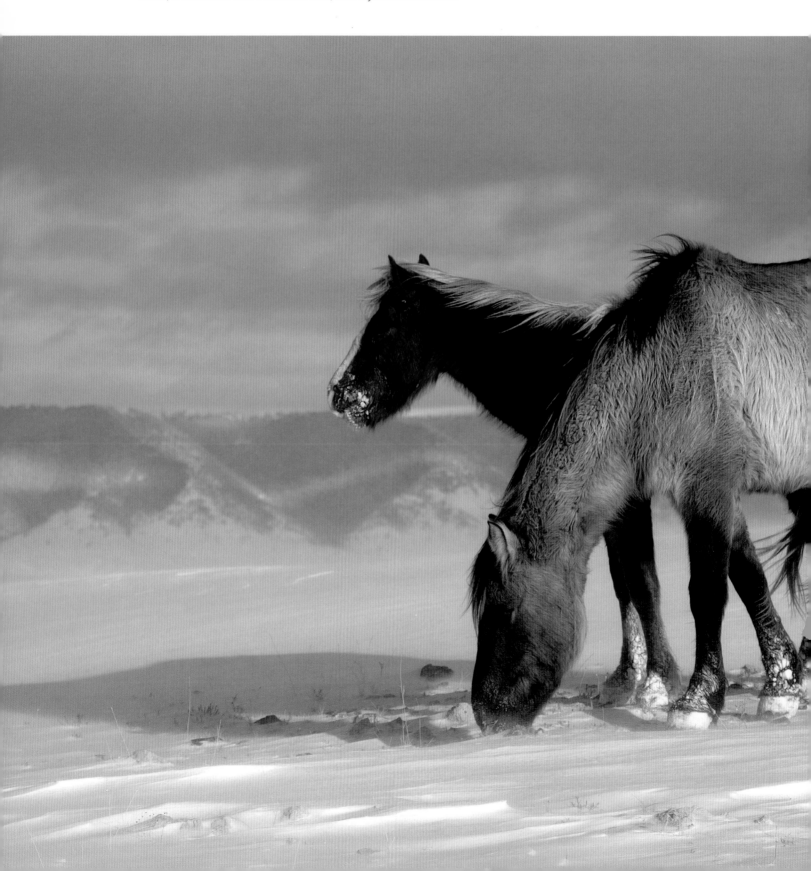

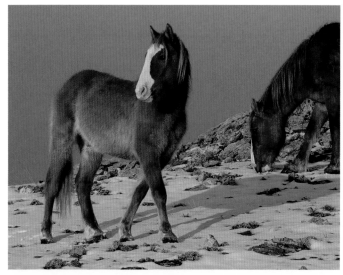

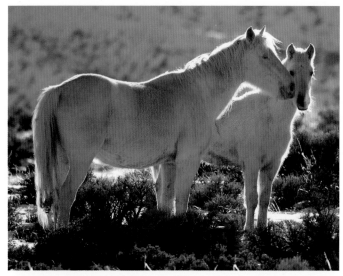

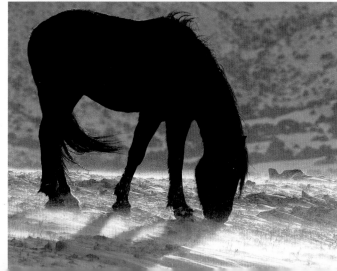

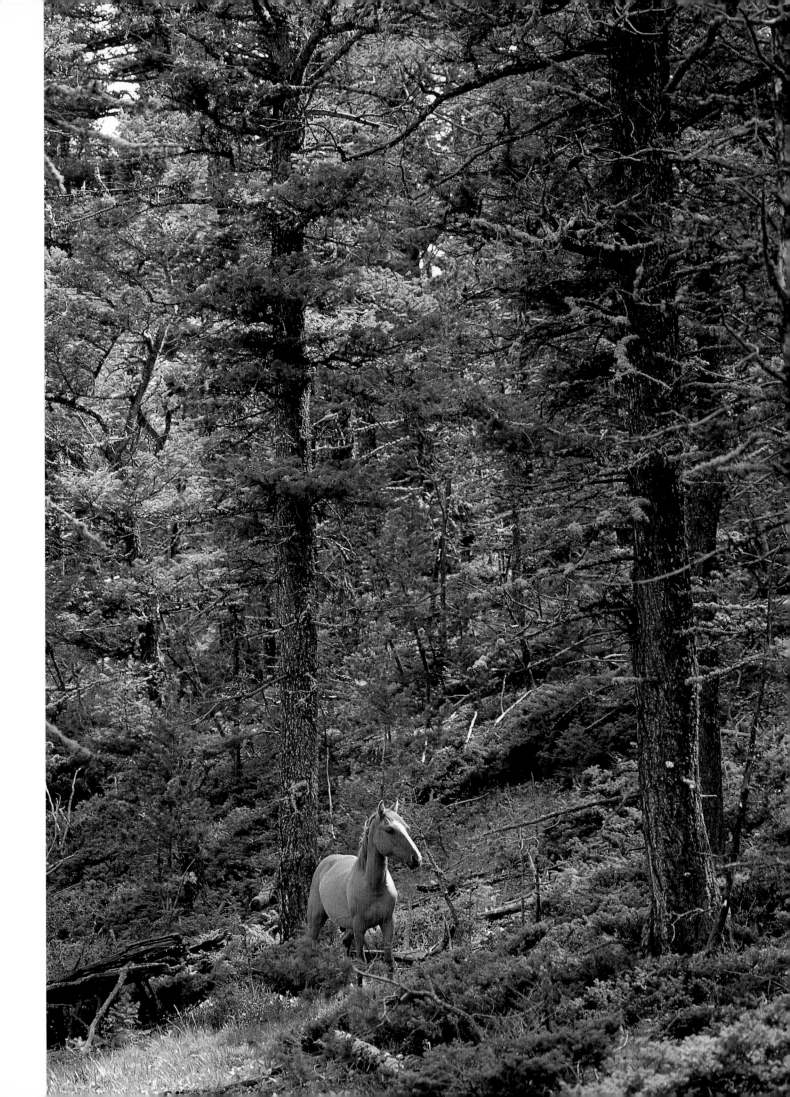

With true camouflage abilities, the dun and grullo (mousy gray) coats are characteristic of the Spanish mustang and of numerous species referred to as "primitives" (sorraïa, fjord, konik and heck-horse). Dorsal rays, striped legs and bicolored manes are typical of these ancestral coats. This young bachelor (opposite), who sports a red coat (a chestnut base) takes advantage of the shade of age-old conifers.

 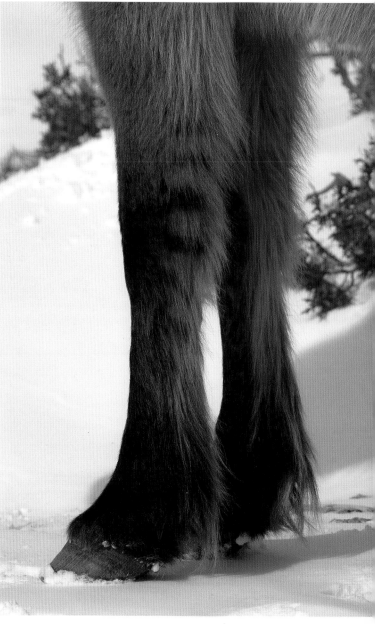

A bay mustang rests under a pine tree (below), while a brown stallion with shades of black, displaying an extended "swan neck" pose, gallops across a field of lupines (top right). In the company of two powerful chestnut stallions, a palomino bachelor blends in with the golden grasses (middle right). Driven by thirst, a dun mare crosses the desert at a gallop, followed by her foal and her shedding yearling (lower right).

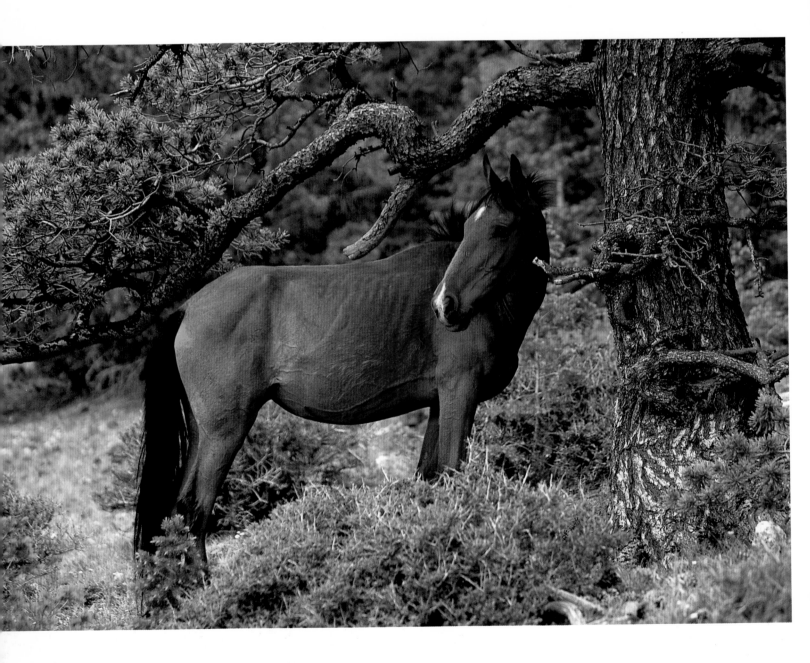

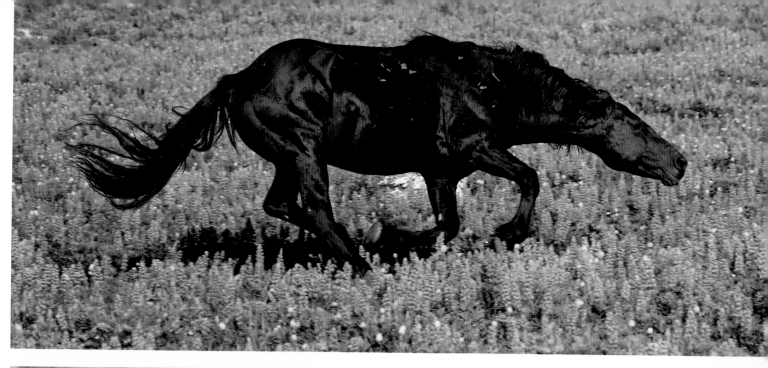

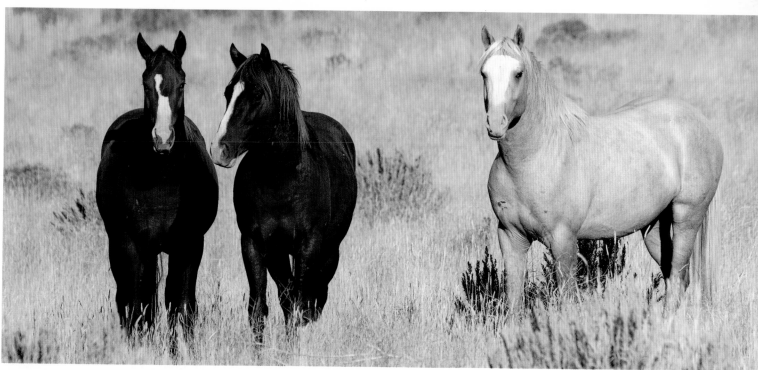

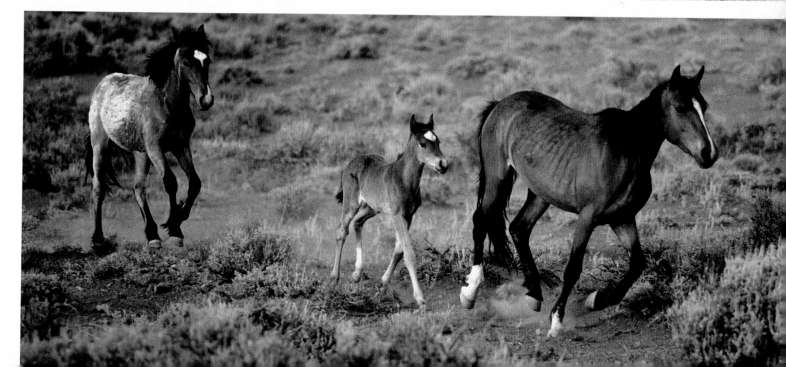

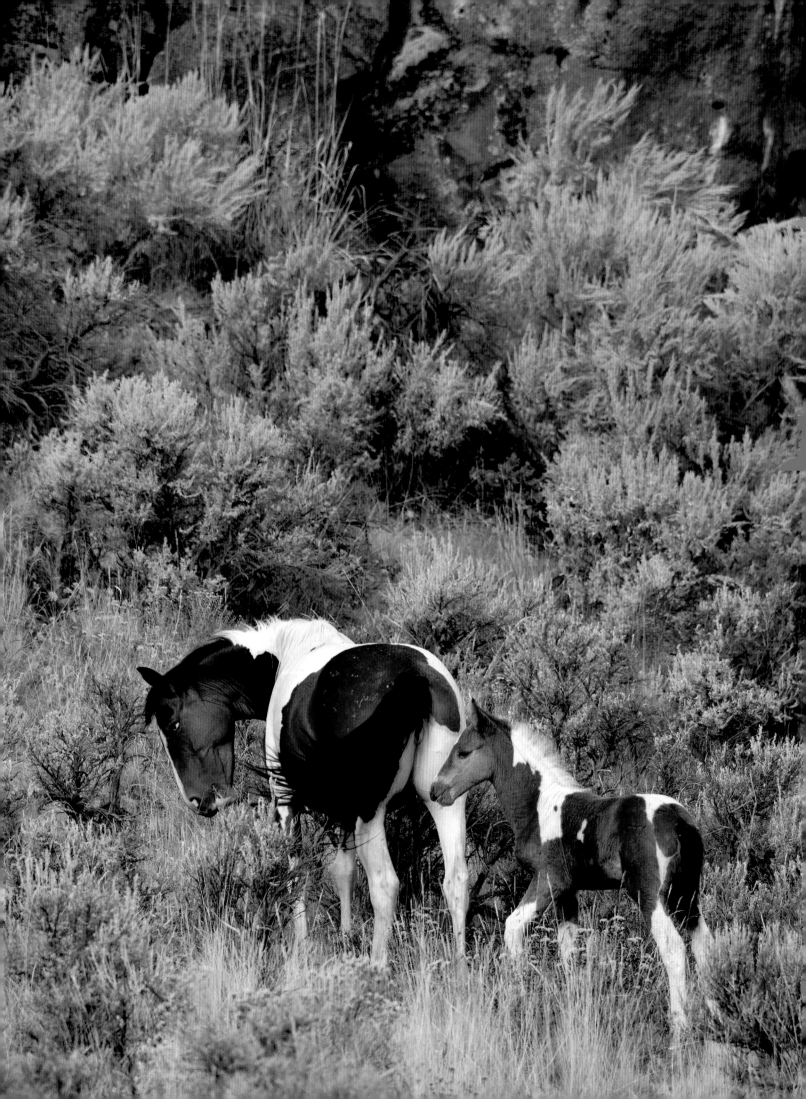

Unlike dun and grullo horses, patterned mustangs are easier to pick out of the landscape. With markings never quite identical from one horse to another, it was easier for us to identify specific individuals. A tobiano mare and her foal munch on a few grains against a basaltic background (opposite), while a mare and her overo youngster observe a neighboring harem (below, top left). A tobiano mustang with a bicolored fetlock swishes his tail while grazing (below, bottom left). Rare among pintos, a mother and her "Medicine Hat" daughter are intrigued by our presence.

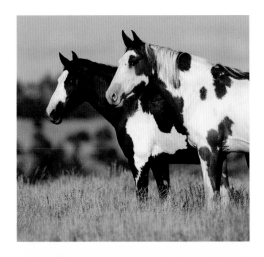

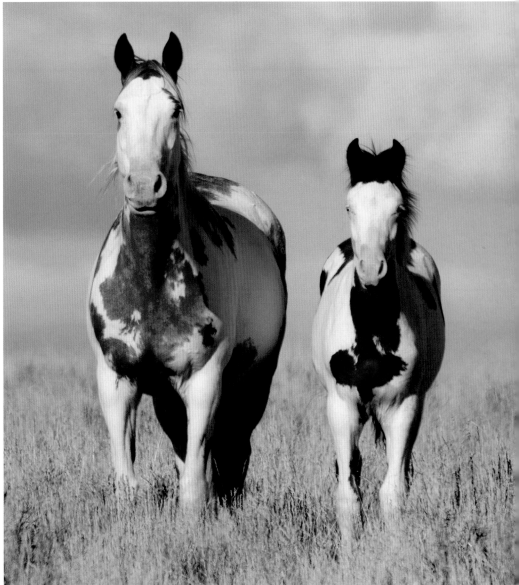

Sounds and Cries

A horse's verbal expressions serve to get the attention of its companions and also exhibit its emotional state within a specific context. We can generally distinguish seven types of sounds — a relatively poor communication repertoire for an animal bestowed with such an intricate social system. Nevertheless, these vocalizations vary considerably in intensity, duration and amplitude, although their meaning is not always clearly identifiable.

Emanating from a closed mouth, the contact call is a short-distance signal. Generally, this soft, quivering sound is meant to attract the attention of a nearby harem member. It is produced, for example, by a mare to her foal, to either encourage him to follow her during the first few days, or to force him to return, should he wander out of sight.

A powerful breath exhaled from the nostrils, which sounds like a sudden snorting, is produced by an alarmed horse or one that is in a heightened state of alertness. The sound, which carries for quite a distance, alerts the members of the group, or occasionally horses from neighboring harems. Generally, a sudden escape occurs a few seconds after the first alarm sound. When fear is mixed with curiosity, a horse will emit a rapid succession of these snorting noises.

Almost like a sneeze, a strong sniff acts to clear the nostrils, which vibrate with the passage of exhaled air. This sound is produced when the mustangs are feeding in dusty or snowy areas.

Squealing, a whinnying sound that is both shrill and brief, is characteristic of encounters between stallions or bachelors, when they exchange "breaths" and mutually sniff each others flanks and genital areas. These screams arise from either social excitement or acute tension and frequently occur during antagonistic encounters (offensive or defensive). Mares also squeal, particularly when rebuffing a stallion's sexual advances. Though much rarer between mares, squealing sounds typically arise as a result of a misunderstanding.

True whinnying is produced from an open mouth with nostrils flared. It is actually a higher pitched and more enduring vocalization. Heard from a long distance, it is produced during a separation, for instance between two nearby offspring, and enables each animal to signal its position. Whinnying is always the result of a state of great excitement and, in the majority of cases, it is a sound that expresses distress. A foal may whinny to its mother when, left behind after a long nap, it is separated from the harem. Similarly, a mare will whinny to call her foal. Occasionally, if a mare has been lagging behind due to either pregnancy weight or if she was nursing her young one, she will whinny to locate her harem — for example when leaving a watering hole. A stallion will emit a more modulated whinny to his foal if he comes too close to a nearby harem or any strange horses. Another situation which may result in the same kind of sound is the disbursal of a harem: the newly separated mares will whinny in unison in an effort to find one another. In the same manner, a stallion will whinny to locate mares that have just been kidnapped by an adversary or if the harem has split up due to an unusual event (such as a storm or an attack by a predator). The stallion emits a violent whinny, as a "call-to-arms," at the sight of bachelors or a rival stallion.

The stallion that intensely smells another horse produces a kind of "whirring" sound. This acutely tense expression is produced by deep and prolonged breathing, causing the walls of their nostrils to vibrate. This sound is produced, for example, when a stallion sniffs a receptive mare or when a bachelor appraises a new, young stallion.

A very soft sound, a type of quivering exhale not unlike a sigh, punctuates calm moments when the horses, still or relaxed, are near one another. Horses produce this kind of sound mostly at the end of their naps, just before resuming their grazing.

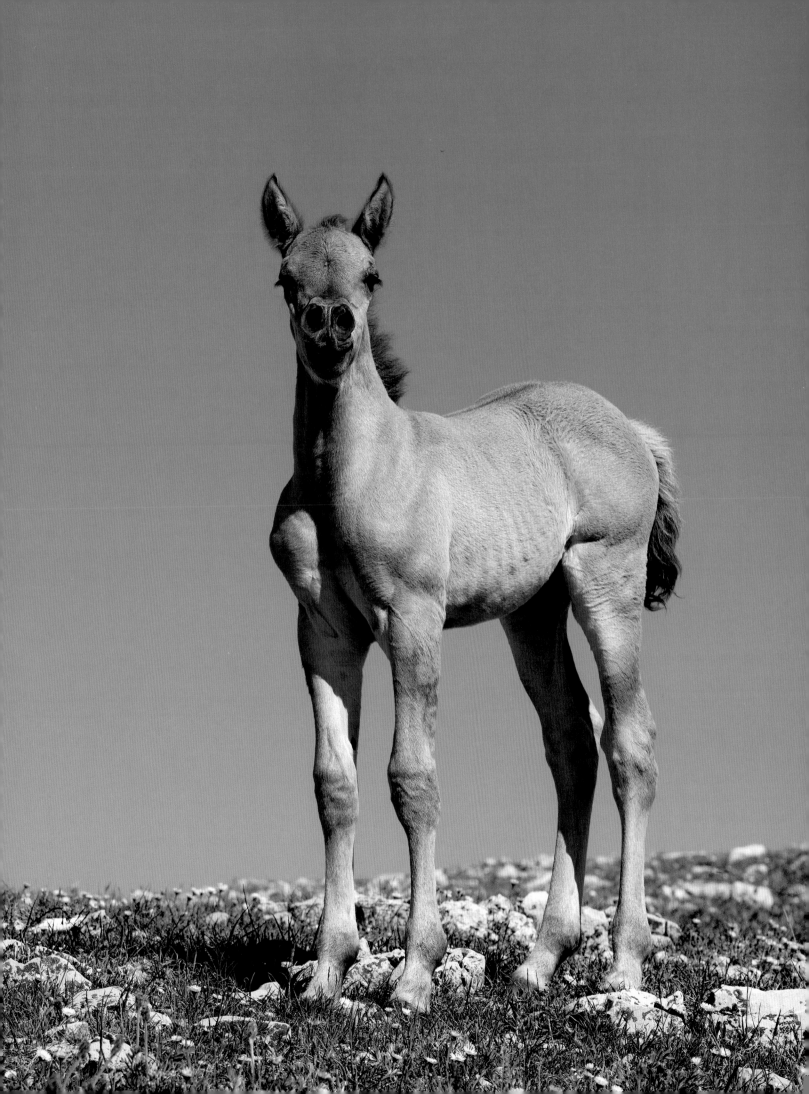

Always on the alert with all his senses primed, a young stallion (left) smells the scents that are carried on the wind. Later, he snorts while chewing (below) to dislodge the ice crystals that enter his nasal cavity when he feeds on blades of grass that are buried under the snow.

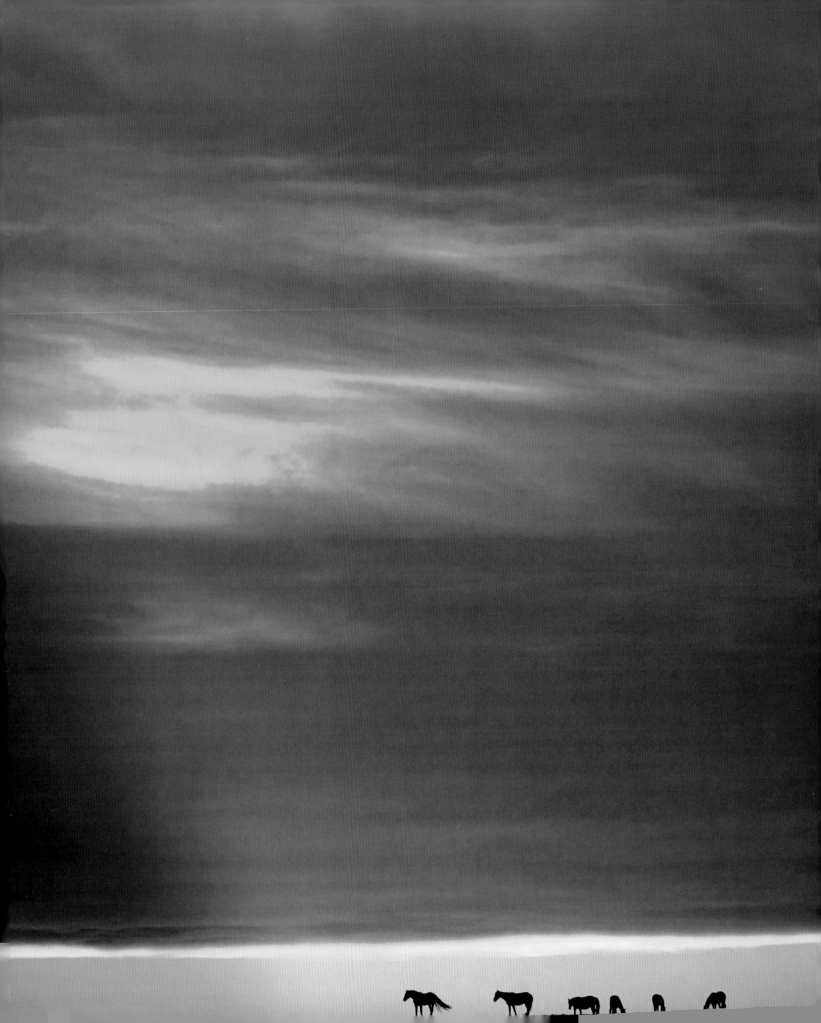

Nighttime does not impede the horses' activities, as they possess excellent night vision. In the summer, many battles take place during the coolness of night, and we were often awakened by the sounds of whinnying and galloping. To our great dismay, the colts would wait for sunset to launch into their dia-bolical pursuits.

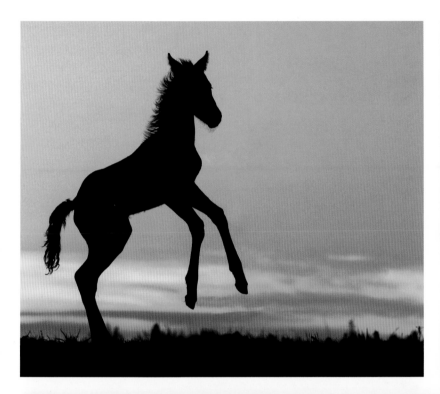

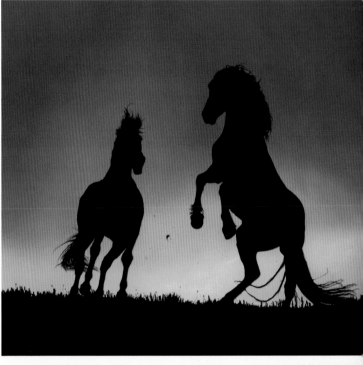

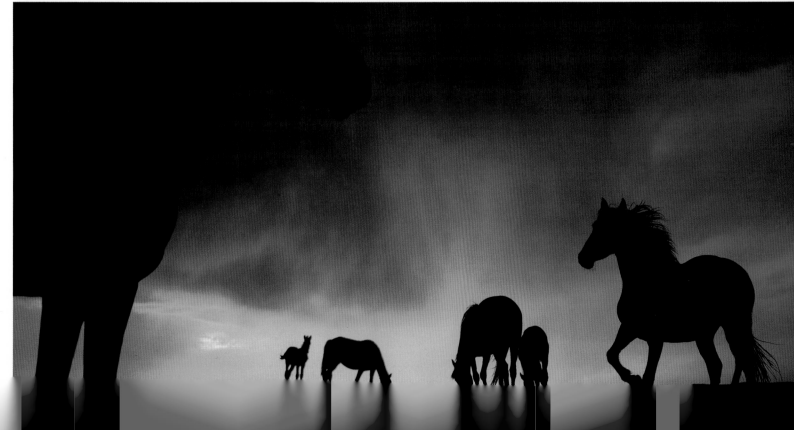

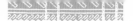

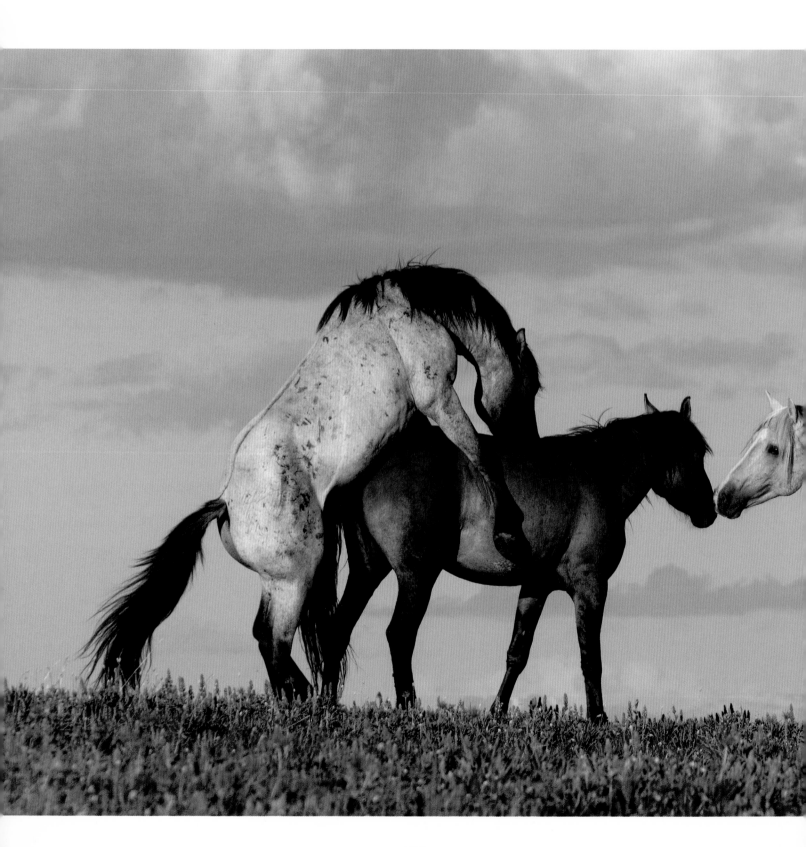

On this rare occasion, a young stallion mounted his first filly (below left) while a stallion from a neighboring harem took advantage of the situation to sniff her! This Flehmen response (below right) is a typical behavior in a stallion, and helps him to ascertain the mare's sexual receptivity. His vomeronasal organ senses the mare's body odors, which are full of pheromones.

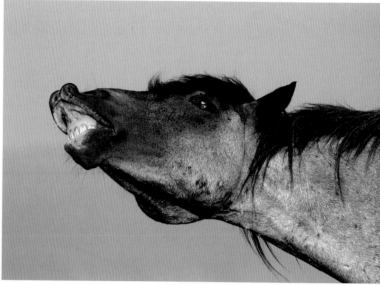

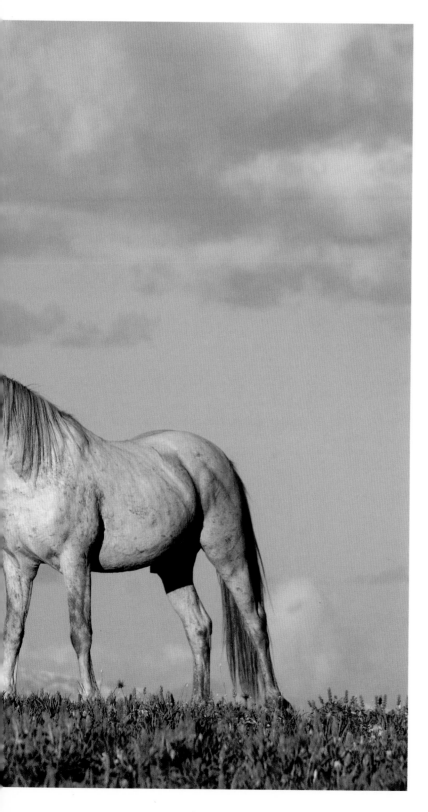

A Summer Day

July 5, 5:15 a.m. The short summer night ends. As hilltop after hilltop is lit by the sun, a new day dawns for Geronimo's harem. He is accompanied by his three mares, each followed by their respective colts. Chippewa, the youngest, is just a week old.

5:30 a.m. Geronimo couples with Yakima, the dominant mare. Awakened by the stallion's raucous snorting, Chippewa stretches languorously, and nurses soon after. One after the other, the harem members begin to graze. The temperature is only 43°F (6°C). Energized by the cool weather, the "twins," grullo half-brothers now one month old, play vigorously and then take their turns grazing. At left and at right in the distance, other harems are grazing on the slopes.

5:45 a.m. Even though the sun has not yet fully risen, it is already as bright as day. Shortly after this both haze and horseflies will mushroom in the heat. In the valley below, the rivers are running dry. Here, at an elevation of 7,900 feet (2,400 m), where pine trees and junipers have replaced the wormwoods, water comes primarily from melting snow patches. These packs of melting snow are now the sole remnants of a nearly forgotten winter season. Under the piercing sunlight, they feed a hundred brooks, which in turn feed temporary ponds where muddy waters evaporate almost in the wink of an eye.

8:42 a.m. Yakima starts walking toward a water site along a rocky outcrop. Two stag mules come out of the forest. The mare, alerted to their presence, snorts and then scratches the ground. Visibly shaken by this encounter, she crosses the rocky barrier along a grassy path dotted with thousands of blue forget-me-nots.

8:57 a.m. The thirsty fillies rush to the water source. Geronimo has a lot to attend to as two families have arrived here at the same time. The stallions gauge one another; chasing and fleeing follows. Whinnying, their hooves knock one another, and then each stallion rejoins his own harem. It's nothing serious, as they have known each other for a long time. The weaker stallion's group will have to wait its turn. Yakima advances into the water up to her stomach before rolling over on her side to have a refreshing bath. Her foal tries to imitate her, though water still visibly scares him.

9:04 a.m. Still in the lead, Yakima leaves the deep end of the pond. Without hurrying, but still in a state of some confusion, the family returns to the grassy slopes full of lupines, constantly grazing.

9:30 a.m. All the members of the harem are resting. Most are lying down. Only the stallion and one of his mares remain standing, resting on three legs. The foals totally abandon themselves to the sun's rays.

10:48 a.m. Eclipse, a subordinate mare, is the first to interrupt the nap. One after the other, the horses yawn and stretch. Everyone resumes grazing. Deeply asleep, Eclipse's colt stays behind. When he awakens, he whinnies while heading toward a mare from a neighboring harem, likely confusing her with his mother since they both have the same coat color. Discovering his mistake, the colt champs as a sign of submission. A bit lost, he trots in circles and emits desperate calls. Eclipse answers his cry and he immediately turns around.

Noon. The sun beats down on the slope where the horses are still grazing. Further down the valley, dust devils swirl in the light of day. The thermometer now reads 82°F (28°C).

12:47 p.m. To protect themselves against the scorching heat, the entire harem moves to the shade of a lone pine tree; its branches have been eroded by hundreds of mustang "back rubs." Lying face down, the horses take advantage of the fly-swatting action of their neighbors' tails.

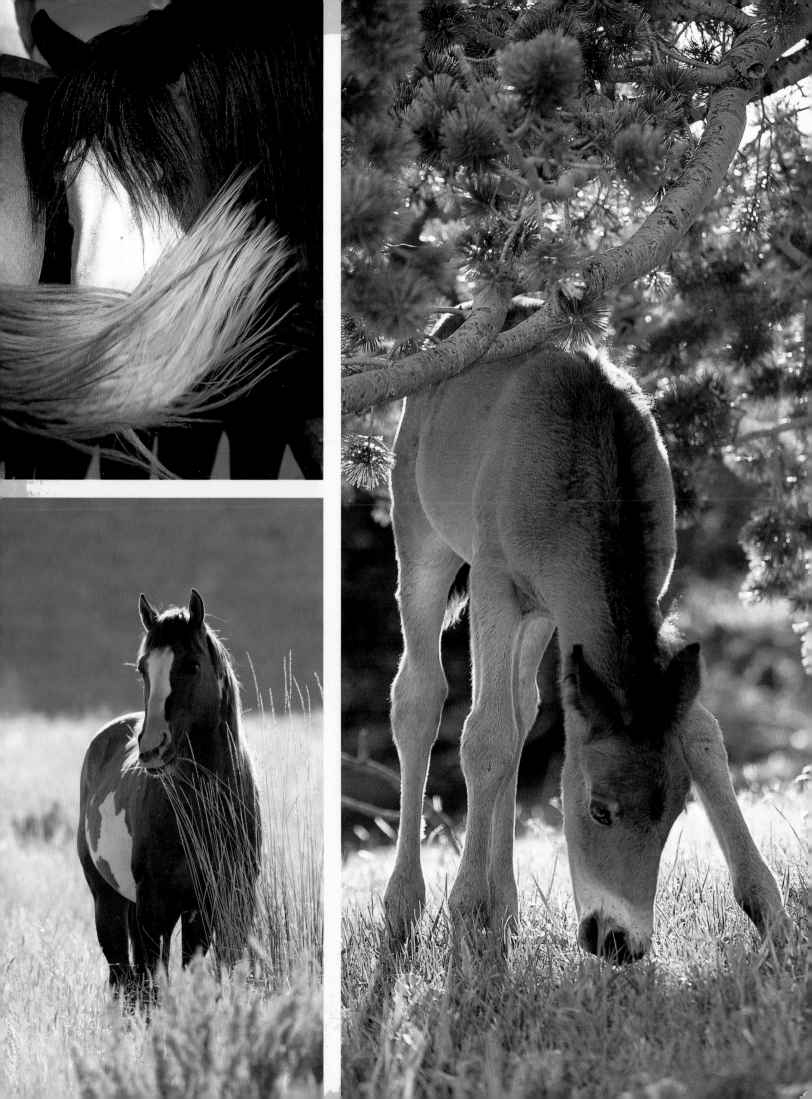

3:15 p.m. After a short stint of grazing, Geronimo's harem returns to the watering hole. The air is getting hotter and drier all the time. Stinging insects enjoy their feast as each horse is literally surrounded by a continuously moving cloud. The horses drink at great length and, after another bath, roll in the sand at the edge of the pond.

3:44 p.m. Yakima is the first to leave the water's edge and scales the slope at a trot. Visibly bothered by the incessant insects, she stops at the edge of the large snow patch that feeds the reservoir. A stallion named Strawberry and his mare already occupy the spot. The surface of the snow patch shrinks day by day, and every afternoon reveals a larger circle of brown grass covered with colorful, vibrant anemone flowers.

3:47 p.m. Geronimo chases Strawberry away with a few head movements, neck arches and forward trots. The entire harem joins together on the dirty snow. The fresh air provides a respite from the insects. As the adults sleep or indulge in mutual grooming, the foals take advantage of the situation to taste the snow, and then amuse themselves by sliding and skipping on the strange surface.

4:32 p.m. Geronimo's harem leaves the snow patch and scales the bowed crest of the hill. The horses will graze here for the entire evening.

7:55 p.m. The family has moved just to the crossing point of two valleys. Several harems join one another, taking advantage of the fresh air as the sun sets on the horizon. The "twins" take part in mischievous games. Chippewa approaches them for some nose-to-nose contact. The three colts then throw themselves into chases and pursuits across the bushy fields of the slopes.

8:45 p.m. Four bachelors from the "Black Jacket" gang appear at the edge of the crest. The sight of all these mares ignites their desire. Geronimo immediately gives chase and pursues them for several hundred yards. Tired from several months of brawling, and covered in scars, the bachelors are very reluctant to engage in combat. They leave almost as quickly as they appeared.

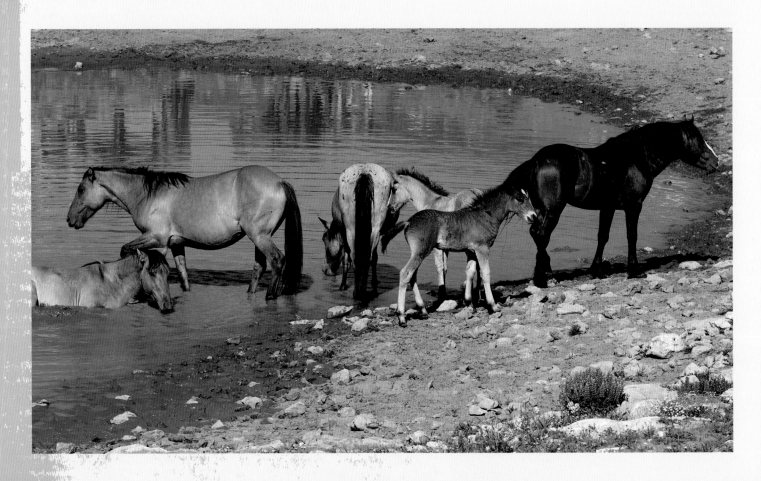

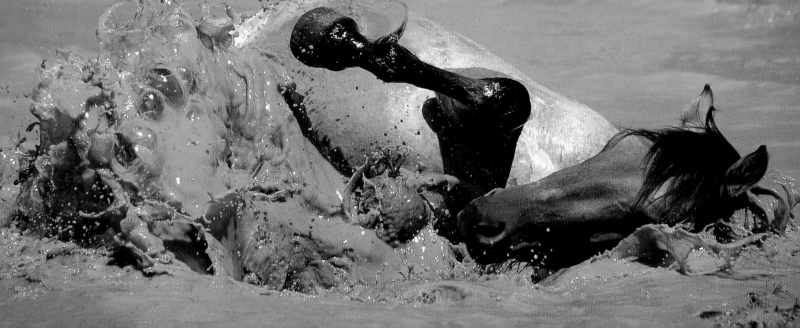

An encounter between two titans — a mixture of speed and power — brings together a bay harem stallion and a dun red bachelor. Open mouths, bared teeth, bites, smashing rear kicks — this body-to-body combat is not without risk to these opponents. Despite his great flexibility, the bachelor does not have the muscular strength of his rival and will end up bowing down.

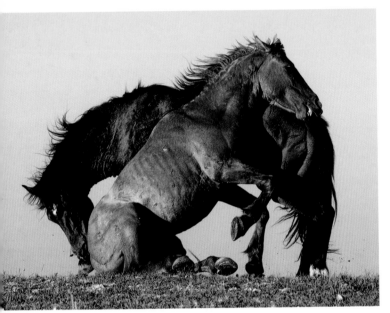

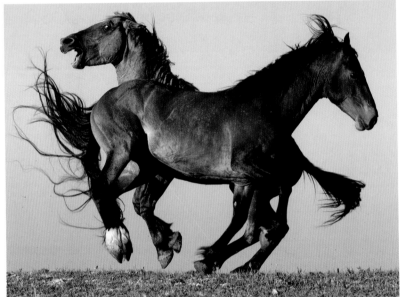

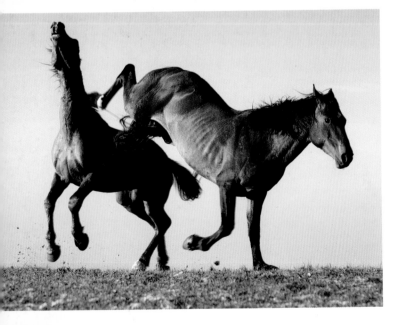

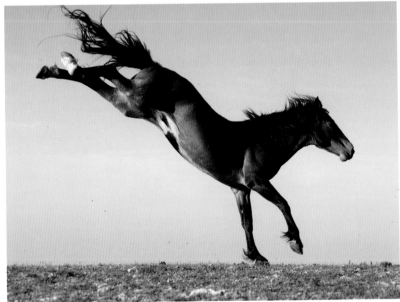

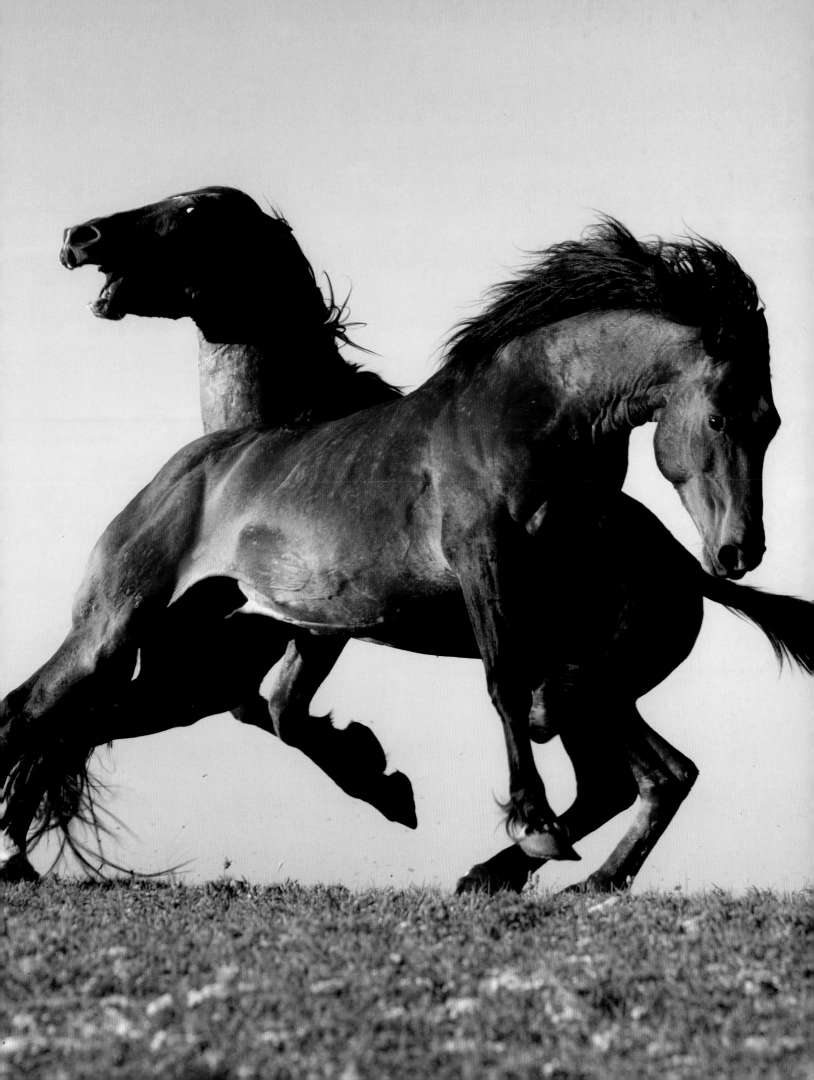

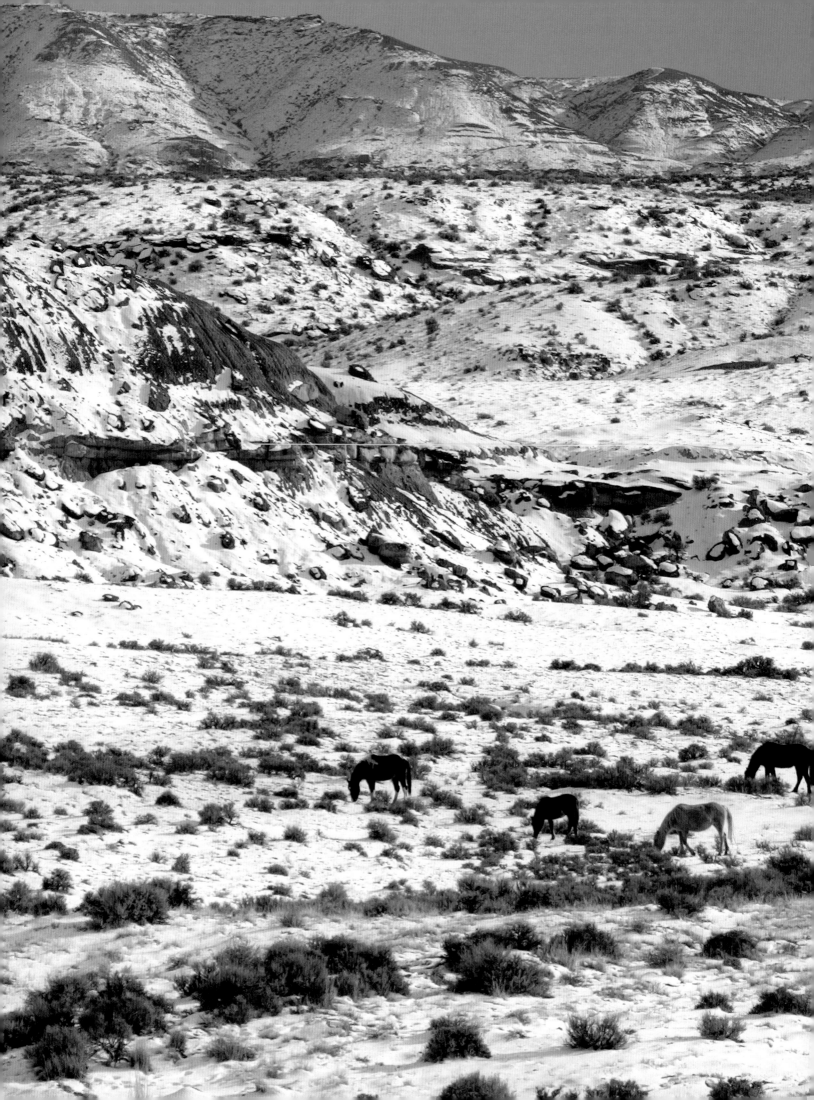

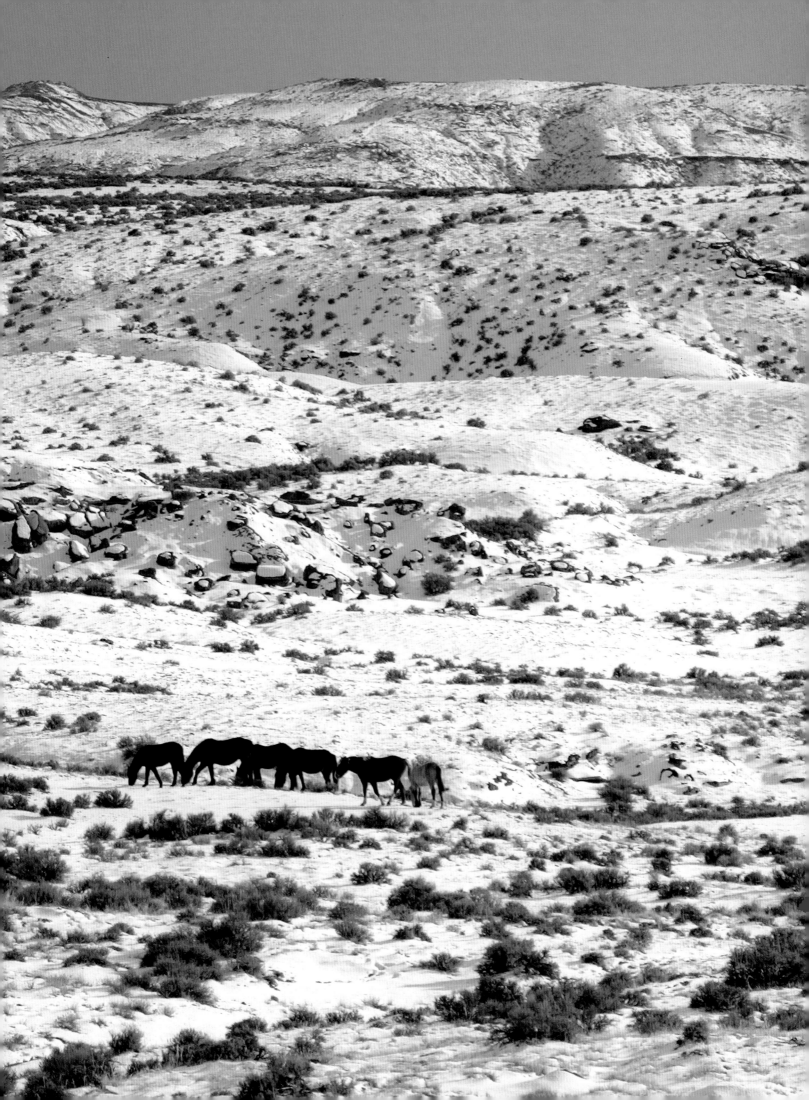

A Winter Day

February 9, 7:45 a.m. On this bright winter morning, the thermometer sits at 1°F (–17°C). A cutting wind blows between the bushes and disperses snow drifts. Taking the windchill factor into account, temperatures easily feel like –22°F (–30°C). Smokey's harem — a stallion in poor physical condition accompanied by two mares, a foal and a yearling — follows a mosaic of tracks over a thin, white blanket. The horses are silhouetted by bright sunlight. At this time of the year, the mustangs resemble large, stuffed bears with thick, protective winter coats.

8:30 a.m. The horses scratch the snow from their hooves, thereby releasing some grains of food. With their upper lips, they dig a small crater around each plant. During these cold days the mustangs do not waste a moment in finding food. Unlike in summertime, they do not rest much during the day, and save the dark, frigid nights for recovery. The short vegetation of the cold Wyoming plateau is composed mainly of bushlike trees, and wormwood is the most predominant. Junipers, bushes known as rabbit brush and the occasional pine complete the landscape.

9:40 a.m. The group advances slowly between the snow-covered junipers. The sky is clear. These wind-struck mustangs have fled from the higher elevations. Long forgotten are the green prairies and high mountain pastures of springtime. Only one obsession now exists: to stock up on food to ward off the frigid cold until the beautiful seasons return.

11:15 a.m. The mustangs have stopped on an open plateau and graze above a steep canyon. The constant wind at this location prevents snow accumulation and thereby provides more access to vegetation.

11:52 a.m. A filly and her yearling groom one another and then remain standing, leaning on each other. Though this resting phase is short, it is nevertheless important to the mare, who is exhausted from nursing. Smokey continues rummaging the soil about 30 feet (10 m) away. With his hoof, he scratches at the snow and the frozen earth in an effort to extract a few roots. He does not hesitate to break apart a wormwood bush so he can remove its rough branches to chew on. Once in a while he takes in a mouthful of snow to quench his thirst.

1:28 p.m. The glacial wind increases in strength, accompanied by a haunting whistling, and brings with it a thin layer of ice crystals. The mustangs quickly turn their rear ends in the direction of the wind blasts; in doing so, they reduce their caloric expenditure.

1:46 p.m. With a signal barely visible to the human eye, the family takes the cue to leave together, with the lead mare heading them. Necks held low, the horses march in single file. The snow is not too deep, and by advancing slowly they conserve their strength. During the winter, the reproductive behavior of the male is put to rest. It is the lead mare who takes the initiative to shelter her family against a storm or to move to a different pasture land.

2:33 p.m. After walking slowly but steadily for more than 2.5 miles (4 km), the family arrives at a riverbed. The horses sniff the surface and break through the thin, frozen top layer with their front hooves. With the precious liquid finally accessible, they quench their thirst from the tips of their lips. Though it takes more effort, water appears to be preferred over snow.

2:47 p.m. The mustangs leave the river. Without rushing, they ascend the wall of a small canyon that has been eroded by wind and rain. After reaching the summit, they resume grazing on a desolate terrace. At one end, red hills, remnants of the Triassic era (245 million to 208 million years ago), look like a Western movie backdrop.

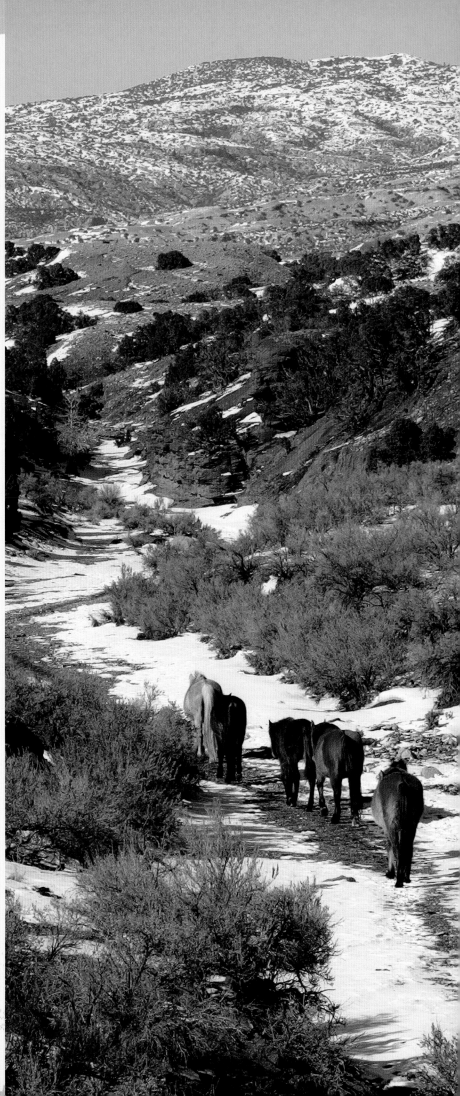

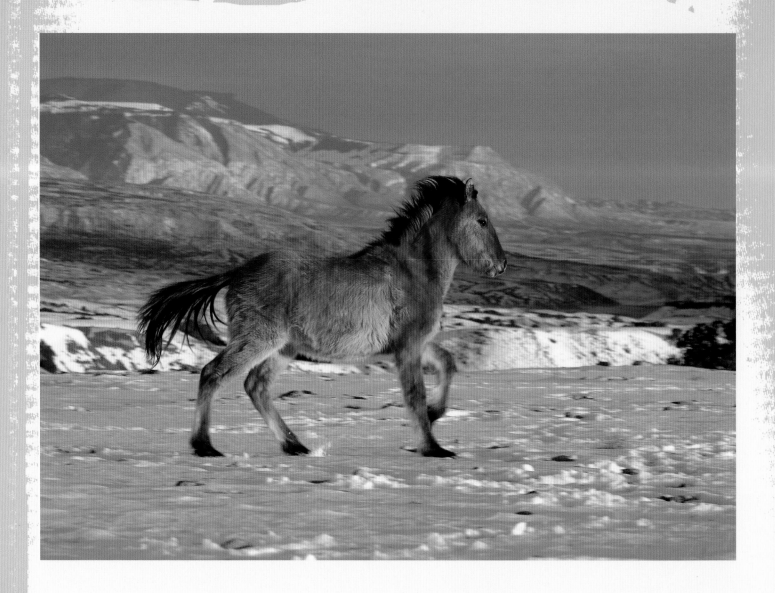

4:20 p.m. During weaning, the foal rubs itself against a lone juniper trunk. His heavy winter coat releases a few hairs that are carried away by the wind. Smokey rolls around in the red dirt, which is mixed with snow.

5:15 p.m. The wind has diminished and the sky is covered with clouds from the East. Already low in the horizon, the winter sun assumes warm hues. The horses move slowly while grazing on a rare patch of dried grasses. Their breath rises in the air like smoke.

5:34 p.m. Like a flaming hot-air balloon, the sun has just disappeared behind the ragged peaks of the Rockies. The adults eat feverishly, not losing a second before night falls. The yearling and the foal sleep under a full moon, which has just risen in a partly cloudy sky. The night promises to be bitterly cold. To warm up a bit, the mustangs will move closer to bushes or to a ravine to be shielded from the wind.

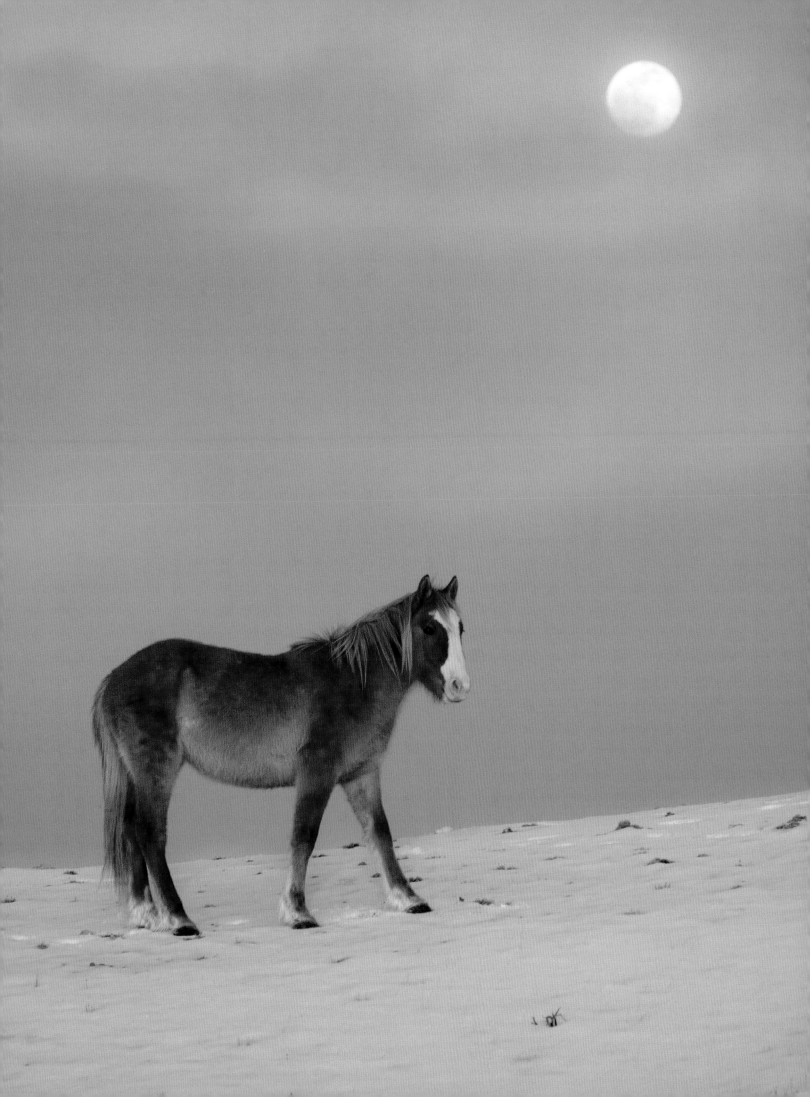

After several stormy weeks, we were truly grateful to see the sun return, as were the mustangs, who took advantage of the calmness to graze. On windswept plateaus, where the snow is less deep, they free tufts of grass with their lips and noses, thereby leaving tiny craters in the snow as a sign of their passage.

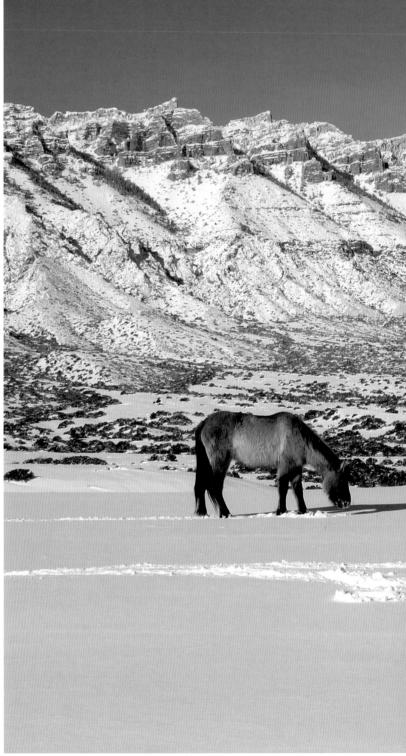

186

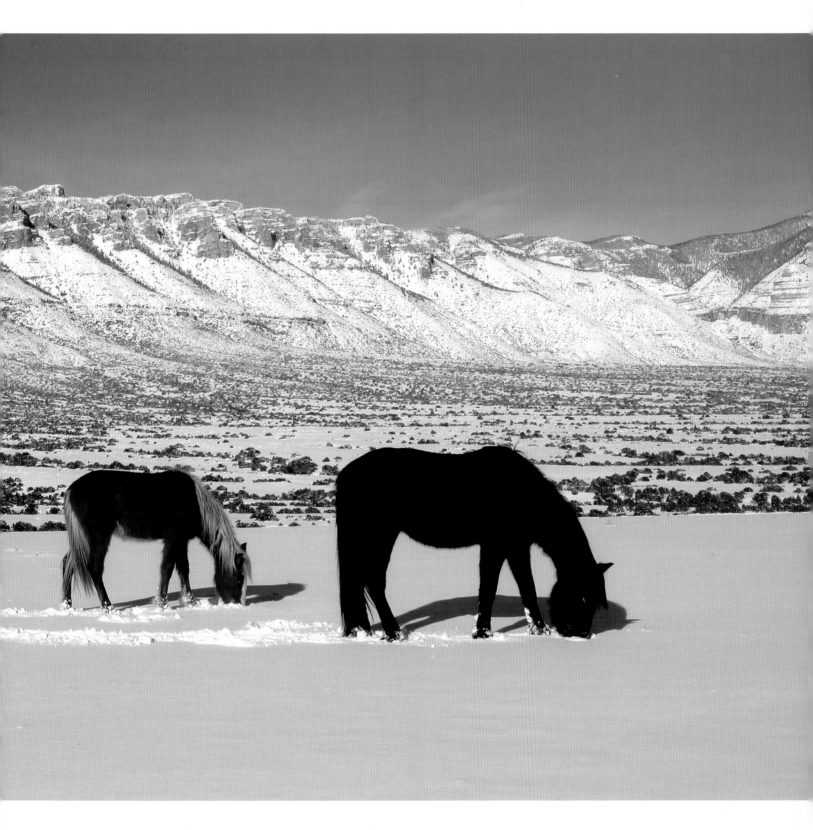

With the lead mare at the head, and the stallion bringing up the rear, a harem progresses slowly along an ancient riverbed. There is no point in quicker movement, which only burns more calories. From November to March, the frozen days go by slowly, interrupted here and there by periods of storm followed by periods of calm.

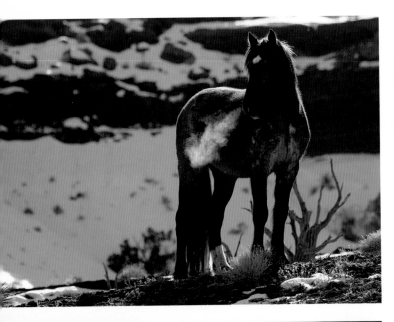

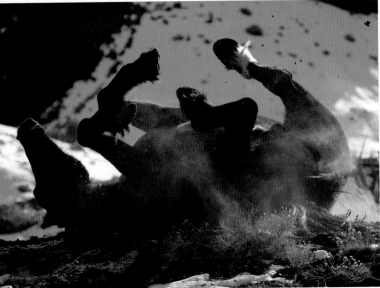

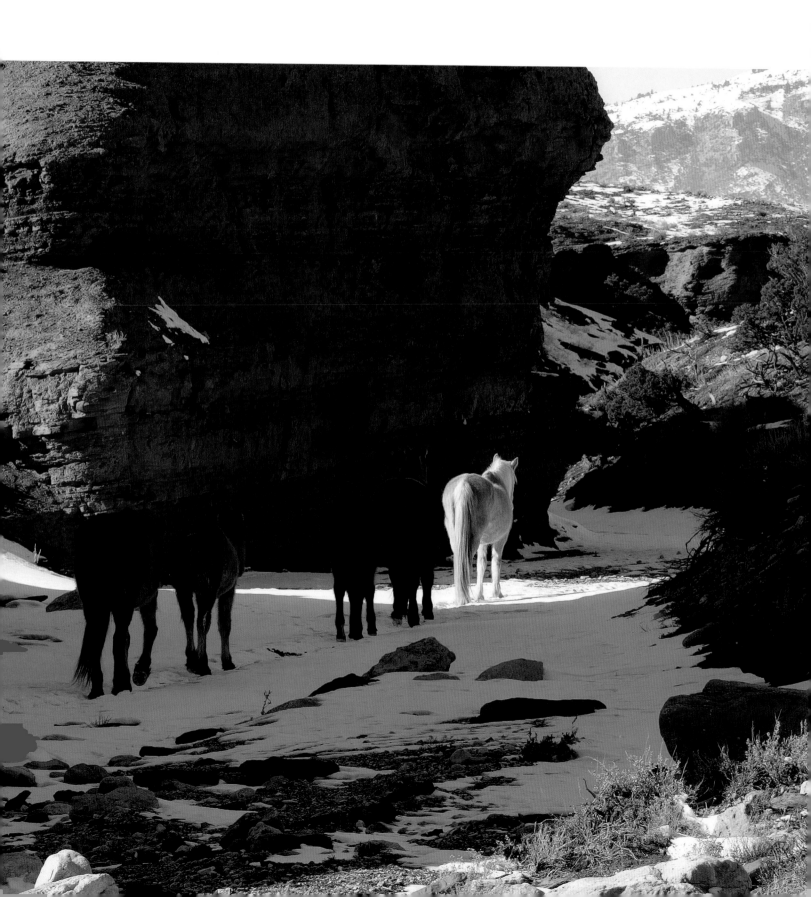

At the Heart of a Blizzard

It is mid-February, and a violent blizzard coming down from Canada engulfs the valley. The conditions are hostile, with hill crests disappearing behind a blinding, thick layer of ice crystals. For several hours now we have been looking for Blackie's harem, which, up until the night before, had been frolicking in the sand dunes.

His family consists of four mares, their three foals and three yearlings. This is a large enough group not to go unnoticed. However, the storm seems to have swallowed them up. We are just about to abandon our search when a blast of wind rips through the curtain of snow and gives us a glimpse of a few members of the harem, bunched tightly against a grove of junipers. Hardly recognizable, they are covered with a thick white shell. Several individuals are missing, most noticeably the stallion. One of the foals, transformed into a snow sculpture, is no longer accompanied by its mother. The blizzard undoubtedly took them by surprise at dawn, resulting in the break-up of the group. The mares and the male yearling make sure the foals are held tightly against the bushes.

The temperature drops to −4°F (−20°C). The wind is so strong that we can hardly remain standing; the freezing cold, coupled with the windchill factor, bites our faces and numbs our fingers despite our heavy clothing. With heads lowered, the mustangs wait, still and expressionless, huddled up against the ferocity of the storm. Toward nightfall, the wind releases its hold somewhat. The yearling then ventures away from its shelter, and is soon followed by other members of the harem. Visibly starved, they immediately begin searching for food, almost frantic. Each second that goes by threatens their survival …

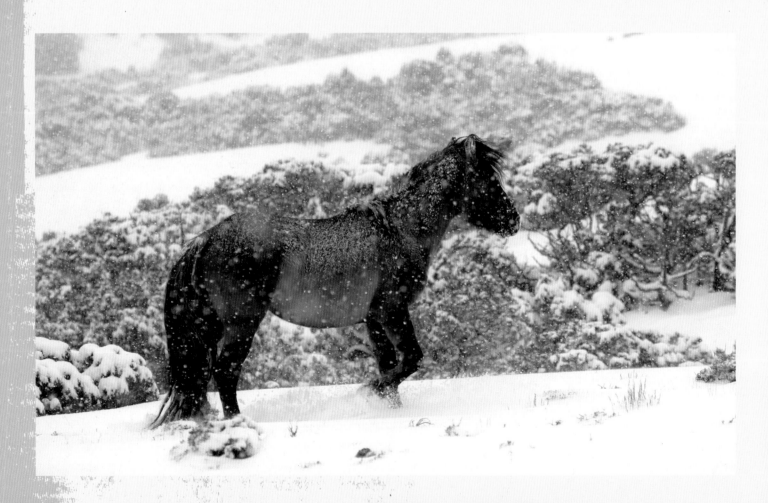

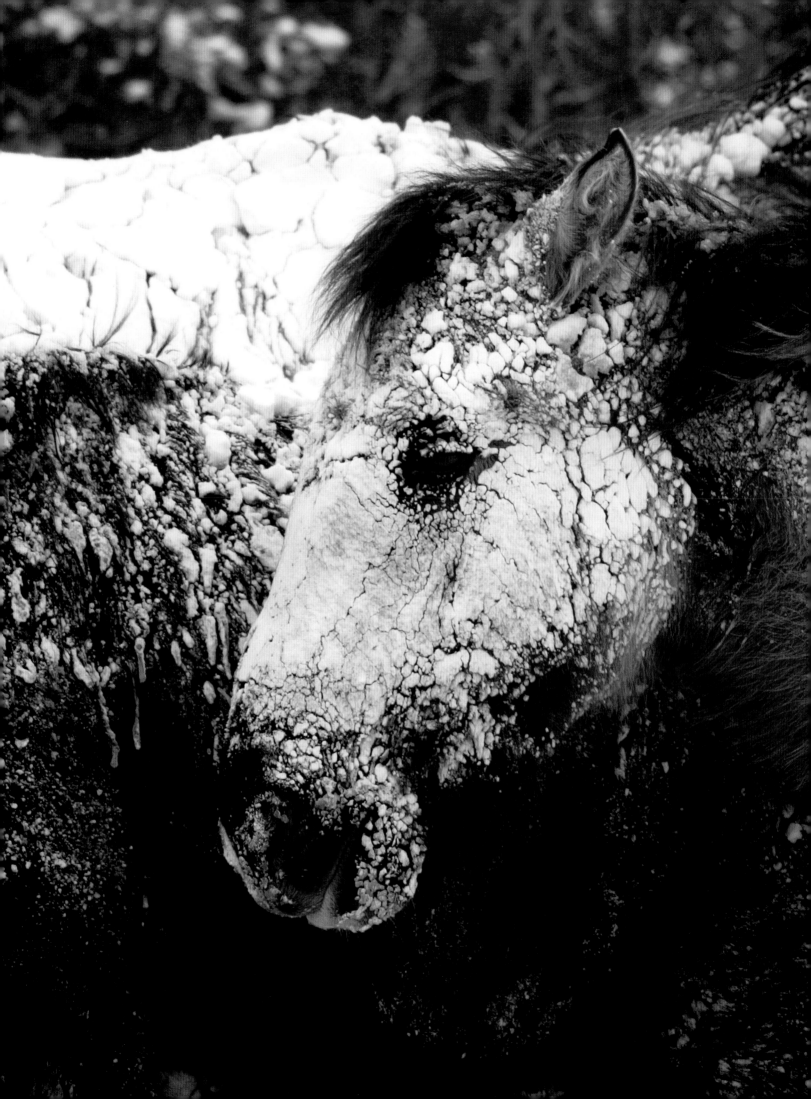

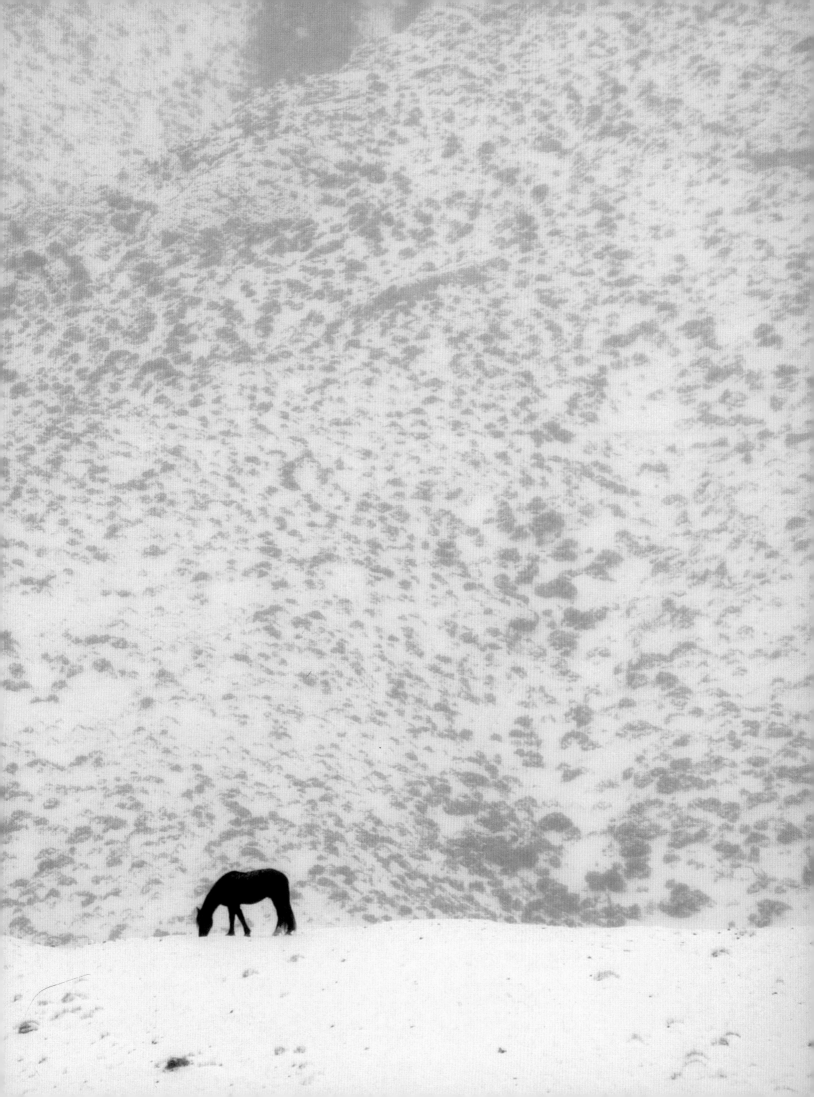

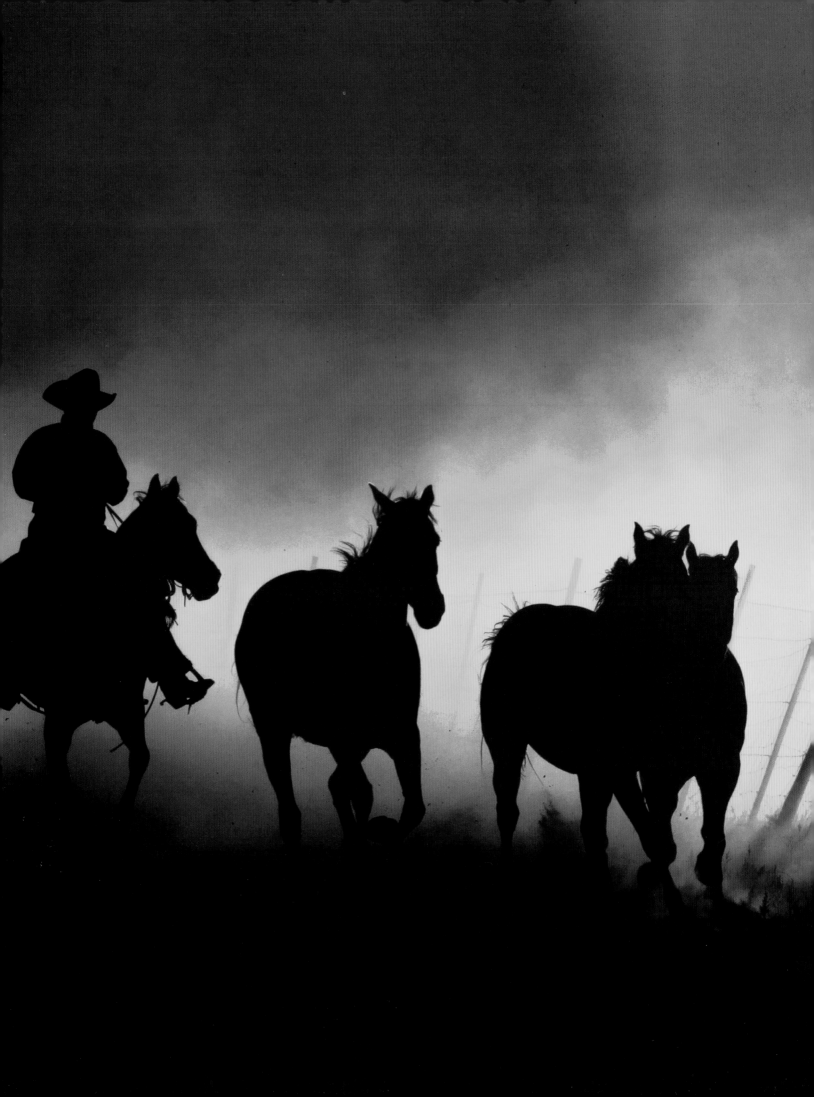

Humans and Horses

Mustangs in Danger

In the 1930s, mass eradication of mustangs — which were considered pests — took place, plummeting their numbers to 17,000 from more than 2,000,000 in 1860. Legs were sawn off and eyes were gouged out — there was no limit to the cruel mutilation that was carried out to make transporting their carcasses easier.

CHRONICLES OF AN OFFICIAL ERADICATION

The return of the wild mustang is principally due to the persistence of Velma Johnston, a diminutive but energetic woman better known as "Wild Horse Annie." In the 1950s, with the support of journalist Hope Ryden, she alerted the public to the ongoing massacre of mustangs, and her efforts were not in vain. In 1971, the United States Congress proclaimed that mustangs were "living symbols of the history and spirit of the West" and should be protected. This resulted in an increase in the mustang population to about 60,000 by 1977, but under pressure from cattle ranchers, their numbers declined again to less than 40,000 over the following decade. By 2005, only 27,000 remained, and their numbers have continued to decline. The government plans on reducing the total population to 20,000 horses, a threshold approaching the lowest levels in history, in order to appease the oil and natural gas industry, as well as large cattle-raising interests.

Political Victims

The terrain available to mustangs has diminished considerably. Over 20 years, it has shrunk from 84 million acres (34 million ha) across 16 states, to 27 million acres (11 million ha) across 10 states. Over the same time period, over four million head of cattle have been allowed to graze on public lands and have irrevocably destroyed the complex prairie ecosystem of the American West. Any effort to curtail cattle grazing, however, seems like political suicide.

Due to the decline in petroleum-based energy sources, exploration and recovery of these resources has become the United States' top priority. These efforts are focused on many of the wildlife refuges, among them the few remaining areas available to mustangs, like the Red Desert basin and the immense Adobe Town in southern Wyoming. These last wild sanctuaries are being overtaken by the machinery of the oil and gas industries.

Managing the Reserves

The Bureau of Land Management (BLM), a government agency, is charged with the management of some 260 million acres (105 million ha) of public land, which is under increasing pressure from human activity. Cattle are allowed to graze for very modest fees, hunters track the woods in search of trophy game, mining companies prospect and destroy the land, and tourists ride all-terrain vehicles. The mustang population is confined to about 27 million acres (11 million ha) of these public lands, subdivided among several separately managed regions. In the light of such conflicting interests, mustangs are often seen as nuisances or competitors, particularly by farmers and hunters.

Wild horses have little commercial value since they are not attractive hunting trophies and are shunned by consumers as edible meat. Worse still, management of mustangs is costly for American taxpayers. Roundups, placing horses for adoption, setting aside pasture land — all this is extremely costly.

Despite strenuous opposition from animal protection groups, the government has recently authorized the unconditional sale of mustangs that are over 10 years old and those that have not been adopted after three attempts at auctioning them. Slaughterhouses are first in line, though these

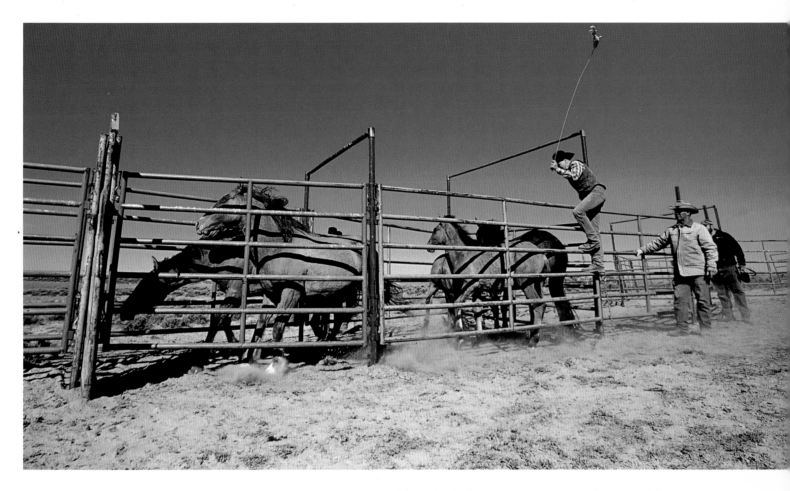

horses have found their way to Canadian abattoirs for many years and their meat has been exported to France, Belgium and Japan.

ADOPTION

Adopting a mustang in the United States is very simple, both through registered organizations and on the Internet. For a few hundred dollars, any adult who can prove they are capable of taking care of a horse and have some place to house it can cart one off in a trailer.

Many Failures …

Problems usually start as soon as they arrive home, as a wild horse does not behave like a domesticated animal. Its sensory acuity is extremely high and, when combined with fear, a mustang's reactions are totally unpredictable. Since it is not used to people or familiar with its surroundings, the animal must learn everything from scratch. It may take several months before any attempts to mount it can be made. Faced with such challenges, most owners give up and lose interest in an animal they obtained so cheaply. To insure that such animals are not abused or sold to slaughterhouses or rodeos, the BLM retains title to these horses for a year after purchase. The bureau also monitors adopters to verify that the animals are kept under sanitary conditions. After this trial period, the BLM grants title to the owner, who can then dispose of the horse as he or she sees fit. Unfortunately, the BLM does not have enough inspectors to be effective, and many a mustang ends up kept in a tight enclosure waiting to be sold for slaughter. The sad reality, therefore, is that for a profit of a few hundred dollars, most mustangs end up in slaughterhouses.

… For a Few Successes

Fortunately, some adoptions do result in happier circumstances: mustangs that become well known in parades and shows, shine in harness racing or polo, or compete in dressage. Others become patrol horses, or packhorses for hunting or trail riding, while some become training animals, and a few lucky ones become icons of the Old West on private ranches.

Panic- stricken mustangs refuse to be corralled in tight, steel holding pens and are at risk of limb fractures when climbing the ramp into a livestock trailer.

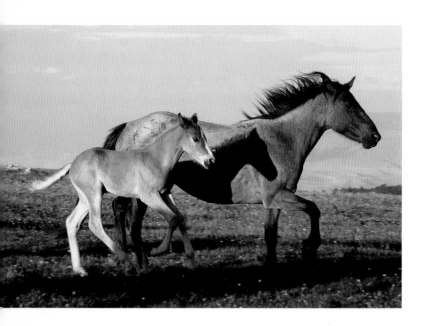

In order to overcome some of the difficulties involved in taming mustangs, the BLM is teaming with natural horse trainers at select holding sites to facilitate the process. Expert trainers like Steve Mangle and Bryan Neubert work with horse owners to help them educate their "rough" horses. In addition, dedicated prisons have been set aside where inmates can volunteer to help motivate and prepare mustangs for human contact and riding. Since both have lost their freedom, strong bonds often develop between inmates and mustangs, who share a common goal: learning and relearning the rules of society.

THE MANAGEMENT OF NUMBERS

The annual growth rate of a mustang population ranges between 16 and 20 percent, depending on the environmental setting; predation and drought can drastically lower these numbers. Overgrazing and habitat destruction are the arguments used to justify artificially managing the size of wild mustang herds. Consequently, every four years, large-scale roundups are held in the reserves to cull excessive numbers of animals.

The Roundup

In recent years, it is estimated that an average of 10,000 horses have to be culled annually, a clear increase in "harvesting" despite the growing numbers of would-be buyers. Not all populations of wild mustangs are regulated in the same manner. For instance, in herds where animals with desirable traits predominate (for example, the horses are of Iberian lineage or have preferred coat colors) only young animals are selected, as bachelors, young mares, yearlings and fillies are more likely to adapt to human contact. Although the remaining animals are left in their environment, this does not prevent the destruction of harems, but at least their genetic diversity is retained and some horses remain free.

Chemical Contraception

An additional means to controlling mustang populations is to inject mares with biochemical contraceptives. The effects are fully reversible as long as the treatment is not administered for more than three years in succession. Fillies under two years of age are the primary targets, as well as aging mares, to help improve their physical condition. This approach is certainly a good one as long as the contraceptive used is not PZP (porcine zona pellucida). This product was "improved" to prolong its effect and prevent mares from having their first foal before they reach the age of five or six — or even older. At the same time, the age at which adult mares are now treated has been reduced from 15 to 11 years, thereby shrinking the reproductive window of mares even further. Government-funded research, however, does suggest that such modifications in the hormonal status of young mares does not change the overall behavior of the harem, nor the age when young mares leave it.

In the absence of an independent scientific evaluation of the situation, questions arise regarding the moral and ethical issues of these practices. With this type of intervention, can we still consider these "wild" horses? Similarly, since people select individual animals for sterilization, this approach differs little from what is widely practiced with domesticated horses. Therefore, the debate continues, even though the low cost involved in this type of "reproductive management" cannot be denied.

WHAT ABOUT NATURAL SELECTION?

Natural selection would clearly be the best alternative, though the introduction of predators is not appreciated by ranchers, who are concerned about the safety of their cattle. This only leaves natural catastrophes, such as a prolonged period of drought, which can easily reduce mustang population growth by as much as 5 percent. Of course, scenes of starving animals wandering aimlessly in stifling heat or the bodies of horses lying in a pool of dried blood are not what anybody wants to see. So, in the absence of natural selection favoring the fittest individuals, animal protection groups have forced the BLM to undertake heavy-handed rescue operations. Thus, between destruction and overprotection, mustangs are trapped in a web of political, social and cultural interests.

Misery at the Hands of Humans

Raising horses is all about profit, whether it involves racing them or even slaughtering them. The more prized the horse, the more attention it gets — though this attention is mostly inept, and often harmful. And yet, by simply returning them to a more natural environment, horses will profit both from a physical and a psychological standpoint, be they simple riding animals or thoroughbred racers.

WHEN CAPTIVITY LIMITS FREEDOM

It is astonishing that even after 6,000 years of domestication, we still do not fully understand horses. The majority of problems associated with issues like health, shodding and horse behavior are the direct result of human intervention in their ways of life. The answer to this is really quite simple and only requires us to change how we have traditionally managed these animals so as to better meet their ethological and ecological needs.

Horse Rehabilitation

The way of life we have imposed on horses in captivity differs radically from what they encounter in the wild. All we have to do is compare how a wild horse spends its time as opposed to one kept in a stable. Wild horses spend about 60 percent of their time feeding, versus 15 percent for a stabled horse, and a great deal of the remaining time is spent resting — about 20 percent for free horses and 70 percent for animals in captivity.

Instead of roaming freely in pastures, domesticated horses are typically forced into inactivity, cloistered in stables, fed three meals of concentrated grain daily — all without social contact with others of their kind. They are cooped up for perhaps 23 hours a day, exercised for about an hour and then expected to perform at the peak of their physical capabilities. If the stalls open into an internal corridor in the stables rather than to the outside, the animals are deprived of virtually all sensory stimulation. Worst off are horses that are tied in their stalls facing only blank walls. Such confinement, solitude, boredom, lack of stimuli and social contact are the root causes of all sorts of behavioral problems. For these reasons, many horses held at equestrian centers develop such well known problems as nervous tics, unusual eating habits, leaning, walking tics and ingesting air. Psychological problems develop well before they are expressed in such odd, repetitive forms, and once acquired are very difficult to correct. Only a more natural life (roaming in pastures and socializing) will prevent appearance of these "stable defects" and prevent them in most cases.

SOME SIMPLE RULES

Horses have two basic needs in order to thrive: maintaining social contact with their kind and enjoying at least some freedom of movement. This can only be accomplished by abolishing individual holding stalls and providing horses with access to open spaces. Clearly, only animals with strong

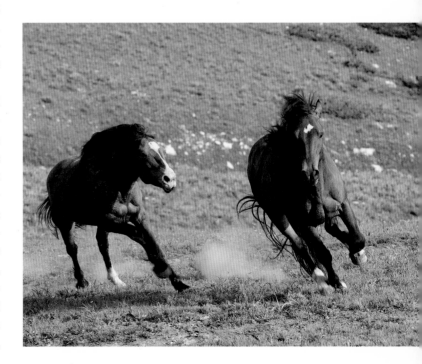

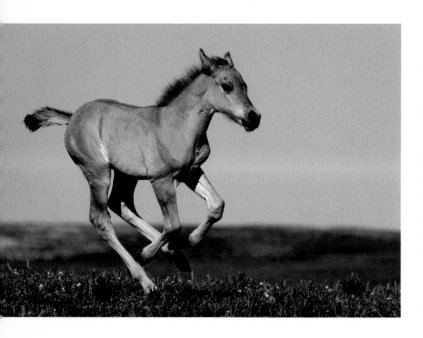

chewing with its head in an upright position. Dental problems can lead to digestive problems, and combined with an unnatural feeding posture can also cause backbone problems.

Feeding with the head toward the ground is not only more natural for the horse, but also allows better control of the amount of dust entering its respiratory system. The automatic water dispensers, feeding troughs and racks in stables are usually mounted too high. If available pasturelands are not extensive enough to meet food requirements, they could be supplemented by providing large feeding baskets placed close to the ground between some trees, thereby ensuring the animals keep extending their necks while feeding. Finally, it is important that horses obtain a varied diet. Calorie-rich grains combined with a lack of fiber produce large quantities of lactic acid — the cause of much illness and repetitive behavior in horses.

links can be grouped together. It's only natural that owners of expensive horses will be concerned for their animals' well being, and so they will have to introduce them gradually to suitable groups of animals to avoid possible harm or injury. Even stallions could be integrated into groups without mares to avoid sexual conflict.

Stables with open facilities allow several horses to live together and provide them with ready access to a paddock or meadow; they also afford the best living conditions for domesticated horses. Animals housed in this manner encounter fewer respiratory and locomotion problems, and perform better in competitive events — something that racehorse and show horse owners should appreciate.

An Ideal Meadow

German veterinarian Dr. Hiltrud Strasser has shown that daily hydration is important for the health of a horse's legs and hooves. An ideal meadow, therefore, should contain a brook or pond for horses to soak their hooves in, and even bathe in. Failing that, a pool about 6 inches (15 cm) deep could be constructed for this same purpose. The moist and humid soil typically found in most pastures is not well suited to horse feet, which, after all, evolved on prairie lands. The ideal meadow should also have areas covered with several square feet of rock, thereby placing obstacles that will direct horses along longer pathways to their feeding locations. Shade trees would also provide relief in the summer as well branches for scratching against.

In nature, a horse spends about 15 hours a day grazing, thereby keeping its head close to the ground for more than two-thirds of the time! In sharp contrast, a horse kept in a stable keeps its head up most of the time and, since it feeds from a high trough, many dental problems arise from

BAREFOOT IN THE GRASS

Despite its externally rigid and cornified appearance, the foot of a horse is a flexible and supple body part — truly an anatomical and engineering masterpiece. The distal phalanx is embedded in a kind of hydraulic shaft (the corium), which contains blood vessels and a mesh of laminae that anchor the bone to the internal tissues of the hoof. Extraordinarily resistant, these two interwoven tissues, with a total surface area of 775 square inches (5,000 cm^2), support the animal's full weight and also serve as shock absorbers.

The horse's foot is like a bona fide blood pump; each time it touches the ground it expands a few millimeters in width and fills with blood. When the foot is raised again, the hoof's elastic sole contracts, emptying the blood back into the circulatory system toward the heart. After 20 years of research, Dr. Strasser concluded that affixing horseshoes causes many locomotion problems in horses, and also accounts for the their short life spans when domesticated. The elasticity of the horse's hoof is compromised when it is shod, preventing it from releasing blood properly. Blood vessels are compressed within the hoof and the sole is pushed upward. This is just like a person who is wearing shoes that are too small — the foot is compressed and circulation is restricted. Such contraction of a horse's feet produces widespread inflammation and causes limping. Metabolic wastes and toxins, which are partly eliminated through the wall of healthy hooves, also build up and accumulate in the liver and kidneys of horses that have been shod for many years. It is really important, therefore, to always do blood tests when removing old horseshoes, to ensure the animal is healthy, otherwise it risks succumbing to sudden metabolic poisoning. Returning horses to barefoot status should be undertaken slowly and with gradual adaptation.

Success is only possible if the animals are allowed to live naturally on different terrain and given the time required — one year — to rehabilitate their feet.

Healthy Hooves

One sunny afternoon we came across two mustang stallions pursuing each other energetically down a rocky crest in Nevada's Granite Range. The noise was jarring as their hooves struck the hard surface. When they reached the bottom of the escarpment, their hooves were still intact, with not a crack or dent visible. After observing some 300 mustangs close enough to inspect their hooves, we have been struck by the extraordinarily healthy appearance of their feet. Whether the terrain is stone, clay or sand, the hooves repair themselves quite naturally. In fact their movement across natural substrates is as effective as the work of the best farrier. Hooves are adapted to the most varied terrain, growing steadily for wear and tear and strengthening on hard ground.

Compared to the hooves of our domesticated horses, those of mustangs are worn down evenly, with short toes and heels that don't protrude more than a quarter of an inch. Puzzled by the walking problems common among riding horses, farrier Jaime Jackson has studied mustangs in the wild for some time. He has also observed newly captured mustangs to assess the natural tilted angle of their hooves, irrespective of foot size, which varies with lineage and length of the hoof wall, which are almost identical (3 inches/7.5 cm) front and back. He notes that the front feet are angled about 54 degrees with respect to the ground, and the hind feet 58 degrees. The weight of the body is primarily borne by the side walls of the hoof and the bars, followed by the concave sole and the frog. The frog only touches the ground passively, like the arch of a human foot. On a flat, solid surface, the frog sits just a few millimeters above the ground, while on damp or sandy soil, the foot sinks and the frog leaves a very characteristic imprint.

Unlike their thick and leathery appearance in our stable horses, the frogs in mustangs are flattened, firm and compact, and feel dry and firm to the touch, like a piece of hardened leather. Finally, it's noteworthy that the rounded tip of the hoof provides a solid footing, similar to athletic or walking shoes.

REESTABLISHING COMMUNICATION

Apart from being a mount, the horse is first and foremost a social animal, and nothing is less natural for it than to carry a person on its back, or to be adept at physical exercise! Unfortunately the majority of riders only see horses in this way. It should not be surprising, therefore, that serious communication problems arise, and that a horse's dissatisfaction is often ignored by its rider. It is not until performance and obedience issues emerge that the rider wonders about the lack of cooperation of his or her mount.

On the Same Level with Horses

It's hard to overemphasize the importance of olfactory contact, brushing and walking when dealing with a horse. Greeting a horse requires a respectful approach; gently blowing on the nostrils is a common greeting among horses, which occurs before further contact takes place.

Brushing a horse is akin to mutual grooming and provides a great opportunity for friendly bonding. Often the animal likes to reciprocate to being brushed and groomed and "returns the favor." Though frequently neglected, a short walk on foot is the best way of instilling confidence and establishing good rapport. This way, young horses and stabled horses that don't get out much become familiar with their surroundings and with new things. It is also a good idea to occasionally spend time with a horse out in pasture. This way, without making any demands, you can just observe your horse and also engage in some grooming. In short, a good horsekeeper is first and foremost a horsekeeper on foot, leading and working with the mount on the ground.

The mustang hoof is characterized by a short wall, a low heel, a wide, solid frog and a concave sole.

Horse Whisperers and the New Masters

After the release of the motion picture *The Horse Whisperer*, well-known whisperers across the world and of all nationalities emulated the techniques and took advantage of a lucrative opportunity. Students of well-known practitioners, and talented self-taught individuals have provided a real service to horses and their owners. Others, who have developed their own methods, have sometimes traumatized horses for life. It's best to be cautious and careful when selecting a practitioner.

Despite much talk about collaboration and harmonious relations between people and horses, some approaches are far from gentle. Psychological pressure, as favored by many new horse owners, can be as much a form of violence as physical punishment. Today, many animal behaviorists criticize the "join up" method, whereby socialization is discouraged and horses lose their interactive nature. For example, forcing horses to trot left and right in a round pen can cause much stress and excessive perspiring. The trainer stops chasing the horse the minute it lowers its neck, chews or lowers its tongue (a sign of submission or seeking approval). The horse thus learns that to avoid running again, it has to observe the trainer's reaction, move toward the trainer and stay close.

This action should under no circumstance be seen as a surefire formula that can be applied to any horse, as there are as many different techniques as there are problem horses. Above all, educating and reeducating a horse requires a flexible mindset on part of the trainer. Horse training may be simple in theory, but it takes many years to acquire the concentration and physical stamina necessary to fully communicate with the animal.

Horse whisperers have actually not invented anything new. Their methods are little more than a return to practices of Native Americans, Moors and such classical masters of the skill as Xenophon, Antoine de Pluvinel and even François Robichon de la Gueriniere. However, the American horse-whispering practitioners deserve credit for having brought together this knowledge and developing an orderly approach that anyone can master and communicate to others.

The American methods of horse whispering have been extremely successful because so many riders have shunned the constraining methodology of traditional equestrian practices. In most riding clubs, coaches do little more than explain to novice riders how to direct a horse. The animal's behavior, needs and means of communicating are generally considered unimportant. Horse whisperers have filled this void by teaching riders a very practical way to pursue a more intimate relationship with their horses.

Negative Reinforcement

Far from murmuring magic incantations into the ears of horses, the whisperer is first and foremost an astute observer who can detect the most subtle signals and respond to them with perfect timing and appropriate body language. As in classic dressage, the underlying principle is negative reinforcement. Instead of trying to prevent undesirable behavior, the goal is to allow the animal time to reflect, act on its own accord and give it the illusion of choice; specifically, unwanted behavior will result in discomfort, while positive behavior will result in relaxed well-being. For instance, when faced with a horse that refuses to back away, the handler will move the longe line (a long training rope) attached to the head harness to the left and right, until it gently taps the horse on the rear. This action stops the moment the horse backs away. The horse soon understands that it must back away to avoid being hit by the line. Since the handler seeks to secure and comfort the horse, he or she will use these kinds of techniques to improve the training method.

If new owners avoid punishing their horses in training, they must be precise, just and authoritative, and infinitely patient. Thanks to such efforts, many horses that would otherwise be branded as "dysfunctional" and sent for slaughter now have a second chance.

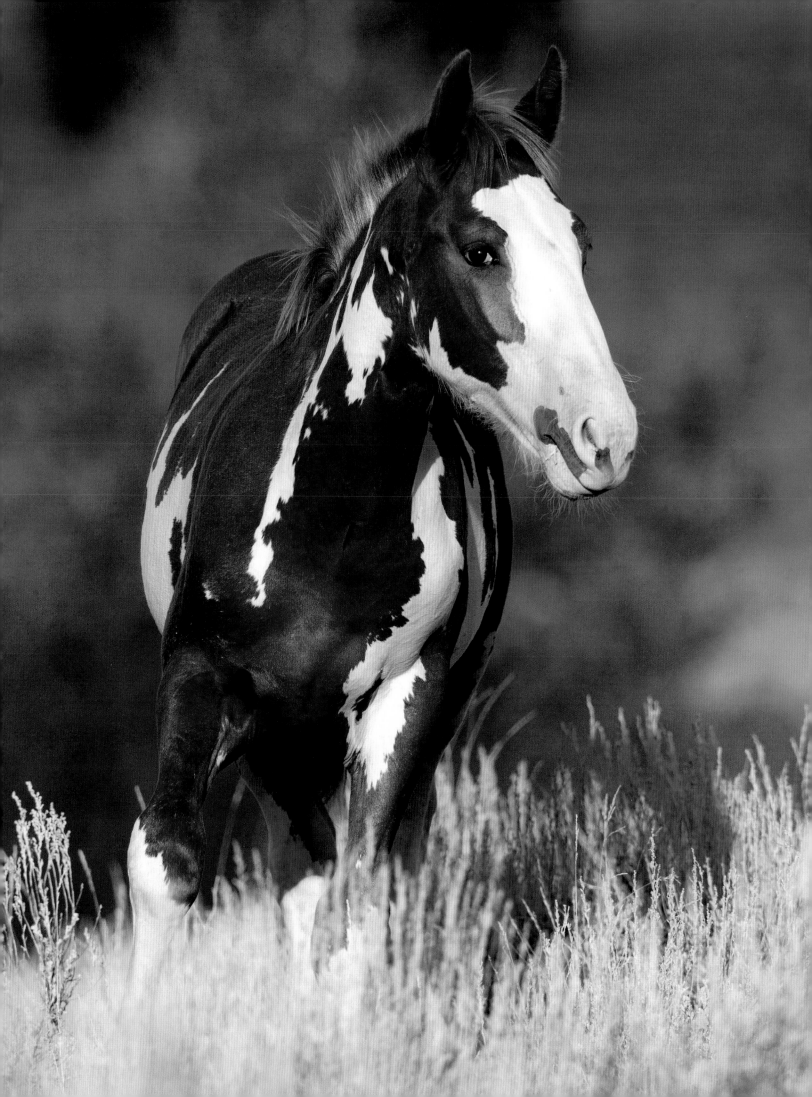

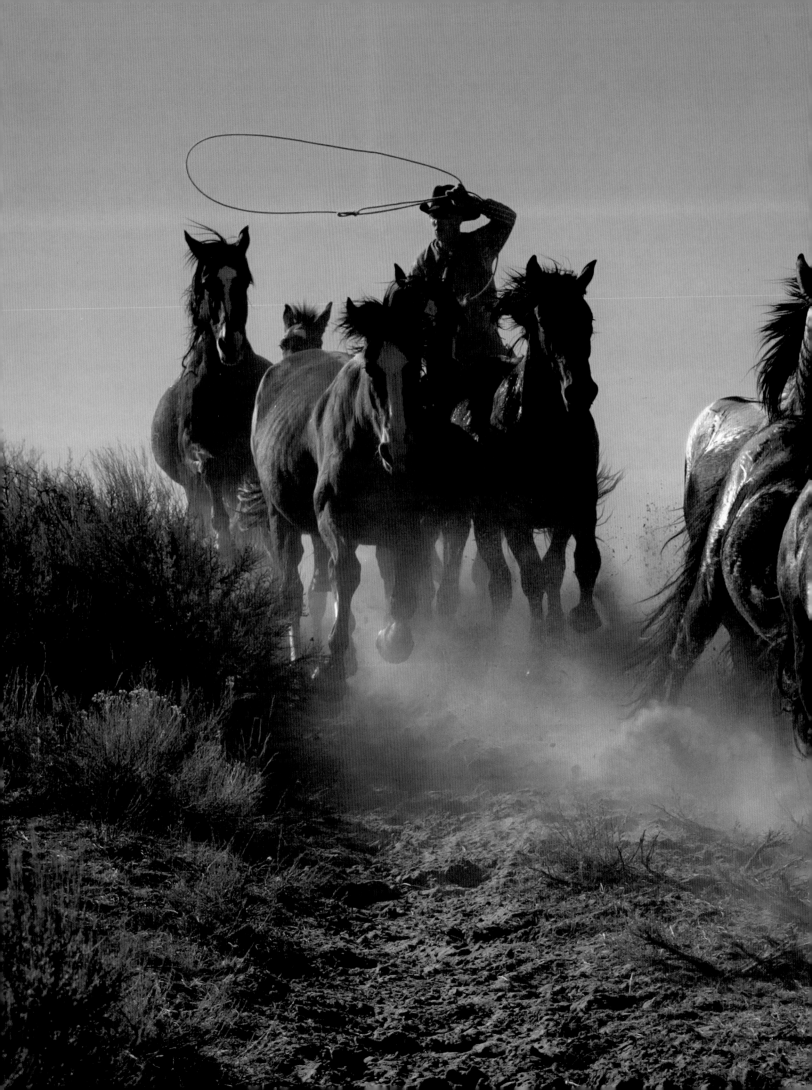

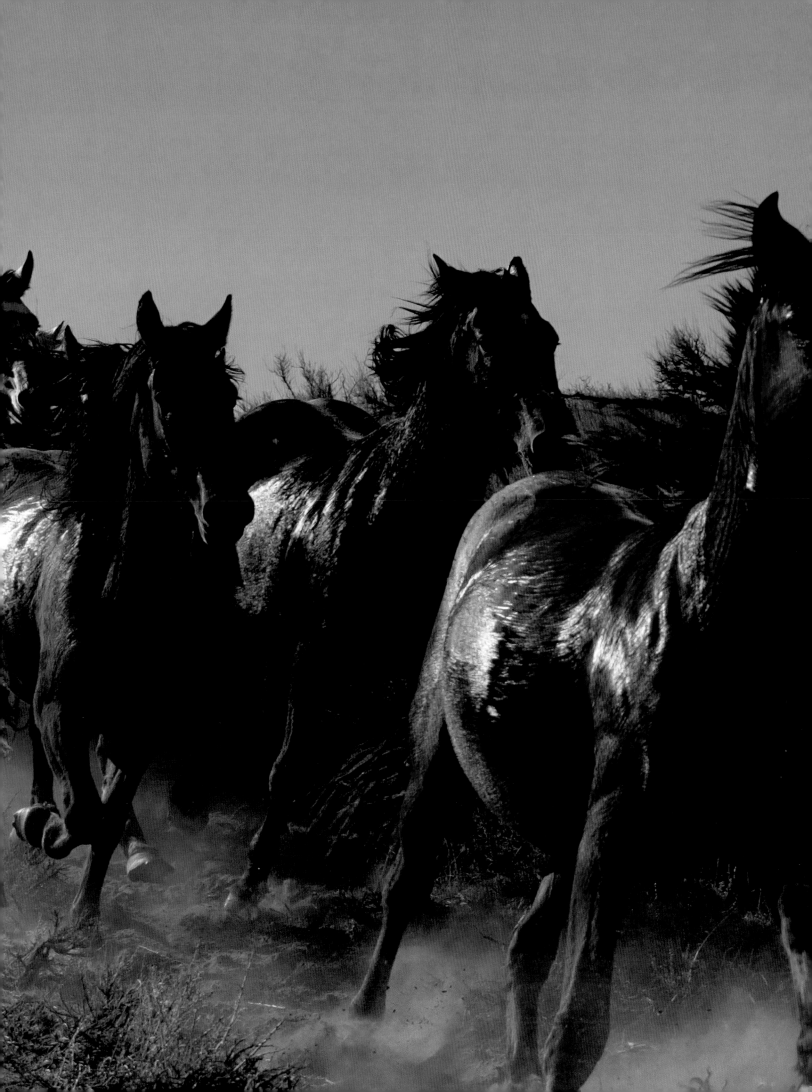

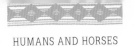
From September to February, teams of wranglers take part in mustang management. Each day at dawn, employees of the Bureau of Land Management string out large curtains of jute to form a gigantic funnel. Supported by a helicopter, the cowboys prepare to force the mustangs into this "fishnet." During these roundups, more than 10,000 horses are removed annually.

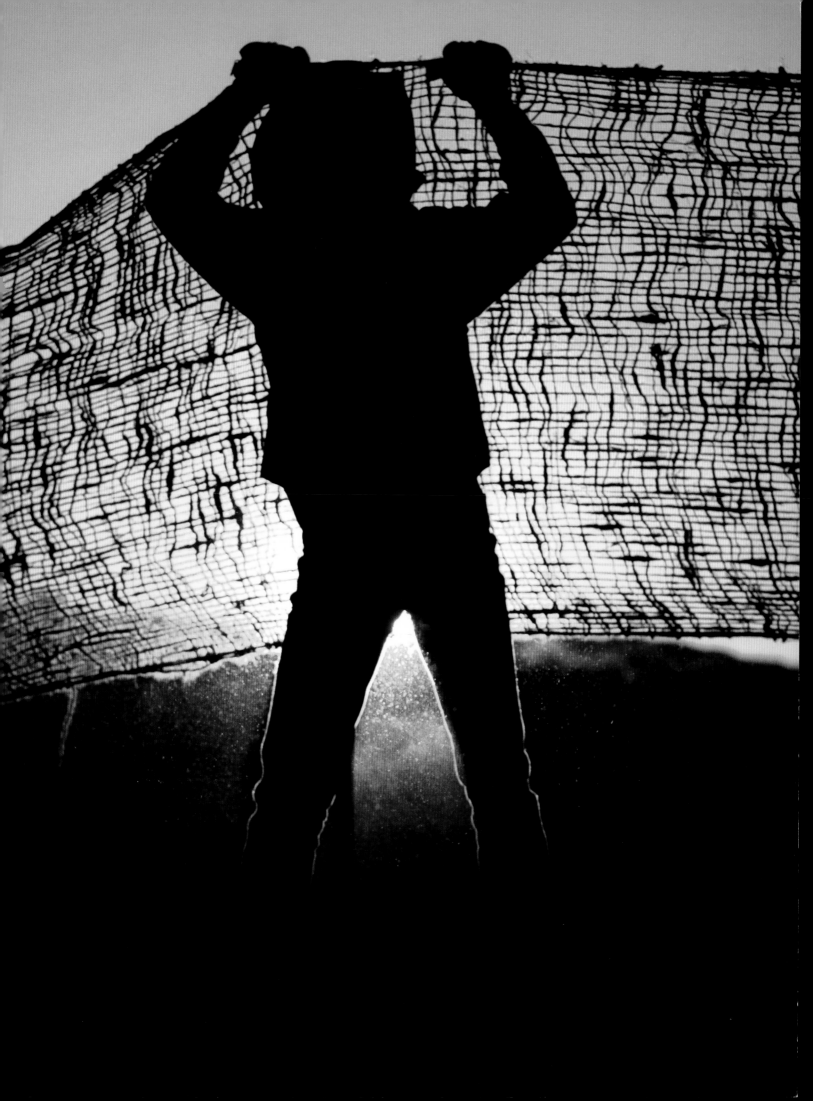

If we can look past the questions that address the future of the mustang, a roundup is undoubtedly the source of fascinating images — tributes to the best Western movies. The riders approach the wild horses with great precision, guiding them toward a metallic enclosure amid a loud concert of hooves and whinnying.

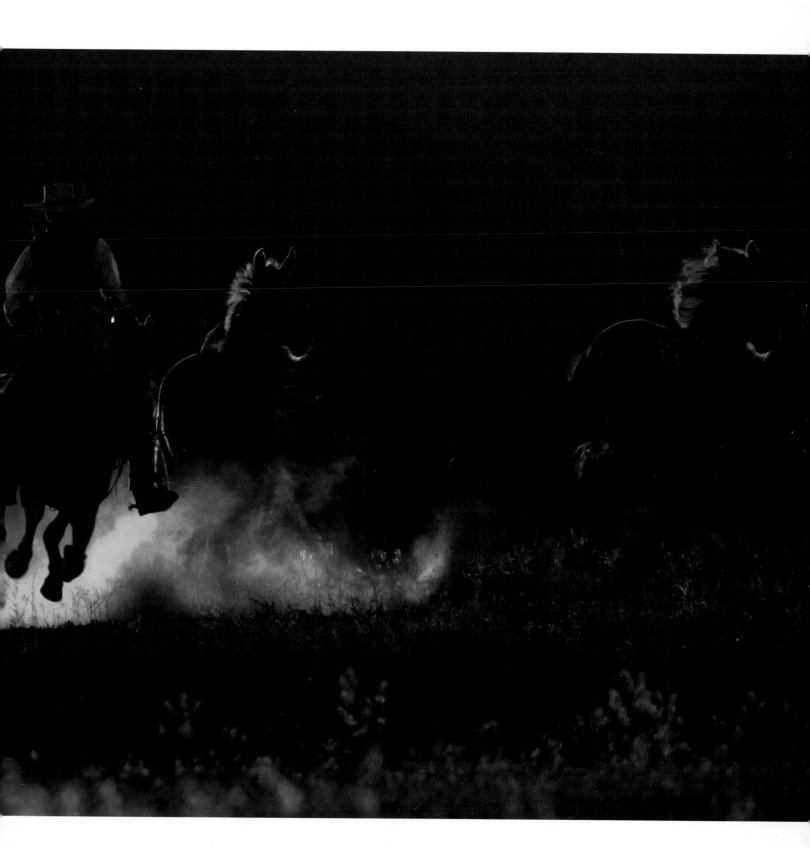

The Roundup

It's 4 a.m. Dawn breaks over the immense expanse of the Great Divide Basin. Two livestock trucks and several pickups speed over a deeply rutted track of the Red Desert, leaving a long, dusty trail in their wakes. In this desolate region of Wyoming, hundreds of "superfluous" mustangs must be removed according to the Bureau of Land Management's (BLM's) program. For more than a week now, we have followed the daily habits of a team of wranglers specializing in capturing wild horses. The air is dry, but the wind is chilly on this September morning. The men pull down their Stetsons, pull up their jacket collars, and shake off the dried mud stuck to their boots before fitting their spurs.

In the first light of day, the wranglers install long bands of jute in a light, uneven pattern. The mustangs do not see the V-shaped trap until the very last moment. About 20 minutes later, the thundering sound of a helicopter, at first barely audible, becomes amplified. The pilot directs about 20 mustangs toward the funnel, while honking his horn at regular intervals to prevent potential escapees from exiting at the sides. With eyes wide open and nostrils flared, the horses are sweating. They radiate fear. Riding along-side, the cowboys take over from the helicopter. One of them releases the "Judas," a domesticated horse trained in its role to gallop ahead of the panic-stricken mustangs and lead them straight into the trap. Before they even realize it, the mustangs are caught! Overcome with fear, they press themselves against the metal enclosure. The gate closes. There is no chance of escape.

Unfamiliar stallions are confined in close proximity. Hooves burst and kick; teeth become embedded in flesh, the mares whinny, the foals shake all over. The odors and movements of these humans terrify them. The horses throw themselves against the metal fences, rearing up while trying to jump over the barriers. Finally, through a system of locks and corridors, they are guided one by one toward the live-stock trucks. Silently, the wranglers wave pennants at the end of sticks. This visual and acoustic signal is often sufficient to make the mustangs climb the ramp. If all else fails, an electric prod will convince even the most hesitant. The horses fear passage into the dark and closed world of the truck. Some refuse to enter with all their might, rearing and backing up, even at the risk of breaking their necks. Strangely enough, once they do enter these metallic confines, they calm down and silence returns once more. The comings and goings of the helicopter will continue until both trucks are full. By mid-morning, the installation is dismantled and the team returns to the nearest collecting station to transfer the mustangs.

Before being adopted, the horses are kept in huge, enclosed holding facilities, where they are under the care of a veterinarian, assistants and wranglers. Despite the circumstances, this well-equipped and experienced team tries to not panic the horses further. Wounded animals receive first-aid treatment. Some have necks torn by barbed wire, others have thighs torn during furious rearing, or hooves shat-tered by a too-sudden turn. On top of these physical traumas, the frenetic pursuit has left a psychological imprint. Held between two retaining boards, every mustang is dewormed and vaccinated; and its teeth are inspected to estimate the animal's age. Then a code is imprinted on the left side of its neck with a cold branding iron kept in liquid nitrogen. Finally, a small colored cord is slipped around its neck (red for mares and their foals, black for stallions), tagged with an identification number, and the horses are released, stallions to the right, mares to the left. Only foals under six months of age are permitted to stay with their mothers. They then receive fresh water and bales of hay, though this golden cage is no less of a prison to them. The stallions will then be castrated under anesthesia.

All the horses remain at the station for an average of three months before they are put up for adoption or redistributed to other states. Torn from their harems, deprived of their freedom, the animals feel totally bewildered and some undergo rapid physical deterioration.

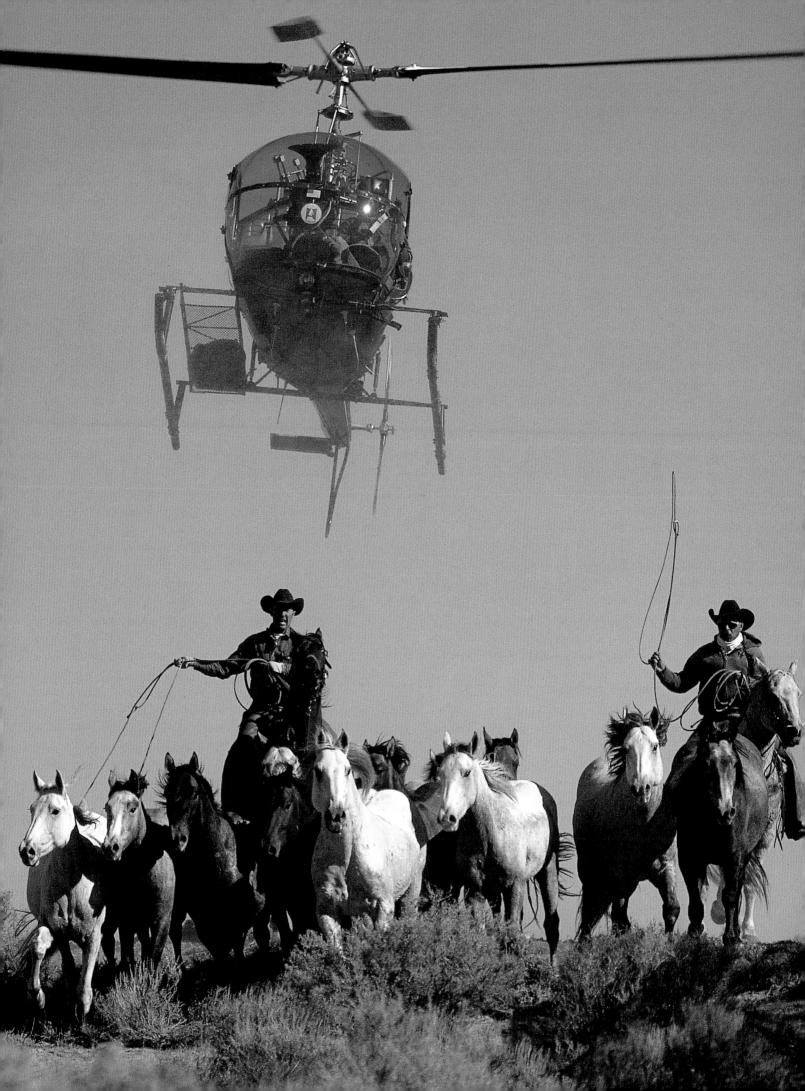

Once vaccinated, dewormed and cold-branded, the mustangs are divided by gender and released into huge enclosures or holding facilities. Only individuals under five years old are put up for adoption. Those between five and nine years of age are turned over to trainers who collaborate with the BLM to have them broken. Older mustangs are sent to sanctuaries in the eastern United States or are sold directly to slaughterhouses.

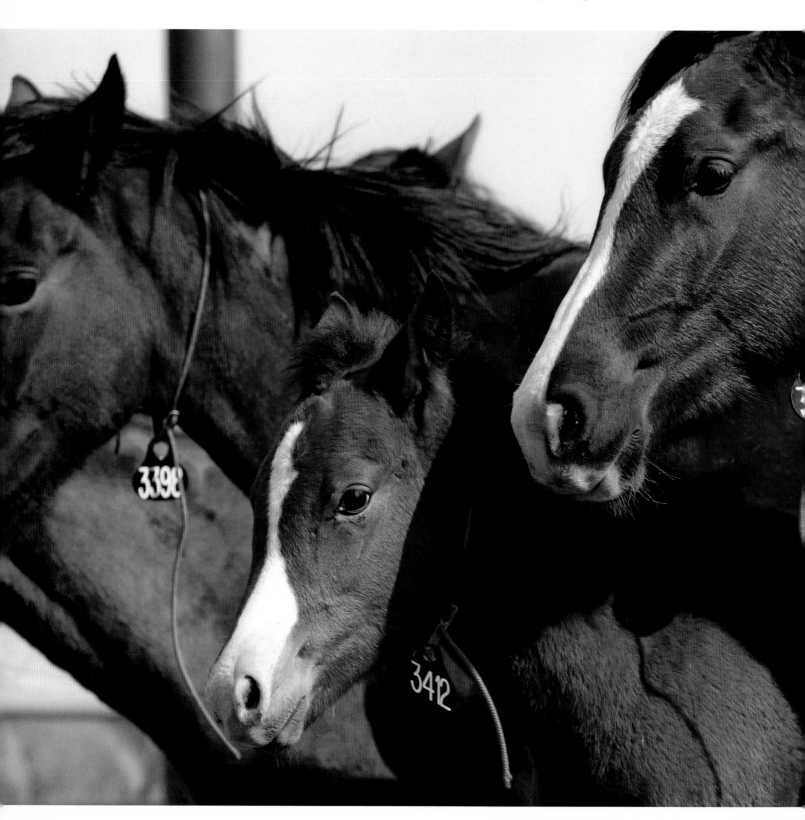

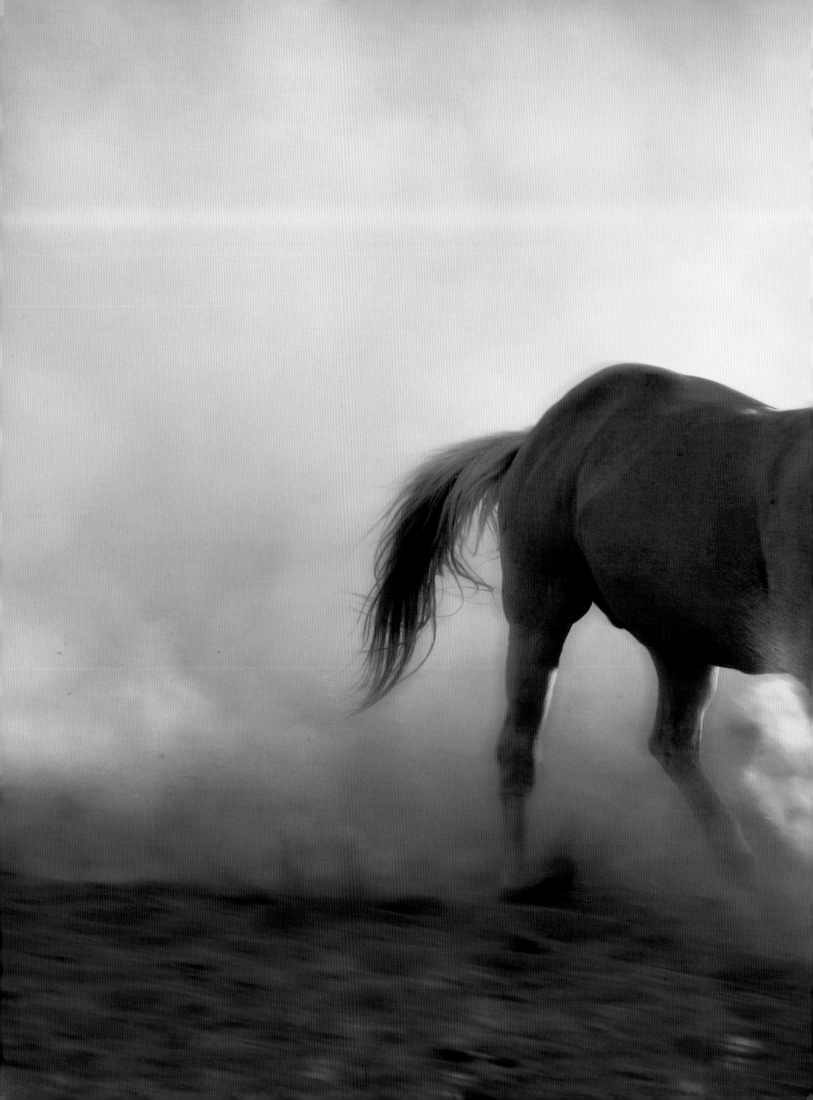

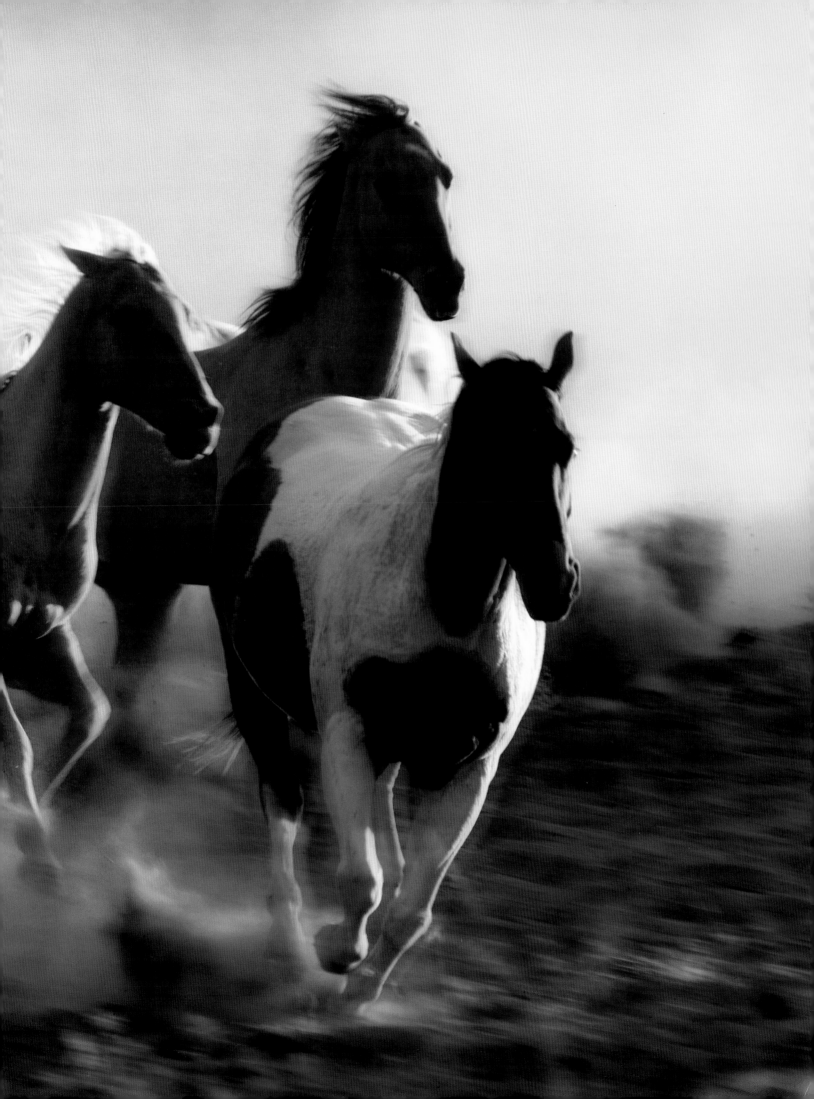

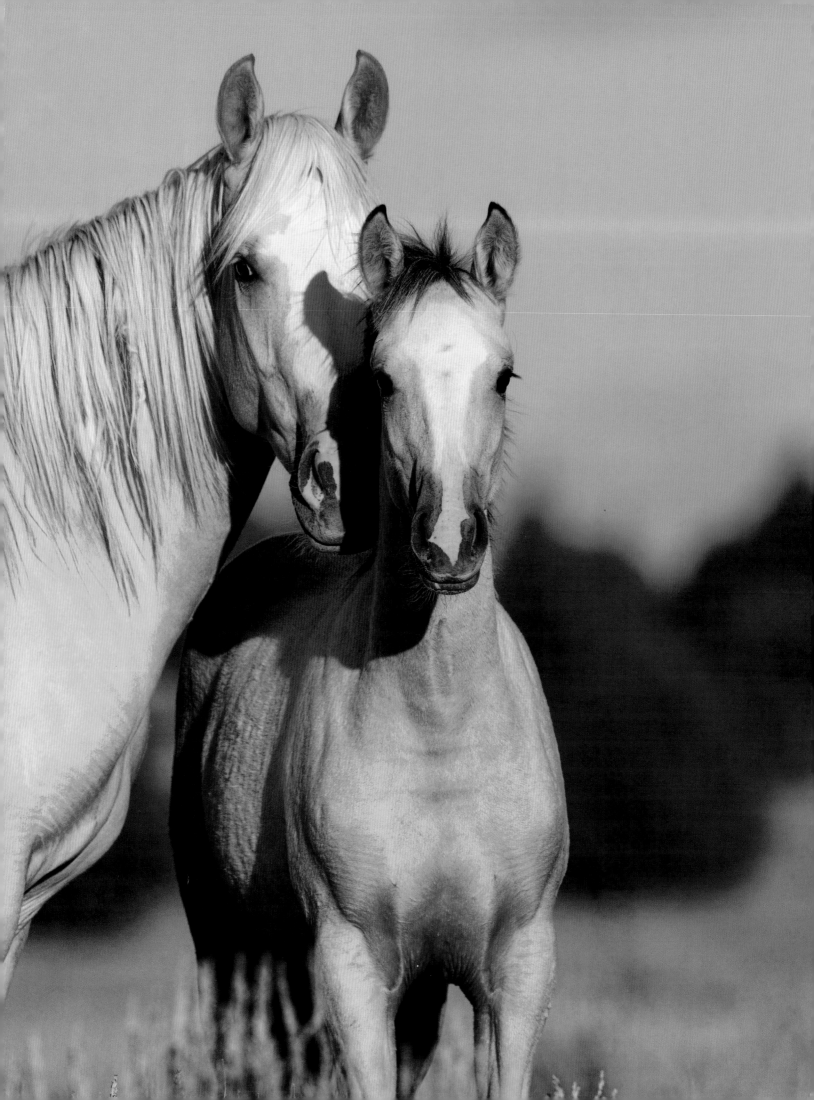

Wild Horses
Around the World

The largest number of wild horses in the world (between 200,000 and 300,000) are found in Australia between the arid Red Centre and the Snowy Mountains; they are known as brumbies. About 10 times less populous, mustangs in the American West are overseen by the U.S. Bureau of Land Management. The many regional offices of this federal agency prefer to keep the horses within safe preserves. Less well known is a herd of about 500 kaimanawa horses in New Zealand, which are distributed over an area of about 50,000 acres (20,000 ha). A number of islands, including Canada's Sable Island, as well as Shackleford Banks and Assateague off the east coast of the United States, have all become home to long-haired feral ponies. Small populations of wild horses are also found in the Argentinean Pampas and Los Llanos in Venezuela — areas subject to flooding during the rainy season. About 150 mostly bay and chestnut horses also survive in the hostile and extremely hot deserts of Namibia.

Many varieties of semi-wild horses live in several countries in Central and South America, Asia, Europe and on certain islands in the Pacific and Indian oceans. In France, Mérens ponies take part in an annual migration to higher pastures in the eastern Pyrenees, just like the blond-maned Haflingers in the Tyrolean Alps. Perfectly adapted to the damp and windy climate of Great Britain, several thousand Dartmoor and New Forest ponies, as well as a few hundred Exmoor ponies, roam across moors, peat bogs and hills, oblivious to the weather.

To make identification easier, the majority of wild and semi-wild horses are tagged through branding, specific hair cuts and distinguishing ear piercings. The management of such animals consists of periodic removal from their natural habitats and, regardless of the time of year, placing several mares with only a single stallion in a confined area (as is the case with the Camargue horse, for example). These extremes are widely practiced in Iceland. Quality horses are generally kept in stables, while those intended for tourism or slaughter are free to reproduce year-round amid the fjords and mountains. Only the annual roundup, organized to auction off young animals, interrupts their quiet existence.

Domesticated horses raised in a semi-free fashion can experience an existence similar to that of their wild cousins, provided they are allowed to roam over a terrain of several thousand acres and form harems and bachelor groups. Unfortunately, this has become quite rare in Europe, as most horse owners are reluctant to allow formation of several harems and to provide sufficient land area for them. On the other hand, land preserves set aside to protect so called "primitive" breeds like the Hucul, Gotland and konik ponies, and even the Exmoor, are generating awareness among people interested in finding out more about horses "in nature." For example, the Oostvaardersplassen preserve in Holland holds about 500 konik ponies as "brush clearers" within 13,800 acres (5,600 ha) of land. The Merfelder Bruch preserve in Germany has been set aside in an effort to safeguard Dülmen ponies. And the Takh Associaton is involved in the reintroduction of Przewalski's horse to Mongolia, with a herd that has been developed on the Méjean plateau in France.

Numbers and Distribution of Mustangs in 2005
(U.S. Bureau of Land Management and the Wild Horse Society of Alberta)

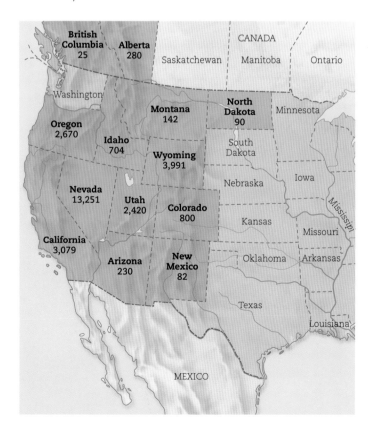

Glossary

Akhal-Teke: An ancient equine species with a delicate and elongated body shape, originating in the steppes of Turkmenistan, Kyrgyzstan, Kazakhstan and Uzbekistan.

Apache: A collective name for several related Native American tribes that speak a Southern Athabascan language. They historically lived in Arizona, New Mexico and Texas, as well as northwestern Mexico, and specialized in capturing and breaking mustangs.

Appaloosa (coat color): A term that groups together several coat patterns, of which the most common are the leopard and the blanket. These patterns are found in several equine species, including the North American appaloosa, the Danish Knabstrup, the Austrian Noriker, the Gotland pony, as well as certain Asian species.

Arapaho: Great Plains Native American tribe that historically lived in Colorado and Wyoming.

Bachelor: An unmatched (unmated, uncoupled, single) stallion.

Bay (coat color): A horse with a brown body and black mane, tail and lower legs.

Brumbies: Wild Australian horses.

Buckskin (coat color): A yellow, cream or golden coat with black points.

Cannon: A bone between the hock and the fetlock (posterior) or between the knee and the fetlock (anterior).

Cayuse: Great Plains Native American tribe that continue to live in Oregon. Renowned for their horse-rearing skills, their name was (somewhat pejoratively) given to the Cayuse pony, a small, sturdy and quick horse ridden by Plains peoples.

Champing or teeth clamping: A rhythmic opening and closing of the mouth behavior, like chewing with an empty mouth, that is used as a submissive gesture.

Cheyenne: Great Plains Native American tribe that historically lived in South Dakota, Wyoming, Nebraska and Colorado, and specialized in capturing and breaking mustangs; they had a long tradition of horse rustling.

Chestnut (coat color): A horse with a reddish brown body and mane.

Colostrum: The very first expression of maternal milk, rich in antibodies (immunoglobulins), which immunize young mammals against major infectious diseases and promotes the evacuation of the meconium (first bowel movement).

Comanche: Great Plains Native American tribe that historically lived in Texas, Oklahoma, Colorado, Kansas and New Mexico; known for their excellent horse riding ability and skill in capturing and breaking mustangs.

Crow: Great Plains Native American tribe that historically lived in Montana, in the Yellowstone River valley, and had a long tradition of horse rustling.

Dun (coat color): A coat with primitive characteristics (including zebra striping, dorsal stripes or crucial banding). According to the tonality of the coat (from bay to yellow), it may be further described as red dun, apricot dun, light dun, and so on.

Dung or manure pile: A pile of horse droppings several feet in diameter and about a foot high, maintained by the stallions at the edges of trails and near water sources. Defecating on a manure pile is an important part of stallion marking behavior. Acting as a means of olfactory communication, the dung pile diffuses scent information about the hierarchal status and identity of the defecator.

Dust Devil: A small dust whirlwind, seen frequently in the arid plains of the American West.

Eohippus: From the Latin "dawn horse," also known as *Hyacotherium*: discovered in 1841 England by Richard Owen; it is considered by most paleontologists to be the first ancestor of the modern-day horse.

Filly: A young mare between one and three years of age who has yet to birth a foal.

Flehmen response: A behavior exhibited by ungulates, including horses, in which the animal curls back its lips to enable odorants to reach its vomeronasal organ

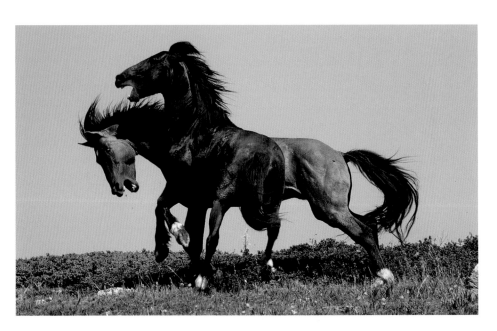

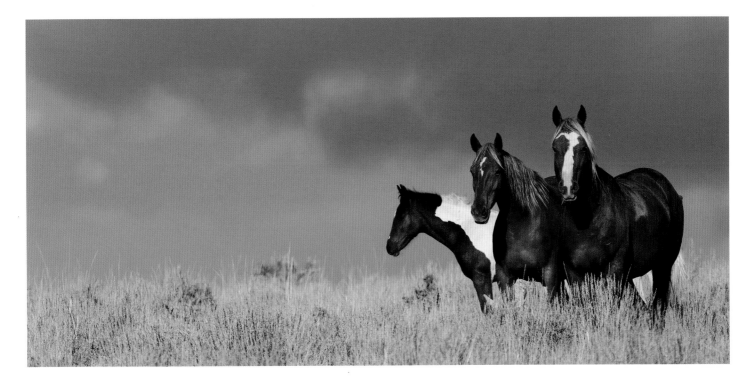

(a specialized scent organ). The behavior is often seen in stallions that are assessing the sexual receptivity of a mare, but many pronounced or unusual odors (e.g., perfume, smoke) can also result in a Flehmen response. Both males and females exhibit the behavior.

Foal: In the context of this book, the term foal designates a small male under a year old. In the equestrian world, the term is most often used to designate a male under three years of age.

Frog: A horny V-shaped pad found on the underside of the hoof; it is rich in blood vessels and plays an important part in the horse's circulatory system.

Grullo or mouse-gray (coat color): A gray-colored coat (diluted black base) with dark dun characteristics (zebra lines, etc.).

Gueriniere, Francois Robichon de la (1688–1751): French riding expert, equerry of King Louis XV, and author of *School of Horsemanship* (*Ecole de Cavalerie*).

Hidatsa: Great Plains Native American tribe that historically lived in North Dakota, east of the Missouri River. Although they were an agricultural society — and thus less nomadic than other tribes — horses were important to them for hunting bison.

Hipparion: A primitive tridactyl (three-toed) equine of the middle Miocene era. With four genera and 16 species, *Hipparion* prospered and overtook Eurasia more than 14 million years ago. In the Laetoli site in Tanzania, *Hipparion* prints intersect those of hominid *Australopithecus* footprints in a 3.6-million-year-old volcanic mudhole.

Juvenile: A young male or female horse at one to two years of age.

Longhorn: Cattle species of Spanish origin with long horns.

Mandan: Great Plains Native American tribe that historically lived in North Dakota and South Dakota, along the banks of the Missouri River. Like the Hidatsa, they used horses to hunt bison.

Maroon: From the Spanish *cimarron*, a term used in the Antilles to designate lost cattle returned to the wild. By extension, this adjective was used as a qualifier to designate escaped black slaves. The American mustang and Australian brumby are considered maroon species. An equivalent term is feral (as opposed to native).

Medicine Hat: A horse with distinct patches, including a "war bonnet" (a patch on the top of the head and around the ears) and a "shield" (patches on its chest, sides and the base of its tail). They were considered sacred by some Native American tribes.

New Master: A horse expert who structures his or her philosophy on that of the horse whisperers, and develops a teaching method using techniques, modules and games to transfer this knowledge to new horse owners.

Nez Perce: Native American tribe that historically lived in Idaho, Washington and Oregon; renowned for breeding and raising appaloosas.

Open Range: Before the privatization and the delineation of pasture lands by barbed wire fencing, cattle breeders were authorized to allow their cattle to graze on vast terrains (the open range).

Osage: Great Plains Native American tribe that historically lived in Oklahoma, Arkansas and Missouri.

Palomino (coat color): A horse with a golden yellow coat and a flaxen or white mane.

Passage: A powerful, dance-like trot used in dressage with show horses. In the wild, a stallion will naturally execute a passage at the approach of a rival.

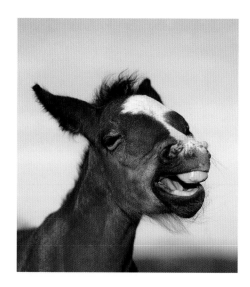

Pawnee: A Great Plains Native American tribe; historically lived in Nebraska along the Platte, Loup and Republican rivers.

Pinto (coat color): A dark or black and white coat with a bay, chestnut or black base in which white spots predominate. Different names are used to describe the horse according to the distribution pattern of the spots; the most popular are tobiano and overo.

Pluvinel, Antoine de (1555–1620): First of the French riding masters under Henry IV of France and author of the work *Instructions to the King on How to Mount a Horse* (*L'Instruction du Roy en l'Exercice de Monter a Cheval*).

Points: The mane, tail and legs of a horse; usually referred to when describing coat color (e.g., The coat is brown with black points).

Protohippus: Ancestral equine species of the end of the Miocene era and the beginning of the Pleiocene era that, with *Callipus*, is often regrouped in the *Protohippine* family. Tridactyl (three-toed) with small lateral toes, *Protohippus* reached the height of a donkey.

Pueblo: Southwest U.S. Native American group comprised of Hopis, Zunis and several other tribes that historically lived in Arizona and New Mexico.

Rabbit Brush: A bushy, yellow ligneous plant with yellow flowers (*Chrysothamnus* spp.) of the Asteraceae family, forming part of the wormwood prairie ecosystem.

Roan (coat color): A mix of white hair in a basic bay, chestnut or black coat. A blue roan coat has mixed black and white hair, while a red roan coat has mixed bay or chestnut and white hair.

Round pen: A corral 50–60 feet (15–18 m) in diameter reserved for working with horses without leads.

Saltbush: A bushy, ligneous plant (*Atriplex* spp.) found in the foothills of the Rockies.

Sioux: Large Native American group with a sedentary, not nomadic, lifestyle; historically lived in the northern Great Plains from southern Saskatchewan and Manitoba down through Montana, Wyoming, the Dakotas, Nebraska and Minnesota.

Social Grooming: A mutual grooming process usually involving two, or sometimes three horses.

Stampede: A turbulent herd movement engendered by uncontrollable panic.

Swatting (of the tail): A term used quite often in the equestrian world. A swatting tail signals tension, nervousness or discomfort in the horse.

Travois: A frame used by the Plains peoples to transport goods. Taking the form of an A-shape, the structure is made of two long poles that drag on the ground and are attached to a harness on a dog or a horse, which pulls it along.

Tsu T'ina (Sarcee): Plains Native American tribe that historically lived in southern Alberta.

Wapiti: North American stag similar to the European red stag.

Whisperer: A horse expert who constantly strives to better the communication process with horses, but is not necessarily concerned with codifying the process or transferring it to the public. The whisperer primarily instructs professional horse handlers from all sectors or those dealing with breaking in wild horses. Some other horse professionals (in rodeos, for example) may also be considered whisperers.

Windchill: Used in the case of intense cold, windchill measures the perceived temperature by the human body by taking wind speed into consideration along with the actual temperature reading.

Winter Grasses: Bushy plant of the Chenopodiaceae family. One species, *Eurotia lanata*, or winter fat, serves as a major winter food source for mustangs.

Withers: The highest part of a horse's back, above the shoulders at the base of the neck. A horse's height is measured from the ground to its withers.

Wormwood: A bushy, ligneous and aromatic plant (*Artemisia* spp.) of the Asteraceae family, typically found in the arid regions of the Rocky Mountain chain.

Xenophon (c. 426–355 B.C.): Philosopher, historian and master of Greek warfare; author of the *Equestrian Treatise*.

Yearling: A one-year-old foal.

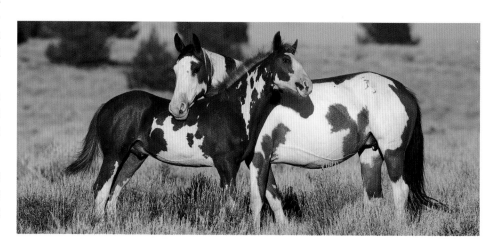

Bibliography

For readers who wish to learn more about certain aspects of equine ethology, the works of Joël Berger, Elissa Cameron, James Feist, Claudia Feh, Martine Hausberger, Katherine Houpt, Ronald Keiper, Hans Klingel, Wayne Linklater, Richard Miller, Stéphane Tyler and Daniel Welsh will be of great interest.

Bender, Ingolf. *Praxishandbuch Pferdehaltung* (Horse Behavior Practice Manual). Kosmos Verlag, 1999.

Berger, Joël. *Wild Horses of the Great Basin: Social Competition and Population Size.* University of Chicago Press, 1986.

Budiansky, Steven. *The Nature of Horses: Exploring Equine Evolution, Intelligence and Behavior.* New York: The Free Press, 1997.

Buissou, Marie-France, and Michel Antoine Leblanc. *Cheval qui es-tu?* (Horse, who are you?). Belin Editions, 2003.

Cabreta, Angel. *Chevaux d'Amérique* (Horses of America). Du Rocher Editions, 2004.

Cameron, Elissa, Wayne Linklater, E.O. Minot and K.J. Stafford. *Population Dynamics 1994–1998 and Management of Kaimanawa Wild Horses.* Department of Conservation, Wellington, New Zealand, 2001.

Franchini, Maria. *Les Indiens d'Amerique et le cheval* (American Indians and the Horse). Zulma Editions, 2001.

Gould, Stephen Jay. *La Foire aux dinosaures.* Seuil Editions, 1993. (Published in English by Three Rivers Press as *Dinosaurs in a Haystack.*)

Horse Behavior and Welfare (Summary of the International Colloquium Held in Iceland). Havemeyer Foundation Workshop, 2002. Text can be found online at: www3.vet.upenn.edu/labs/ equinebehavior/ hvnwkshp/hv02/ hvwk6-02.htm.

Houpt, Katherine, and Rebecca Rudman (eds.). *Applied Animal Behavior Science*, vol. 78, no. 2–4, September 2002.

How to Detain Horses: BVET, OVF, UFV. Federal Veterinary Office, 2001.

Jackson, Jaime. *The Natural Horse.* Star Ridge Publishing, 1997.

Kiley-Worthington, Marthe. *Le Comportement des chevaux* (Horse Behavior). Zulma Editions, 1999.

McDonnell, Sue. *A Practical Field Guide to Horse Behavior: The Equid Ethogram.* The Blood Horse Inc. Editions, 2003.

————. *Understanding Horse Behavior.* The Blood Horse Editions, 1999.

McFadden, B.J. *Fossil Horses.* Cambridge University Press, 1992.

Mills, Daniel, and Sue McDonnell. *The Domestic Horse.* Cambridge University Press, 2005.

Moehlman, Patricia D. *Zebras, Asses and Horses: Status Survey and Conservation Action Plan.* Equid Specialist Group, UICN, 2003.

Morris, Desmond. *Le Cheval révélé.* Calmann Levy Editions, 1997. (Published in English by Crown as *Horsewatchers.*)

Perriot, Françoise. *Chevaux en terre indienne* (Horses in Indian Territory). Albin Michel Editions, 1997.

Ryden, Hope. *America's Last Wild Horses.* Lyon Press Editions, 1999.

Strasser, Hiltrud. *Un sabon sain pur une vie saine* (A healthy hoof for a healthy life). Translated and edited by Kai W. Stensrod and Gregory Ghyoros. Distributed by Katherine Stensrod.

30e Journée de la recherché équine (30th day of equine research). Collective, Les Haras Nationaux Editions.

Ullstein, H. Jun. *Natürliche Pferdhaltung* (Natural Horse Behavior). Verlag Müller Rüschlikon, 1996.

Waring, George H. *Horse Behavior*, 2nd ed. William Andrew Publishing Editions, 2002.

Children's Books

Gill, Elaine. *Ponies in the Wild.* Whitted Books Ltd., 1994.

Klein, J.L., and M-L. Hubert. *Petit mustang* (The small mustang). Pôles d'Images Editions, 2003.

Internet

Adopting Mustangs: U.S. Bureau of Land Management's National Wild Horse and Burro Program
www.wildhorseandburro.blm.gov/index.php
The direct site for information on adopting mustangs through the U.S. Bureau of Land Management (BLM).

The American Association of Natural Hoof Care Practitioners
www.aanhcp.net
An organization that promotes natural hoof care for domestic horses, and offers a certification and training program.

Przewalski's Horse Association
www.takh.org/index_english.html
This is the site of the association for the protection of Przewalski's horses. Contains information on the semi-free rearing of horses as well as the reintroduction of horses in the western region of Mongolia.

U.S. Department of the Interior Bureau of Land Management (BLM)
www.blm.gov
Contains information on the utilization of public lands, their characteristics (mining resources, geology, fauna, flora and archeology), as well as data on the management of mustangs.

Index

Photo Credits

All the photographs of this book are © Jena-Louis Klein and Marie-Luce Hubert and are available from the Bios agency (www.biosphoto.com) with the exception of the following:

2-09